WAR PHOTOGRAPHY

Realism in the British Press

COMEDIA

Series editor: David Morley

WAR PHOTOGRAPHY

Realism in the British Press

JOHN TAYLOR

A COMEDIA BOOK
PUBLISHED BY ROUTLEDGE
London and New York

First published in 1991
by Routledge
11 New Fetter Lane, London EC4P 4EE

Simultaneously published in the USA and Canada
by Routledge
a division of Routledge, Chapman and Hall Inc.
29 West 35th Street, New York, NY 10001

Typeset in Janson Text 10 on 13 point
Book design and Typesetting by Simon Meddings at Lionart, Birmingham, England
Printed in Great Britain
Published with financial assistance from the Arts Council of Great Britain.

British Library Cataloguing in Publication Data
Taylor, John
 War photography: realism in the British press.
 1. British photojournalism
 I. Title
 070.49

Library of Congress Cataloging in Publication Data
Taylor, John
 War photography: realism in the British press / by John Taylor.
 p. cm.
 A Comedia book.
 Includes bibliographical references (p.166), index and bibliography
 1. War in the British press. 2. Journalism, Pictorial. 3. War photography
 I. Title.
PN4784.W37T39 1991
070. 4 33—dc20 90-8759

 ISBN 0 415 01064 0

CONTENTS

ACKNOWLEDGEMENTS

The author and publishers gratefully acknowledge permission to reproduce copyright
material from the following:

Amateur Photographer magazine, *An Phoblacht/Republican News*, *Belfast Telegraph*, *Daily Express*,
Daily Mail/Mail Newspapers PLC, *Daily Mirror*, *Daily Sketch*, *Guardian*,
Illustrated/The Illustrated London News Picture Library, *Independent*, *Picture Post*,
Public Record Office, *Star*, *Sunday Express*, *Sunday Mirror*, *Sunday Pictorial*, *Sunday Telegraph*,
Sunday Today, *The Times*/Times Newspapers Ltd, *Today*

Every attempt has been made to obtain permission to reproduce copyright material. If any
proper acknowledgement has not been made, we would invite copyright holders to inform us
of the oversight.

The author would like to thank all those who have helped in the preparation of this book,
with special thanks to David Corbett and Gaby Porter for their invaluable comments and
encouragement.

1

THE BAZAAR OF DEATH

HUMAN INTEREST

In wartime the press might become a bazaar of death: for at the heart of reportage on war is its certainty. If this 'natural' conclusion to life comes prematurely, or is accepted bravely as sacrifice, or comes with some ironical or bitter twist, then so much the better.

Though mortality seems to be a basic force in news, its expression is restrained in the press – even in wartime. Then interest in death is transformed because it is used to save the nation. Furthermore, the death force in news is accompanied and displaced by more comforting ideas. The subject of the following chapters is not the 'truth' in any absolute sense, as if it somehow existed 'out there', but the special truth of war news published in national newspapers, and the place of photography in this.

Even though photographs are often printed in black and white or imprecise colours, they are widely accepted as standing in for the real thing. They are taken as objective records, different from experience but none the less anchored in the real world. This belief fuels the market for snapshots of family life (in which death does not figure), and is widely held amongst those who use photographs as straightforward evidence (and who have a professional interest in death). The press industry also uses photographic realism as a simple equivalent to reality. We shall examine what is actively produced from this belief and usage.

Newspapers not only use photographic realism as proof of authenticity, but they also ensure its routine production. Photo-journalists must supply pictures which are in focus and have sufficient tones to reproduce well in newsprint. They are helped by using standardized film and equipment. They know that editors demand impact or shock-value, or at least imagery that carries information related to the story, and they create the semblance of proof through using the camera to

produce standard compositions. Photographers place the newsworthy event in the centre of the frame, look for dominant verticals and an even surface pattern, and so create the illusion of linear-planar space. Once the pictures are processed, the photographers' work is reinforced by the choices of picture editors, who crop and retouch pictures to ensure they match the conventions of realism. The routine practice of the bureaucracy helps to shape how the images are made and determine what is shown – what is considered necessary to prove with this type of evidence.

Although the role of photographic realism in supporting news stories had already been established in the popular press by the time of the entry of the British Empire into the Great War in 1914, there were (and still are) limits to what could be said and seen of death. These come from a variety of sources: the limitations of words in describing experience; the technical limitations of photography and printing; customary and legal prohibitions, especially in times of national crisis. In addition, the press is not only busy with death stories. There is the criterion of news-value which depends on the continuation of life, of families and happy consumption. This is important in deciding press stories, particularly in times of active state censorship.

The structures of war and the newspaper industry have changed radically in the period from 1914 to present day reports of terror and crime within the United Kingdom, but the everyday practice of the press has always been subject to legal constraints.[1] In wartime and in security matters in general, governments have placed special obligations upon the press that have impeded the otherwise apparently free flow of news gathering and broadcasting. In both the World Wars the governments had formidable and detailed control, enforceable in law if necessary, over what they would allow the press to say. In addition, during the Second World War, the press came under direct financial control of the government, which loosened the grip of advertisers but drastically reduced the number of pages and pictures. The newspapers retained their hold over readers by continuing to use the mainstay of reportage, the 'human interest' story.

The concept of news as human interest has remained stable because it has consistently sold newspapers. These stories are the most widely read in both tabloids and broadsheets. Their appeal carries across the differences between men and women, young and old, middle-and working-class. This category was described in a survey of newspaper readership in 1940: 'matters concerning the birth and death, marriage and divorce, health, wealth and habits of the great, and especially of Royalty, the aristocracy, film-stars, aviators and athletes are first-call "human interest"'.[2] Celebrities locate the press in the popular knowledges of its audience – or audiences, since the press is not a single unit but consists of many newspapers, each with their imagined ideal readers to whom they speak in a characteristic voice or style of address. What unites them is the news-value of

human interest, and, as the survey of 1940 explained, it is possible for 'ordinary individuals' to be newsworthy only in special circumstances: 'The same details about ordinary individuals must have a special element of the heart-rending or the comic or the merely bizarre to make them interesting to the ordinary individuals who form the bulk of the newspaper-reading public.' In this world, a sensational divorce case was said to be of greater interest to readers than news of the German invasion of Norway; and a torpedoed ship was of interest only if there were interviews with the survivors, and photographs. What is described here, of course, is not the *demands* of the people but the *practice* of the press.

The essential conservatism of this practice enables wars to be *contained* in the newspapers and so avoid the strictures of the official censor. It enables the newspapers to appear regularly and predictably. Stories written from within this framework can transform overtly political news, especially if there are photographs. Realism brings the appearance and values of news stories closer to the entertaining features in the rest of the paper. Awkward questions remain unasked, and history is replaced by whatever can be *felt*, such as natural revulsion or common sense.

Human interest was crucial during the Falklands Campaign. Then the government and military control of information was so complete that the press had the opportunity to say or show very little of ordinarily newsworthy events until they were given the official version and pictures days or weeks after the event had taken place. In these unusual circumstances of news control, the Falklands campaign was scarcely reported at all and, to fill the gap, the press continued as normal.

The news of events in Northern Ireland is different in several respects from those other conflicts, not least in the length of time it has been a running story. The republican armed struggle and loyalist resistance to the unification of the island have been in progress since 1916 at least and, in its modern phase, continuously since 1968. Another important difference took place from the mid-1970s: the perception of the struggle was shifted by the Labour Government from a 'war' into a 'crime-wave'. At the same time, there has been an increase of crime in Britain – the most disruptive being civil disturbances fuelled by racial tension and industrial disputes. So events in Northern Ireland are seen as part of a general increase in lawlessness. This has been further complicated by what is presented as the relatively new criminal class of terrorists who create sudden or spectacular crimes. They bring fear to the whole of the United Kingdom, and show how terror crosses international borders. The threat is both inside and outside the country. This movement of terror justifies the increased vigilance of the forces of law and order. Terrorism also suits the press model of 'interest' *because* it seems spasmodic. The newspapers can leave aside the structural reasons for the conflict, and allow the occasional 'outrage' into the schedules: in this treatment only some deaths and some photographs become meaningful. In news-value, there is nationalism in death.

The process of choosing what is meaningful as news is a matter of debate amongst sociologists of the press. Pluralists believe the power to control the industry lies in consumer sovereignty encouraged by free market forces; instrumentalists, in contrast, place power among the capitalist elites. A third explanation is structural, and refuses to place power simply with one group or other: instead, it argues that the *benefits* of power accrue to those who exploit the financial success of news as a special type of commodity.[3] Commercial success is not based upon the difference of news as a commodity, but upon its *sameness*, its predictability. Success is built upon a static set of items or events – what has been termed 'news as eternal recurrence'.[4] The kaleidoscope of news is more apparent than real. As part of human interest, there are different crashes, different floods and quakes, different murders, different nudes, different comical, sensational and exotic events, any of which can be newsworthy if it fits into the schedule of production.[5] The news cycle is repeated, with variations in the details.

Within this cycle, human interest is not only a type of news: the practice of collecting these stories helps to define the industry. As a concept and a practice built into bureaucracies, it has important ideological significance. It becomes the small change of rhetoric through which it is possible to achieve meaning, and through which people are enrolled in the imaginary unity of the real. In the words of sociologists of the industry, 'human interest' is 'not simply a neutral window on a multifaceted and diverse world but embodies a particular way of seeing the world'.[6] This they describe as a rejection of the possibility of basic structural inequalities in favour of the random and non-historical forces of 'luck, fate and chance, within a given, naturalised world'. The human interest story weakens the idea of living in history (which can be changed), and strengthens the idea of living in a state of nature (which seems to be unchanging). In the newspapers which use this focus as the basis for sales, the ideological effect is quietism. To the extent that photographic realism is sewn into this staple of the industry, it too is useful in the diversion and mollification of consumers: what they see through the 'window' of photography is nothing more than a pictorial analogue of the texts. In other words, the photographs are not 'windows' at all. There is no possibility of moving through them, only of sliding from them to the text (or vice versa): a planar movement of the eye, and a movement that remains actually and metaphorically bonded to appearance at the *surface*. Whilst the newspaper industry entertains in this way, it succeeds in strengthening the pretence that news is something which arises in the 'natural' world, and it is able to disavow the role of news as a product which is used in turn to create consumers.

The newspapers entice readers with stories. In recent times, both broadsheets and tabloid newspapers have increasingly used photographs to lend truth-value to their stories, the peculiar truth and the special excitement of *horror*,

which repels and attracts at the same time. Newsworthiness depends upon the degree of horror measured in numbers of dead and manners of dying, in bodies and the ways they are destroyed. Photographs of the dead carry both the cool authority of record and, weighted by the caption and storyline, the heat of 'news'. Death becomes a commodity to stir the blood of the living, who for a few pence can contemplate the proof of others' mortality. Those who act upon the fantasies otherwise fed by the press and television, who choose to visit the scenes of death, and even steal from them, are considered to have transgressed and are castigated as ghouls. In contrast, it is legitimate for photographers and reporters to pick over the remains; and we as viewers, if we are so minded, can surreptitiously take vicarious pleasure in the horror of it all. This is not a pure horror: it is distant from experience; it is death constructed on the picture editor's desk. The photographs derive from existing practice, often according to unwritten rules of self-censorship in journalism. Most obviously, the ones we see tend to have been taken from a distance. These pleasures we may enjoy. The rest we have to imagine; or experience the feeling of dead flesh underfoot.

In contrast to experiencing or imagining horror, but as part of building a story, the newspapers present the world of human interest. Conceived as fate, it is a thread which runs through the tabloids and the broadsheets. In all of them, from front to back, fate provides a continuum of newsworthiness. It is by chance and mischance that 'ordinary' people may become newsworthy. Through good fortune they may survive, and so be either a 'witness' or a 'grieving relative'.

There are numerous variants on this theme. Fate is newsworthy if there is a twist of irony, if people survive or die by a strange fluke. The newsworthy is anything, such as beauty, cruel fate, or the innocence of youth, which will rack up the story to another level of poignancy and bitterness. To thrill readers, the papers characteristically draw on another measure of news-value, the story which is the-same-but-worse. This does not mean literally that news-value rests only in body counts becoming higher in number with each new incident: the-same-but-worse can be a series of similar crashes in quick succession, so that disaster seems immanent for everyone. The story is worse because death seems to be closing in.

Yet this background of death in the newspapers is matched by an equally constant background of pleasure. The two are presented together and held in tension, so that readers learn that there is relief from the misery visited upon other people. The fragmentary nature of individuals' experience is denied and set against the 'common universal experiences' of

> birth, love, death, accident, illness, and, crucially, the experience of consuming.... The press does not simply promote the consumption of specific objects but symbolically affirms the concept of consumption

generally, inviting everyone to participate. Consumption is emphasized as a central unifying experience, common to all.[7]

Integral to this myth are the advertisements. Readers may feel they scarcely pause over them, and concentrate upon the 'hard' news, or the reviews or sports pages. But the advertisements should not be considered as irrelevant to the news, or merely as revenue to pay for news gathering, printing and distribution. On the contrary, they are related to the news. With some exceptions, notably adverts for charities and political pressure groups which use shocking photographs as evidence, the world shown in advertisements runs counter to the tales of horror in the news. They present commodities and services and suggest their ownership or usage gives the reader a high level of control. They offer something akin to good news, which is otherwise neglected in the newspapers; they are a positive answer to the messages of fate and bad news that abound there. Interleaved with the miseries of fate, the adverts shore us up and protect us from too much reality. Whereas the dream of endless pleasure is shattered in the reports, and only partially restored in the feature stories or the entertainment section, in adverts the dreams remain unbroken. There the conventions of photographic realism are usually ignored, since proof is less important than the promotion of hopes and desires. Whereas most of the news is heart-rending, in contrast the advertisements and some of the features and human interest stories are heart-warming.

Even so, there is no rigid separation between these areas, and they bleed into each other – to the point where some advertisements also try to be heart-rending. In these cases, where shocking photographs are used to encourage people to contribute to the cause, the appeal is similar to ordinary product advertisements: the appeal is still to the magical, transforming moment of consumption, this time turning the heart-rending scene into its opposite. The possibility that either extreme might become the other is the basis for advertisements, and between them they represent a simple model for understanding the world.

Another positive focus for the community of consumers, especially in wartime, is in symbols of national identity such as heroes or royalty. In addition, according to the press, the imagined community of Britons has an overwhelming interest in family life. This is idealized and often turned into a fairytale, lived most nearly by the Royal Family. In this process, its individual members are made over as 'one of us'. At the same time, the press reminds us constantly that they are also unlike 'us': they are living proof of the nation-in-history. The press represents them in a dual role: both as an actual family and as symbols of unity under the flag. It engenders affection for the Royals which surpasses the touristic view of them as merely quaint. As a family of supreme national importance, they are therefore supposed to be much more accessible, and are seen as able to 'speak for'

many more people, than any politician.

Beliefs about the monarchy, family life, pleasure and horror find expression, of course, outside the press. These beliefs and ideas are expressed in custom and practice, and together make up what people understand by decency, a feeling of belonging and knowledge of what is real. The truth-value of news is only one factor in gauging reality, and is often discredited as sensational or simply untrue. As a measure of reality, truth-value is only one factor alongside, for instance, entertainment value. Hence the newspapers do not concentrate upon truth-value above all other considerations, but compete for readers at various levels. This allows them to dispense with accurate accounts of the real in favour of diversion and amusement. Yet, however much the national dailies move in this direction, they refer continuously to other agencies which claim to tell the truth or map out reality. The newspapers choose amongst the competing claims according to their own programme, but still have to demonstrate the authenticity of their choices. At this point, photography is often used as evidence.

EVIDENCE AND PHOTOGRAPHIC REALISM

News-value depends upon authenticity, the eye-witness report or photograph. No reporter or photo-journalist acts outside practice, and he or she will always be subject to the current professional beliefs about newsworthiness as well as the special constraints imposed by government in wartime. Even so, it is precisely this normal practice which invests so much of its credibility in the authenticity of the eye-witness account. Changes to the text by editors or censors are regarded as deviations from the 'original', and the more elaborate the changes or the later the story appears, the less value it has as news. The further the story is taken from the eye-witness source, the weaker the proof that it ever occurred. The types of evidence that meet the needs of news are heavily determined by this burden of proof. We can see the uses of different types of evidence in the following descriptions of death scenes in five theatres of war, at different times and places.

The first comes from an autobiography which deals in part with the Great War, and which was written and published as late as 1972. There the author, Stuart Cloete, recalls a memory older than half a century. In 1916 he saw injured soldiers laid in a row. Then, inadvertently, an ammunition carriage was drawn across them so they 'sat up as the wheels went over them and burst like grapes'. It was, he says, 'a terrible, bloody sight', and becomes so again in the verbs and simile.[8] This description would have always remained outside the orbit of the contemporary press. The reason is not the horror alone, or the mechanisms of the censor, or self-censorship, but the sheer difficulty of turning this incident into the necessary deaths

of heroes. The casual deaths of these unnamed men can only emerge years later in a soldier's memoir, and may not even exist in the official archive.

The value of memories lies in directions other than news. For instance, accounts written later often represent the war in ways that would have been unrecognized by its participants, or at least unvoiced by them in the public media. Often the language used in these later accounts is radically different from that available to contemporary writers, often reflecting in its difference the gap which has opened between the values of contemporary reports and those that come later. It is easier for authors of memoirs to demonstrate in the speech and choice of stories that the conduct or purpose of the war was controversial, wasteful, banal or in error. Their assessments have the various privileges of hindsight, but lack the authority of documentary 'proof' required by newsworthiness.

The second scene and type of evidence is from the Second World War: in Paul Fussell's book on conventional recall and myth there is a dedication to the memory of a man killed beside him in 1945.[9] The man's death is now more than a private memory: it has been transformed by the dedicatory page into a public memorial, but one which reflects upon the author as his act of atonement and gratitude because he lived. The dedication exists somewhere between the *gravitas* of official commemoration and the press stories of lucky escapes, or of those who died though 'not in vain'. Dedications such as Fussell's are rare in the press, being too literary or funereal to fall within the category of human interest, or the ways of representing it. Private memories, if they are to be made public in the press and pictured there, have to become the creatures of copy editors, who alter them to suit the voice of the newspaper.

Thirdly, a scene of accidental death which occurred off-stage, as it were, in the Falklands in 1982. At the time, the story was no more than a rumour (for more on accidental deaths, see pages 97-8). At one point in the fighting on land, all the British casualties were later said (in the 'watchdog' journal *Index on Censorship*), to have arisen from British action, the result of friendly – friendly clashes in the night.[10] The claim (for it scarcely exists as a story) could not have found expression in the daily press. These accidental deaths, if they occurred, for practical and political reasons took place below the horizon of the reportable war.

This is because of official censorship, and because the press was entirely dependent upon the official sources of 'news'. The official channels of the military and Ministry of Defence dominated the press, and succeeded in channelling its reports into set pieces, such as flag-raising and heroes returning. The newspapers are not opposed to ceremonial in time of war, though there must also be 'sacrifice', which is the ceremonial way of presenting news of death.

The publication of the story in the small-circulation *Index on Censorship* indicates that rumours of accidental deaths were confined to the margins of the

information industry. Despite official belief in the power of photographic realism, it is unlikely, if pictures of these scenes existed, that they could 'prove' the truth of the rumours. Even so, the fear of realism among officials is so great that such 'evidence' can have no place in an archive which is used for public relations.

Fear of realism in the everyday viewing of photographs, the common over-valuation of realism as pure record is linked with yet another quality which we give to the image, introducing a fourth type of evidence. Reversing the usual process whereby we seem to pass through the photograph as through a window into another world, we reflect instead upon the photograph as a measure of the creativity of its author. Frequently, pictures which were taken in war zones for journalistic purposes are transported from the news desk across town to the museum or gallery, and canonized, along with the photographers, as artistic. This movement of photographs neutralizes the fear of officials, since the usual practice of exhibition in galleries isolates them from their historical context whilst lending them the values of the new place. In galleries, this often means the high status given to formal concerns, which may be understood to show eternal, transhistorical values.

The Times,
26 May, 1982.
Courtesy of Times
Newspapers Limited.

This status is not confined to galleries, but is confirmed and broadcast in books. The approach is neatly encapsulated in a passage from the book *Journalists at War* by the sociologists David Morrison and Howard Tumber, on 'the dynamics of news reporting during the Falklands conflict'. Their account makes use of conventional beliefs about the appeal of pictures, and the value placed upon their makers. We are told these pictures are more than 'fact': the special capacities of the creative individual mean such photographs are superior in form, and this supposedly introduces viewers to universal experiences. The authors discuss a picture taken by Press Association photographer Martin Cleaver:

British destroyer crippled in new air attack

The last moments of HMS Antelope

> The awesome picture of the *Antelope* exploding, the most famous shot
> of the Falklands war, might be a photograph of any ship of that fleet,
> or any ship of any fleet. By and large [the photographer] if left alone
> free from overt direction, will not make just the 'routine' record of,
> say, Britain's military progress but attempt thematic shots about the
> human condition, or the human condition of war.... The non-artistic
> sentiment of patriotism...may be there, but more than likely subsumed

under a higher artistic feeling.... To gain his images the photo-journalist tends to share the artist's pursuit of perfection as an ideal to be chased at almost any price.[11]

This traffic of photographs into the havens of aesthetics and creativity signals their removal to a safe place. Quite contrary to the expectations of officials, the use of photographs in the newspapers is no less safe – but there they have lower status (except within the profession) and a radically different function.

The press of all political persuasions accepts the photograph as documentary 'proof'. The only choice for the editors is amongst those pictures which can be suitably nuanced through captions either to match the acknowledged bias of the newspaper, or to leave undisturbed its covert programme.[12]

An example comes from a fifth scene in a different theatre of war. In photographs and text in a foreign journal, *An Phoblacht/Republican News*, it consisted of a story which told 'the truth in pictures', 'proving' that 'Bloody Sunday' in Derry on 30 January 1972, in which the British Army shot dead thirteen civilians, was a 'massacre'.[13] The *News'* report was not published until 6 February, and typically used photographs as 'windows' to counter the British suggestion that there must have been an IRA sniper (for more on this see page 125).

The *News* carried several photographs of British troops which 'from their casual attitude and open position' showed that 'it is obvious they are not under fire'. It was equally obvious that they were not dressed in 'the usual riot gear', but were 'ready for combat', and the *News* asked why. The intimation is clear that as the troops were not prepared to deal with stone-throwers, but were equipped to fight, they were to blame for the murders. The captions to the photographs of dead or bewildered civilians, taken as the shooting continued, poured scorn on the British idea of the sniper: here lay the body of Mr Kelly, 'who fell where he was shot, an unusual place for a sniper'; and here stood Mr McKinney, 'seconds before he too was murdered. Mr McKinney was a printer in the *Derry Journal*. The British say he was a gunman.' Although neither photographs nor captions can prove the absence of a sniper, the *News* sought to ridicule the official British version of events. It used photographs as the empirical test: facts were offered up to sight and the crucial details written in the captions. The bias of the commentary is inescapable, but while we are looking through the objectivity of photography, the whole piece seems to shift away from rhetoric and become grounded in the bedrock of truth.

However, the objectivity of photographs is notional: the photographs are intricately sewn into the web of rhetoric. They are never outside it, and always lend it the authority of witness. This becomes clearer if *An Phoblacht/Republican News'* coverage is compared with the choice of words and pictures in the *Daily Mirror*.[14] The front page headline was 'Ulster's Bloody Sunday', which immediately placed

*An Phoblacht/
Republican News*,
6 February, 1972.

Page 2 **REPUBLICAN NEWS** Week commencing 6th February, 1972

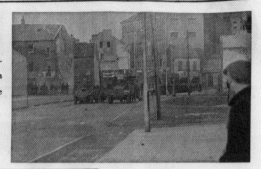

British Troops move into Rossville St. From their casual attitude and open position it is obvious that they are not under fire.

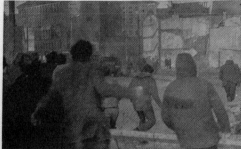

CONFRONTATION AT
ROSSVILLE STREET
NOTE THE ABSENCE OF THE
USUAL RIOT GEAR.

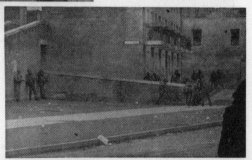

British Troops take up position in
Kells Walk
Still no Sniper Fire

But British Troops are ready for armed combat. They are not equipped to deal with a stone throwing mob.

W H Y ?

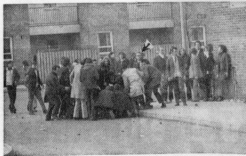

Fr. Bradley gives the last rites to Mr. Kelly, who fell where he was shot, an unusual spot for a sniper. Note the man wearing glasses on the right of the group around the dying man. This is Mr. Wm. McKinney, seconds before he too was murdered.

Mr. McKinney was a printer with the "Derry Journal".

The British say he was a gunman.

the event in *geography*, and in *Unionist* history. It was as if the *fault* lay in the threat to the union and the harm worked upon the loyalists.

In the evaluation of news the purposes of the media and the state are different, but not fundamentally so. In many respects, particularly those touching upon national security in relation to terrorism, there is a close match between the perspectives of the media and the state. This correspondence may be called the official perspective, an orthodoxy that has a resilient philosophic and historic respectability. The *Mirror*'s headline, which displayed how close the newspaper was to this perspective, enabled certain unpalatable facts and accusations to be contained. The paper reported that thirteen people had died, and that the army had

Daily Mirror,
31 January, 1972.

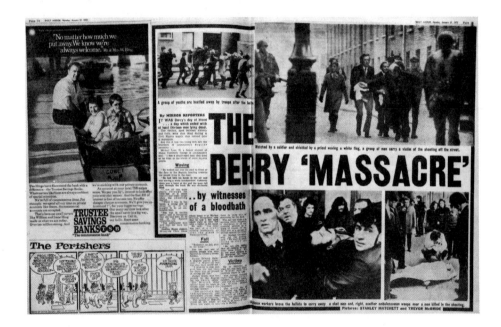

been 'accused of "massacre"', which was denied in the subheading, 'soldiers didn't fire first shot'.

Within this rhetoric, there could be no place for any of the photographs used by *An Phoblacht/Republican News*. Instead, we see in the *Mirror*'s coverage photographs that *complement* the rhetoric of the headline. The captions promote the idea of a battle and of cross-fire. Men carry a victim off the street 'watched by a soldier', and ambulance workers 'brave the bullets to carry away a shot man'. On the front page is a picture of a man receiving the last rites; and on the inside pages we see youths hustled away after the 'battle'. The photographs ignore the state of readiness of the army and concentrate upon the horror in pictures of victims, or

upon redemption in the humanitarian work of priests, rescuers and public servants. The rhetoric of the *Mirror* has moved the story away from the problem of responsibility into the arena of interest.

In addition, the form of reportage runs according to formula and ends in affirmation, and in both the *News* and the *Mirror* we see the use of eyesight to test the credibility of words. In the *News*, the photographs reportedly show the innocent, unorganized victims of British soldiers. In the *Mirror*, the intention is quite different. There the aim is to use realism to show how an attack was successfully resolved by the professionalism of the authorities. In this respect, the *Mirror*'s account follows the form of an everyday news story.

Typically, in the ordered world a sudden event kills many people. In response, the news moves in two related directions. The first dwells upon the disordered scene: to view it, to number the dead, to name some of them according to their newsworthiness; to speak to eye-witnesses. The second movement is set in motion immediately after the first confusing reports, and eventually supersedes them. Its function is restorative: to report the visits of Royalty and politicians to visit the scene, and the wounded in hospital, to review and congratulate the rescue services; to seek explanation and apportion blame; to seek revenge or redress; to restore faith in the established order. As the story moves in this second direction, we see that the system or formula is entropic: the news story exhausts itself. In restoring order and faith, the narrative cycle is completed, and newsworthiness consumed. These two related movements are characteristics of storytelling. As we see in the *Mirror*'s story, the closeness of the press to the official version of events is explicable within the everyday practice of the newspaper industry. We do not need to seek a detailed conspiracy between the government, the army and the newspapers in this matter, but press practice is useful to officials concerned with public opinion. Simple stories with happy solutions, transferred to news-value , show how the true strength of arms is not brute force but spiritual force. The destabilizing purpose of enemy action is defeated in the end by the unbreakable will of the people.

The ability of photographic realism to support the written stories derives from the kind of proof it is supposed to offer – the proof of 'being there'. This is invested with the sanctity of truth-value; at the same time it is feared, because the media can abuse the authority of 'being there' and distort real situations to suit its own purposes. The idealized version of the photo-journalist is someone who stands outside the event – a neutral eye. Even though this is impossible, photographers are not supposed to interfere in history. When they do, and are exposed for staging or provoking incidents, they cast doubt on the authenticity of photographic realism. An example of this occurred on the twentieth anniversary of British troops being deployed in Ulster, when press from all over the world were present in anticipation of news. On 15 August the mainland British press carried photographs of

stone-throwing children. In *The Times*, the front-page picture showed a close-up of 'A young rioter, armed with petrol bomb and stones, [moving] in to attack security forces' in West Belfast.[15] On the same day, the *Independent* published a longer shot which showed many press photographers 'lined up to take pictures of stone-throwing children'.[16] The Unionist Lord Mayor was concerned that children were playing to the cameras, and that the media was prolonging disturbances and providing distorted coverage of life in the city, so he called for them to leave. The *Independent* and *The Sunday Times* then examined how on this occasion photographers had provoked the scenes that the media expected or hoped would happen.[17] As the report in *The Sunday Times* said, the photographer who pictured the boy with the bottle and the one who pictured the press in action 'had come out to cover a story that did not exist in real news terms, and had come back with an offbeat picture that would sell well to newsdesks geared up for Ulster stories'. By turning media practice into the substance of the story, the press removed the event from real news and presented it as an aberration that came from the unusual pressures placed upon photographers by picture editors. The exposure of manipulation, and the fact that in this case everyone had engaged in it, was an attempt to limit any damage the incident might cause to the professional integrity of photo-journalists, and reinstate the authority of realism in the majority of cases when it is attached to 'real news'.

The fear of manipulation is ever present amongst officials, but its exposure is comparatively rare. Of course, the exposure of an abuse of photographic realism has several effects: it reveals the particular scene as a confection (which can have important consequences for those who used it as proof or condemned it as lies); it alerts readers to the possibility of other, unexposed cases of media manipulation; and when accompanied by professional indignation, it reinforces the truth-value of the overwhelming numbers of images which are used as straightforward representations of reality.

It is much more usual for the authority of 'being there' to be accepted, and for realism to be taken at face-value. We can see this quality if we examine a story which appeared in the *Daily Mail* in June 1982. It published a special issue as a 'picture souvenir' of the Battle of the Falklands. The front page carried a photograph of 'The Moment of Triumph', with Major General Moore holding the surrender document. Immediately inside, it carried two pages of photographs showing the 'steps down the road to war'.[18] The photographs had the authority of eye-witness, and guaranteed the truth of events. On show was the 'look' of the immediate past, the 'look' of history transformed through photographic realism into 'steps'. The causative link between what stands before the camera and what appears as the photograph was taken much further: the series of photographs suggested a causative link between the events themselves, from invasion to

surrender. One event was seen as the necessary cause of what followed. On the front page we saw that the final step had been completed, and the truth of this was given in the overlapping realisms of the documentary photograph and the documentary proof of victory embodied in the enemy's signed acceptance of defeat. On the inside pages we saw the earlier 'steps down the road to war', confirming the existence of a linear progression from past to present. As the American photographer and author, Allan Sekula, says,

> At their worst, pictorial histories offer an extraordinarily reductive view of historical causality: the First World War 'begins' with a glimpse of an assassination in Sarajevo; the entry of the United States into the Second World War 'begins' with a view of wrecked battleships.[19]

For the readers of the *Mail*, the battle for the Falklands 'begins' with the sight of Argentinian soldiers in control of Port Stanley: 'we' have been invaded and therefore must retaliate.

However, this reliance on photographic realism has important consequences. In the words of Sekula, it means that an 'awareness of history as an *interpretation* of the past succumbs to a faith in history as *representation*. The viewer is confronted, not by *historical-writing*, but by the appearance of *history itself*.'[20] Sekula then describes how photographs are invested with the power of the objective documentary: he says, 'the very term "document" entails a notion of legal or official truth, as well as notions of proximity to and verification of an original event'. If we apply these ideas to the use of photographs in the *Daily Mail* 'souvenir', we see they claim to be more accurate than memory: the 'steps' in the 'souvenir' are positive in the manner of so-called objective science. It seems that we could pass through these pictures in the *Mail* as if they were 'windows' into that other world, replacing the biased voice of historical narration with what Sekula calls the objective 'silent authority' of the photographic record. The photographs on display are linked 'unobtrusively' into 'a seamless account' of 'incontestable documents' without acknowledging their official scope and use in making the official history real. The photographs that appear in the public domain tend to be reprinted, and the repetition confirms their truth-value.

The claim of photographic realism to the objectivity of eye-witness hides its material use to institutions. In addition, photographic realism has another, similar attribute: it hides the procedures of the groups who use it by offering in the first place an immediate *experience*. Photographic realism establishes its truth not by logic but by offering an experience that veers between 'nostalgia, horror, and an overriding sense of the exoticism of the past'. This is almost as good, or even better,

than 'being there'. Before the 'authoritative institution' of photography, 'all other forms of telling and remembering begin to fade'.[21]

Each category for understanding photographs, as art, as documents, or as experience, makes it difficult to perceive them in other ways. Breaking free from these categories becomes easier if we ask 'What is photography's *position* in the power relations of its time?' In answering this, we loosen the hold of two standard but restricting ways of thinking about the medium. We can move away from thinking about photographs as art, which is severely limited by the Romantic notion of the individual artist as source of value and meaning in the world; and we can dispense with the common sense view of photographs as windows-on-the-world. Instead, we see photographs in *places* and put to particular *uses*.

In war, the press draws upon photographs released by the military authorities and combines them with its own preferred practice. The effect is to deny death in warfare as the product of history and, by association, place them both in nature. The 'naturalness' of the appearance of *history-itself*, which we are encouraged to see in the transparency of photographs, is associated with a similar 'naturalness' in this matter of death. To return to the *Daily Mail* 'picture souvenir' of the Falklands, deep within the paper was a spread called 'The war at sea', in which, the readers were told, 'technology changed everything except the way of dying'. Technology merely advanced the typical combat death: to burn, drown or be blasted apart was made more sudden, without a sporting chance of escape. In the newspaper, the deaths and photographs together prove and justify events in war as unpleasant but 'natural': photographs and deaths are such incontrovertible facts of *nature* that their authority erases the possible choices that exist in *history*. The emphasis in the text, supported obliquely by the photographs, is upon the morbid details of death, and not upon the calculations of politicians. According to the newspaper, the technology made whatever happened to these soldiers, sailors and airmen inescapable. More than that, the 'nature' of death and the 'nature' of modern weaponry are collapsed into each other. These elements of 'nature' are bolstered by the obvious realism of photography. Faced with these representations of the 'steps' of war, based upon the commonly accepted truth-value of the documentary photograph,[22] readers are encouraged to think of the war in these terms, but not in any others.

Photography, however, is used more widely than in the press. In the World Wars, governments took a special interest in photography as a way of promoting the values of the nation and confirming the justice of the fight. Photography is also used by amateurs and professionals for all manner of recreational and record work. Photographic realism is so diffused throughout the systems which embody 'truth' that its cohesive role remains unseen even as we look at it. When it does become an object of study, it is the concept of the real that becomes mysterious. The touchstones disappear, and increasingly the certainties which sustained these wars

appear rhetorical and fictive. This does not destroy their power. On the contrary, the certainties take on the power of myth, not in the sense of producing straightforward lies, but in the sense of producing a seamless account of the real. In fighting wars for political reasons, states try to place the reality of older values in the forefront, so that people know what they are fighting for. The danger is that wars also produce new types of reality. To justify the present struggle as the only way to preserve the older values, and to ensure that people will be satisfied with their restoration, states at war take a critical interest in the concept of the real. In its service, many millions have died, or been forced to die.

Daily Mail,
16 June, 1982

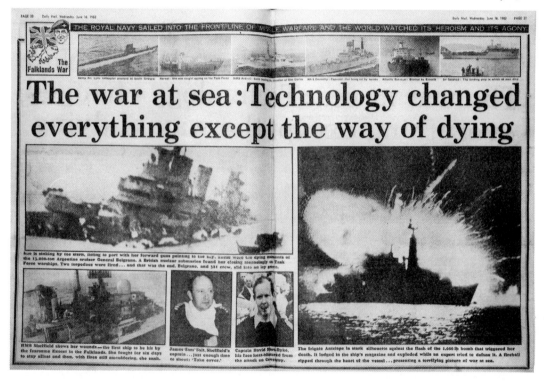

2

THE FIRST WORLD WAR

DEATH AND WORK

The volunteers of 1914 felt that here was a chance for men to be free of the predictable life, and to begin the adventure that would liberate them. They soon found this liberty directed them to the core of industrialized warfare. This was disillusioning for some, especially the sons of the professional classes; for others, it was what they already knew. The Welsh miners, under Robert Graves' command, dug holes and ditches, as they had in peacetime: the only differences were the greater frequency of cave-ins and explosions, and the foremen wore uniforms.[1] Whatever the first excitement when they felt themselves to be free of office or works, the men learned they were fighting within industry and bureaucracy in order to save them both.

As in everyday industrial practice, the war had to be 'managed' and it had to be 'manufactured'. The novelty lay in the change to the concept of alienated labour, in which it is people who are used up in the production of materials. At the war front, this process was altered to encompass the destruction of both men and matter. The various machines of the first scientific and industrial revolution were joined together to multiply the destruction. Massed in sufficient numbers, the improved armour and artillery then forced the armies on the Western Front apart and into positions of defence. The railway was still the main route of supply, but it could not be used to circumvent the trenches. No motorized vehicles, neither trucks nor tanks nor aircraft were adaptable or reliable enough to by-pass or pass over the lines to any really significant effect. Instead, the armies could only line up, lie in wait and watch the shells and many of the men pass and vanish.

This disappearance of men placed them at the centre of the industrial process. Chemicals, steel and flesh exploded and burned together, and parts of bodies were turned into the redoubts. More fascinating because it was a complete

cycle, was to return the dead men to industry as raw material. In 1917 the Germans were supposed to have built a 'corpse-conversion factory' to boil the fat and bones of their dead into lubricants and glycerine.

From 1914 it had been the reported practice of the Germans to tie up the dead with iron wire 'like bundles of asparagus' and transport them two or three thousand at a time in 'trains of the dead' to Germany to be burned in blast furnaces, because 'a dead man has no further interest for them'.[2] Three years later, when the industrial nature of the war had been fully realized, a use for the German dead had been found by British Army Intelligence. An officer, Brigadier-General Charteris, invented this story of the 'corpse-conversion factory'. He took a description of dead

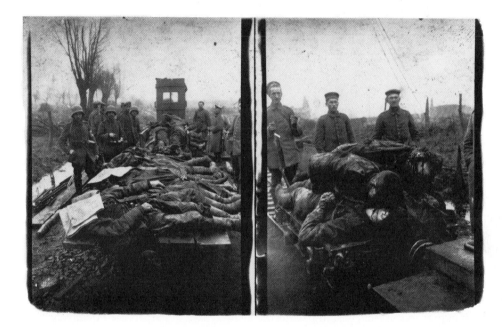

Crown copyright:
Public Record Office,
FO 395/147.

horses which were used to make soap and placed it beneath a photograph of a train-load of dead soldiers.[3] The aim had been to use the faked picture to enlist the support of the Chinese who revered their dead. The canard was duly sent to Shanghai, with the hope it would find its way back to Europe and stiffen resolve to 'fight to the finish'.[4] Charteris also planted the story within Whitehall from where it became the subject of questions in Parliament and accounts in the press proving the barbarism of the Hun.[5]

To keep the story alive in Whitehall, the officer forwarded two captured photographs to the head of the newly formed Department of Information: they showed dead Germans on an open wagon.[6] Though the photographs could not

prove the existence of the 'corpse factory', they could be used 'for propaganda purposes'. The government line was that 'in view of the many atrocious actions of which the Germans have been guilty, in defiance of all the dictates of civilization and humanity', there did not 'appear to be any reason why [the story] should not be true'.[7]

The story spread because the press was avid for scandal, and because various officials were ready to believe their own propaganda.[8] Rumour had only to be placed in government and then in the press for it to grow to irrefutable accusation. It was a smear that lasted until the Second World War. When the stories first came through of Hitler's gas chambers, Fleet Street would not touch them: they wanted to hear no more of such unlikely acts.[9]

This imaginative use of the dead was shocking because it perverted the process of industrial warfare beyond even its new awesome limits. Death in war, even when it was mass-produced, remained the noblest sacrifice: only barbarians could continue with the logic of industry and make oil out of heroes.

PHOTOGRAPHY AS A WEAPON AT THE FRONT

By August 1916, when the war in Europe was two years old, some 4.6 million people had died. This number is double the total of 2.3 million killed in the Crimean War (1854–65), the American Civil War (1861–5), the Prussian Wars (1864, 1866 and 1870–1), the Boer War (1899–1902), the Russo–Japanese War (1904–5) and the Balkan War (1912–13). In 1919 the 'grand total' of dead in the Great War was estimated to be between ten and thirteen million.[10] The scale of losses was a direct consequence of the capacity of factories to mass-produce weapons, and the systems of transport and communications.

That people were made to 'soak up' or consume the enemy's firepower was due in part to the trenches, in part to the artillery and in part to the effectiveness of surveillance. The war machine of guns was augmented by the seeing machine of optical munitions, including cameras for aerial reconnaissance, which were engaged in the observation of fixed positions. The advantage went to whoever saw the enemy first, and in the greatest detail. In the trade journal *The Optician*, it was said that the 'science of sight' had become 'one of the most notable features of the war'. Factories that had made microscopes and telescopes were now 'devoting their entire attention to making optical instruments necessary for the direction of explosives upon objects to be destroyed'.[11] The photographic trade claimed that for the army to have been deprived of photography for even a week would have been 'perilous', and in a sporting image typical of the war, said 'their position would have resembled that of a blind boxer striking vainly in the dark, exposed all the time to

the blows of his unseen opponent'.[12] Since shelling destroyed the landmarks, photography was used to give the general staff a current picture of reality. Even the dead ground was of interest. A camera set above the parapet of the trench was used to photograph no-man's-land, 'to actually look right into the craters and shell holes, thereby acquiring definite knowledge of the state of the ground'.[13] In addition, the photographs were a record that could be studied and discussed by experts who did not themselves have to be present (there was a noticeable absence of 'brass' from the front line).

From small beginnings photographic intelligence grew at a phenomenal rate. Figures for October 1918 alone show the number of negatives to have risen to more

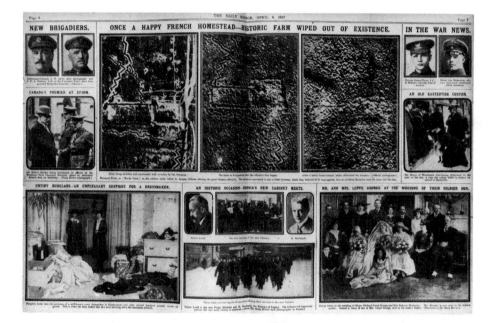

than 23,000 from which 650,000 prints were issued. By September 1919 the photographic staff of the RAF had risen from five (in 1914) to 3,250 distributed throughout the theatres of war and responsible for the issue of almost 5.3 million prints.[14] Other reports put the figure a little higher: 'on the Western Front alone during the last ten months of the war no fewer than 264,605 RAF negatives were taken in the air over German territory, and a gigantic total of 5,800,000 prints was made from these negatives for use of Intelligence Staff'.[15] The number was so large because a complete photographic record was produced at frequent intervals (daily in some sections) of all the enemy trenches extending from the North Sea to Switzerland.

Yet all this information failed to unlock the stalemate at the front. Despite this, the photographic trade continued to make large claims for photo-reconnaissance. Writing after the war in a trade journal that was translated for world-wide distribution, the author of an article entitled 'British photography in the Great War: its romance and its reality', said that 'the success of the advance depended largely on the preliminary work accomplished by the aero-photographer'.[16] But then, there was vested interest in these claims, because 'before an important advance as many as eleven thousand negatives a week would be made'.[17]

With this information, accurate maps were prepared with emblems for the new terrain of dumps, gaps, wires, mortars and machine-guns. Other annotations could mark the presence of men – information gathered from friend and foe alike about local names and the number of men supposed to be living in a dug-out. Attention could be drawn to special features, such as the fact that some shell-holes had been linked by a sap, and were probably used to store wire.[18] Fighting the war was preceded by reading it in the aerial photographs. It was like reading a superior type of detective story with 'a real flavour of the exploits of Sherlock Holmes'.[19] The 'trained eye' of the detective/scientist could look at spots, scratches, blurs and blobs and see 'a wealth of meaning'. That scratch could be a path to an unlocated gun, that blur the gun itself: the blobs could be a camp or an ammunition dump. It was possible to read the whole life-story of an enemy position through a series of photographs taken at the same place: its beginnings, the camouflage, the gun in action and finally a white spot ragged at the edges, where the British bomb had found its target – 'the camera "observer" never makes a mistake'.

The commanders had the advantage of the pressmen. The military gained their knowledge of the targets and progress of the battle from reading photographs, whereas journalists on the Somme (for instance) were guided to a vantage point overlooking a section of the twenty-mile front, almost like generals of old. From there, it was very difficult for the reporters to see what was happening. Since they had no intelligence of the way the first day of the battle had gone, they had to rely upon what they themselves had seen, and what they were allowed to say in a war that did not permit journalistic scoops. They had to write their stories to accord with the official communiqué, which revealed nothing. On that infamous first day, the worst in British military history, the men were said to have 'swept forward cheering and encountered no great resistance'. The casualties then came in quickly, 'many of them lightly wounded in the hands and feet'.[20] Exactly these sentiments and procedures were paralleled in the pictorial press – as we shall see: cheerful men going up and then wounded and prisoners coming back. The rest became invisible.

Those most intimately involved in battles sometimes misread the evidence, passing back favourable reports, whilst suppressing the others. General Haig, who

presumably knew everything there was to know about the progress of this battle, thought the day's casualties had been 40,000, only two-thirds of the true number. 'Everything seemed to be going well', he wrote.[21] Even modern intelligence could not track the rate at which modern warfare killed men, nor overcome habits of thought that justified the 'sacrifice'.

PHOTOGRAPHY AND MORALE

For a long time civilians in Britain felt that everything was going well, and even when they knew it to be going badly, the public posture was still one of optimism or at least of resignation. By 1915 British soldiers were said to accept the prospect of death with a composure on the grandest scale the country had ever seen. At home the *Spectator* reported that people were equally composed in accepting the deaths of their loved ones: 'weighted by their sense of helplessness, they are only anxious when death has claimed a member of their families to go on with their work quietly, and to lose more if so the country's cause may be served'. The British people welcomed death if it meant civilization would be saved; but in return they expected that the government would offer 'candour, frankness and the entire truth'.[22]

Candour was not the only path to truth. Censorship and press practice also produced the truth of war. Photographs did not open people's eyes to a knowledge of the war that was at odds with the written account: on the contrary, eye-witness photographs lent authenticity to the texts. Together they created a reality that was firmly established as truth.

Daily Mirror,
12 April, 1917.

On the home front the daily newspapers emphasized that the armies were steadfast and facing an enemy that lacked substance. In 1917 the *Daily Mirror* reported 'Big Counter-Attacks Made by the Germans', but downgraded the impact of this information with photographs that showed the strength of the British presence. 'We Raided the Enemy's Trenches' said the headline, and we see soldiers led on and then returning. The Germans themselves are absent, or enter the scene only to be demeaned, this time in the person of the Crown Prince, mockingly described as 'Little Willie Sent Home in Disgrace'.[23]

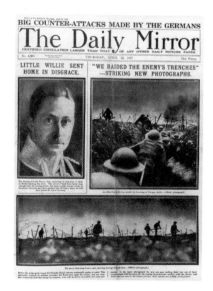

The page is the result of several accommodations: censorship imposed by the military and the government, self-censorship practised by the press and the press' usual expectation of human interest in its stories. The question is not the simple truth or untruth of these pictures, but what

version of the war, what kind of history is born of these accommodations? The story of trench warfare, even in 1917, was one of men 'making their way out' and then returning, 'their mission successfully accomplished'.

Both government and press were separately engaged in determining how the war looked. How it would be received also depended upon 'common sense' beliefs about family life, or the superiority of the race. Common sense consists of the existing core of ideas and practices which make up the everyday reality of society; it cannot be completely controlled by either the government or the press, both of which are of course themselves subject to it. In the war, they continued to represent what they took to be the core elements of the British way of life. Both family and work were cornerstones of experience, and government and press put the virtues of both to a higher purpose. The emphasis moved away from straightforward duty at home or at work to sacrifice for the sake of the nation.

Photography played its part in this. It was well situated to represent the unity of the nation as a middle-class family. Since the coming of the mass market in the 1880s, the success of the photographic industry had been built upon the expectations of those with spare income and leisure time. Sales of equipment and film were based upon idealizations of family life, and the family album was full of pictures which represented the ideal unity of the family. Its communal memory depended upon trade, but both were now under threat. They were saved because both were useful in wartime – after all, the chief elements in the idealized home life were harmony and the acceptance of hierarchy. Hence, marketing the family in wartime photography made it coterminous with the nation: then the family/nation was seen as natural and obvious, and though endangered, it would flourish.

THE FAMILY IN THE PHOTOGRAPHIC TRADE

In September 1914 the British photographic trade hoped to 'capture' the German market for photographic goods in neutral countries: this would be 'at least as valuable as the acquisition of a colony'.[24] But by April 1915, it was clear that an export drive would not succeed. The initial policy of 'business as usual' had collapsed: the factories were understaffed or engaged in war work, and there was an attempt to block goods from reaching Germany. If the photographic trade was to grow it would have to do so at home.

The most profitable company was the American firm Eastman Kodak, which supplied a very large part of the British market. Indeed, it had been George Eastman who in 1888 had begun the mass market in photography with the development of cheap box cameras and foolproof cartridge film. Camera and film were part of a complete marketing strategy that was designed to draw families into

the hobby, partly by an advertising campaign aimed at parents, who bought 'vast quantities' of materials to photograph their children. The other mainstay of the market was holidays: a second advertising campaign had shown a cyclist in a landscape taking snaps as he went along.

The obsession with gadgets or prints for their own sake was not enough to sustain the industry: it relied upon the through-put of film in volume. To encourage people to spend money on film, photography as a hobby needed 'to feed from a host interest, ...a yacht, a summer cottage, or a spot of mountaineering', or 'a Cook's tour of Europe-in-a-hurry'.[25] Producing photographic materials, and servicing the market for studio portraits and amateur snapshooting were big business.

From 1914 the areas in which the trade flourished, namely London and the south-east of England, particularly the holiday resorts along the south coast, were also those regions in which photography was most heavily restricted, for military reasons. So the threat to the retail trade did not come from the loss of men to the Forces (since almost half the employees were women) but from the restrictions on open-air photography imposed by the Defence of the Realm Act (DORA). It was forbidden to use a camera anywhere near naval or military work, and since transport and industry was now of military significance and the police were empowered 'to deal summarily with any use of the camera which can be in any way construed as recording information of value to the enemy',[26] open-air photography was difficult in many areas of Britain. In specified regions it was illegal to photograph a house or traffic from the roadway, a football match or a tombstone in a churchyard.[27] Attempts were made in the photographic press to give amateurs some guidance on the conditions that were imposed in their localities,[28] but as spy-mania was rife, anyone carrying a camera without a permit ran the risk of assault or arrest, and there were many such incidents.[29] The safest place for photographers, as DORA prescribed, was the professional studio or the private house and its garden. The pessimists in the trade expected the worst.

Wartime restrictions put an end to recreation outside, and the limits on materials put brakes on amateur practice in the camera clubs. In 1916, the anonymous author of an article in the *Amateur Photographer* said that public attention was 'distracted' and the public purse 'straitened'. He would have expected photography to be swept away along with many other things in 'our common abundant life'.[30] But, on the contrary, photography was growing. He said there was so much photographic journalism as to 'overwhelm any future compiler of an illustrated history of the war'. He added that the prohibitions had no effect on family photography and that the war had even renewed interest in family portraits, which had long been the mainstay of the trade.

Those people who thought that photography should be put to scientific 'record' work hoped that the 'subservient race' of illustrators and photographers

would abandon the sentimental in favour of 'the stern realities' of the times. However, this hope was based on a misunderstanding of both the practical difficulties of 'record' work under the DORA regulations and the way the structure of the nuclear family had become the same as the nation as a whole: 'the war has made us more inveterate sentimentalists than ever', said the *Amateur Photographer*, 'and if we can soften down any of its awful realities, or register the transition of a people from the frivolous to the heroic, it is surely not a ministry to be spurned'.

To help photographers register this, in July 1915 large coloured posters appeared on the hoardings: soldiers happily parting from their wives and children at the cottage door.[31] They announced a new organization called the Snapshots from Home League, set up, apparently, by the YMCA, and given extensive publicity in the *Amateur Photographer* and in the trade journals. By Christmas the League boasted 7,000 representatives and 200 local secretaries responsible for regional branches, and had already dealt with 50,000 requests by soldiers and sailors for free photographs of their families.[32] By February 1916 the number of amateurs enrolled in the scheme had risen to 10,000, with secretaries in 250 towns: over 200,000 men had been provided with pictures.[33] To lend credibility and respectability to the scheme, the *Amateur Photographer* printed examples of snapshots taken by the well-known art photographers Will and Carine Cadby and Alvin Langdon

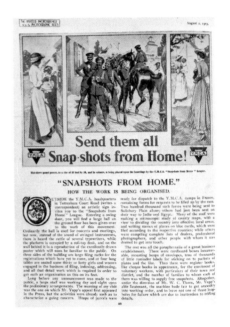

Coburn.[34] The costs of the free photographs were borne by the 'patriotic and philanthropic' members of the leisured classes, 'from the lady of the hall or rectory...or from the members of weekend holiday-making parties, who, in a motor trip from London to the coast, have taken the opportunity to visit some of the addresses obtained from the League before starting'.[35] When it came to choosing subjects, it needed 'no great strain upon the imagination' to know 'their' preferences – 'a photograph of the "missis", of Tommy junior in his first knickers, in some cases of a new tenant of the cradle, born after the father had gone to the wars, in others a bit of the old garden, the mother at the cottage door, perhaps a corner of the old workshop or mill'.[36] And since 'the possibility of a lady or gentleman calling

to take a photograph would at least ensure the wife and children being clean and tidy, another great influence is to be found in the work of the Snapshot from Home League'. [37]

So it was that the civilizing effect of photography was taken to the disadvantaged and used to include them in society. Properly enough, the diploma awarded to those who volunteered to work for the League was illustrated with a picture of a Britannia-like figure, complete with camera; she greeted Tommy Atkins as he emerged from the trench and she pointed towards the family he had left behind, now standing outside the idealized English home – the 'Ann Hathaway' thatched cottage.[38] At this level of abstraction the emblems fitted together with no

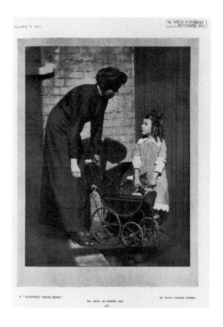

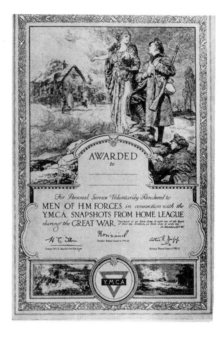

Far left:
Three-panel colour hoarding, twelve feet by ten, reproduced in *Amateur Photographer* magazine, 2 August, 1915.

Centre:
'A "Snapshot from Home"', by Alvin Langdon Coburn, *Amateur Photographer* magazine, 8 November, 1915.

Left:
The 'Snapshots from Home Diploma', detail from *Amateur Photographer* magazine, 10 July, 1916.

difficulty into one picture of civilization: the patriotic, the Britannic, the sacrificial and the familial all as one.

In fact, the League was conceived as a marketing programme for the photographic trade: the YMCA was a respectable front for a committee 'almost entirely composed of proprietors and representatives of the large photographic houses'.[39] Most of the money spent on the publicity to promote and organize the League was donated by manufacturers.[40] The YMCA was mainly concerned that the League should be solvent, and this it managed until winding up in February 1918, when a small surplus was donated to the War Emergency Fund. The real profits for the companies were made in the increased sale of materials. Some

companies strengthened their position in the market through amalgamation, issuing shares for public subscription, and most continued to pay high dividends, thus attracting more investment.[41] The history of the League shows that, in spite of DORA, it was possible to make money in the retail trade in photography, though it was as well to conceal the 'sordid motive' of profit with an appeal to patriotism.[42]

THE FAMILY IN THE PRESS

The essence of family photography is selective amnesia. In the album, memories are happy, centred on children and some ceremonies such as weddings and birthdays; less happy memories and the sadder ceremonies tend to be ignored. The ethos of the 'common abundant life', which belonged to the middle class, was widely illustrated in the popular press as a measure of normality – although its most genteel expression was found in the *Amateur Photographer*. There the soldier, or 'Hero of the Hour' was served tea by doting women,[43] or a boy admired his father who had been a 'hero'.[44] The wider context was an enthusiasm for volunteering for the Forces, and there were pictures of the camaraderie of those who were accepted[45] and the misery of those who were rejected.[46] The initial rush to picture the war before it had begun for the British Forces made reference to the country's glorious military past in the victories of Nelson, or to the symbolic subject of a woman mourning upon 'The Steps of Time'.[47] In the *Amateur Photographer* this rhetoric soon subsided into a coverage of the expectations of a cosy family life. There was scarcely a mention of the harsher realities of experience which (within the censorship) were the ordinary stuff of the newspapers.

Technical innovations in press cameras and the half-tone process meant that by 1913 an image took less than an hour to prepare and cost £4, compared with the £60 for a woodcut.[48] Modern printing presses and less absorbent paper combined to produce local and national papers and magazines that were full of photographs.

Like the editorial and advertising content, the photographs suggested the variety of experience, drawing together in the front, centre and back pages of the popular dailies so many 'windows on the world' in a symmetrical and orderly lay-out. The kaleidoscope of newsworthy events was a 'slice of life', but its diversity was much more apparent than real. Newsworthiness was based upon celebrity entertainers or politicians who provided steady copy, or upon murder or divorce cases which, because different actors were involved on each occasion, could ring the changes on the basic 'tragedy' or standard scandal.

The war affected this mix in two ways. Firstly, the lack of journalists at the front and the complexities of the censorship in practice defeated the attempts of the press to report events of military significance.[49] Once these problems were

'The Hero of the
Hour', by Will Cadby,
Amateur Photographer
magazine,
19 June, 1916.

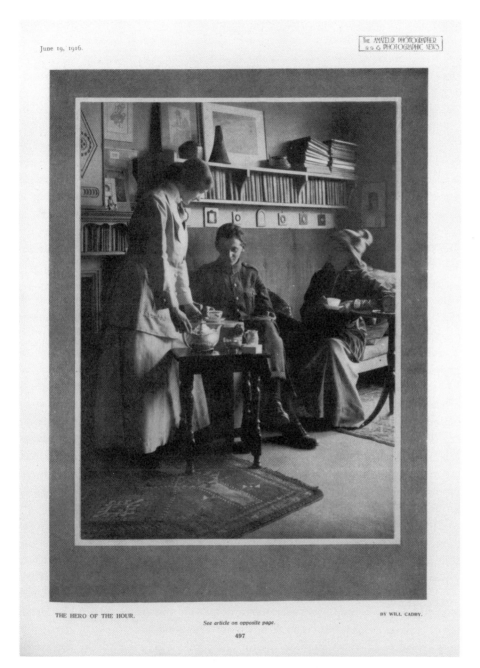

June 19, 1916.

THE AMATEUR PHOTOGRAPHER
& PHOTOGRAPHIC NEWS

THE HERO OF THE HOUR.

BY WILL CADBY.

See article on opposite page.

497

partially overcome the press still reported the events in the most favourable light. Secondly, new topics for the press were shifted to the centre of the stage – topics which had previously been unknown (such as the capacity of women to work in industry) or mundane (such as death in the average family). They did not replace the usual entertainments, but they did have a profound effect upon the way people were able to see the war.

In the press the shift from the frivolous to the heroic was achieved by changing ordinary family mementoes into the relics of sacrifice. The battlefields were littered with the debris of the dead, and often family snapshots and lockets were retrieved. In a mix of pride, pathos and ghoulishness, these were displayed in the press, as in the *Daily Sketch* front page, 'These Were Picked up where Our Soldiers Fell'. The papers appealed for the owners of the photographs to reclaim them, and even turned the screw by printing touching messages such as 'Darling Flo - think of me sometimes although I am gone'.[50] The relatives of a dead soldier were thus able to see themselves in the papers, perhaps before they knew for certain that their husband or son had been killed.

A family snap belonging to a soldier who had died, and which was published in a newspaper, lent him a posthumous notoriety that was denied to his fellows. It distinguished him even in his absence (since he was not usually pictured amongst the women and children) from his comrades who had also 'fallen' but who had left no trace. This was an inversion of the customary treatment of dead officers, whose portraits appeared in the press, and in the weekly magazines such as the *Illustrated London News*: there it was the lost men who were honoured, whilst the likenesses of their families were not disclosed. This difference in memorial, stemming from differences in the origins of photographs and differences in the class of audience for cheap daily papers and expensive weekly magazines, intimates the gap between officers and Other Ranks. Yet, in either case, it was the family album that had been drawn into the newsnet. The album had been accorded this privilege because the 'supreme sacrifice' was fashioning a new precept of normality: the family used to patriotic purpose.

The family was traditional, restricting women to childbearing and child–rearing. The mass movement among women for political justice and equality in suffrage, education, labour, marriage and family legislation was practically destroyed by the war. Women's value lay in patriotic submission to the war effort, including their demands that 'men must go'. By 1915 the rush of volunteers had been consumed by the war and fewer were coming forward to replace them. The Derby Scheme, invented as a preliminary to conscription, called upon men to 'attest' that they would serve when required, in the forlorn hope that eligible single men would be the first to step forward. On the last day of the scheme the *Daily Sketch* pulled a 'stunt', and arranged to photograph a man 'attesting' in his sick-bed. As he was

Daily Sketch,
13 September, 1915.

DAILY SKETCH, MONDAY, SEPTEMBER 13, 1915.

The King Who "Wanted" You, Does Not Forget You.

DAILY SKETCH.

GUARANTEED DAILY NETT SALE MORE THAN 1,000,000 COPIES.

No. 2,032. LONDON, MONDAY, SEPTEMBER 13, 1915. [Registered as a Newspaper.] ONE HALFPENNY.

THESE WERE PICKED UP WHERE OUR SOLDIERS FELL·

These photographs, with the two underneath, are all from metal lockets which have been found and sent

This is also from a locket picked up near Havre.

A R.A.M.C. man sent this from Ypres.

Four of a number of photographs a private of the South Lancashires discovered after a charge of the Royal

home by soldiers in France. The senders are anxious for them to be claimed.

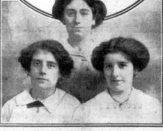

Scots and Liverpool Scottish, somewhere in France during June.

"Your paper being so popular, I thought you might find the owner," writes the finder from France.

A memento of Neuve Chapelle. It is believed to have belonged to a Manchester man.

A relic of the terrible fighting on the Gallipoli Peninsula. Sent home by one of the Lancashire Fusiliers.

Found in a German trench at Hooge. Believed to belong to L.-C. F. P. Thomas, 4th Cheshire. This was sent to us from Gallipoli. It was found on August 17. One of many lying scattered in a Flanders trench. Probably the property of a Suffolk man. "To wish you luck. Yours sincerely, Lizzie."

Another selection of photographs which have reached the *Daily Sketch* from the battlefields of Flanders and Gallipoli. Many of them are in lockets, and were undoubtedly the parting gifts of wives and sweethearts. Further details relating to the photographs will be found on page 10.

unable to get up, his wife had brought in the recruiting officer, and all three solemnly contemplated the viewer under the headline: 'Are Married Patriots to Save the Single Shirkers?'[51] This woman knew where her husband's duty lay.

Dutiful housewives were not the only female patriots. Essential war work was carried out by women in industry.[52] Even so, men disbelieved that women could perform any useful work there. In response, in 1916 the Ministry of Munitions produced an album of photographs of women workers 'as an incentive and guide in factories where employers and employed have been sceptical as to the possibility of much important engineering work being done by women'.[53] Contrary to these beliefs, and useful at this juncture, women had learned enough from the suffrage movement to be ready for what the novelist Rebecca West called 'the rough and tumble' of wartime tasks. Writing in the *Daily Chronicle* in 1916, she said it was doubtful that women

> would have gone into the dangerous high explosives factories, the engineering shops and fields, and worked with quite such fidelity and enthusiasm if it had not been so vigorously affirmed by the suffragists in the last few years that women ought to be independent and courageous and capable. [54]

Among the strengths of women listed here, and their war work, the presence of 'fidelity and enthusiasm' are critically important: they indicate that the duty to 'King and country' overlay the duty to women's emancipation. Everywhere, including at home, in the factory or in the office, women's work was put to the service of men and the *status quo*.

With the disposition of the press to value distraction and amusement, it could best handle the capacity of women to work if some note of harmless novelty could be struck, with attractive headlines. The *Daily Sketch* ran a cover story about 'The Girl Who Never Sleeps', with pictures to 'prove' her exemplary self-sacrifice.[55] A woman might then become the measure for patriots, and

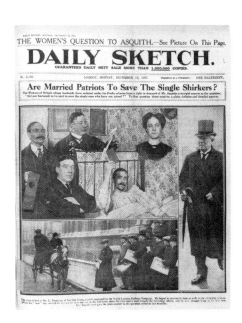

the accuser of idlers and shirkers. However, even ordinary numbers of hours in the factories were enough. This was symbolically validated by the King himself on a visit to a munitions works where he was said by the *Sketch* to have 'clocked on' for the shift.[56] The extraordinary visit of royalty to the factories brought two of the most potent symbols in the land into an alliance that effectively dismissed as irrelevant the actual differences between a king and a 'canary' (as the women were called, having been stained yellow – and poisoned – by the chemicals). Such stories showed the necessity and normality of it all; and they seemed to show the compliance of the whole work force in the struggle. Once it was over, women were quickly displaced in the heavier industries and lost the special significance they once had as key workers.

The symbolic importance of their roles was never their own to use, but was attributed to them by the press for its own specific purpose. As workers, women were said to apply themselves with 'enthusiasm, earnestness and devotion', and so defined by contrast those who were less than patriotic, notably labour on strike. In July 1915 when the Welsh miners had struck, the papers were full of photographs of empty coal wagons – a loss of fuel which endangered the Royal Navy. They contrasted this dereliction of duty with images of women workers who marched and demonstrated against the malingerers. The *Daily Sketch* picture spread was captioned, 'The Women's Example to the Welsh Miner'.[57] Men in dispute with their employers were made to seem unpatriotic. The real differences of interest and

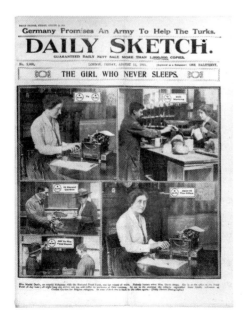

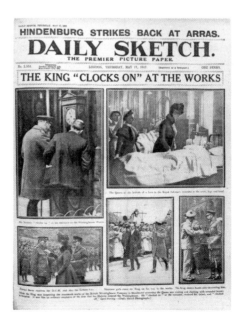

Far left:
Daily Sketch,
13 December, 1915.

Centre:
Daily Sketch,
13 August, 1915.

Below:
Daily Sketch,
17 May, 1917.

class were flatly denied in a photograph of an anti-strike demonstration: in the *Daily Mail*'s picture story of 'Men Who Are Idle and Women Who Will Work' we are encouraged to see that 'the pit lass and the woman of leisure walk side by side'.[58]

The role of women in eliminating class and creating an ideal unity took on mythic proportions. The press circulated these stories, reported them and so sustained them, thus creating a normality that seemed to be free of sectional interests, party and privilege. Everything that women did, because of their earnestness and devotion, was both natural and true. Women from whatever class were natural creatures, led by instinct and not reason: it was through their wombs that they appealed to the higher instincts of men who would save the race. Women were supposed to have a biological and therefore undeniable urge towards the birthing and nurture of future armies. This meant 'nature' was of interest to the state. It successfully promoted child care and the reduction in the infant mortality rate. In July 1917, during 'National Baby Week', the Queen attended an exhibition on motherhood, and the *Daily Telegraph* said, 'If we had been more careful for the last fifty years to prevent the unheeded wastage of infant life, we should now have had at least half a million more men for the defence of the country'.[59] Women were seen to endorse this view in the photographs of their marches and banners in the *Daily Sketch*, which declared 'A Clarion Call to Mothers – the Future of Our Race Lies in the Cradle'.[60]

In contrast to the traditional British way of life, the enemy's *Kultur* destroyed children. After the German Navy bombarded the north-east coast in 1914 the *Daily Mirror* said, 'German Ghouls Gloating over Murder of English Schoolboys'.[61] In 1917, two weeks before the royal interest in 'Baby Week', the *Daily Mirror* reported 'Babies Killed in Daylight Raid', and ran a picture of the King arriving at the hospital to visit the wounded.[62] The actual disparity of British life was bridged in these short journeys taken by the King and Queen in their concern for babies: instead, civilization was opposed to *Kultur*, while health in babies (and the future of the motherland) was opposed to disease or degeneracy in the national character. Furthermore, class differences and interests were negated. The Monarch and the poor of the East End of London were shown as one family, grieving but united in sorrow.

Saving the nation from the Hun and from degenerate Britons or other types of 'enemies within' required a specific leadership. It would come best from those who instilled in others the need for sacrifice, for duty performed with courage, discipline and sportsmanship and in deference to

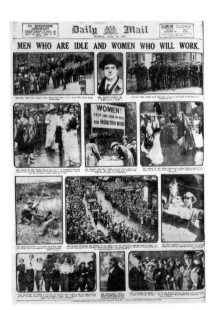

Daily Mail,
19 July, 1915.
Courtesy of Mail
Newspapers PLC.

hierarchy, precedence and power. The appeal to patriotism and the establishment pushed class and gender conflicts to the margins, whilst credit given to the order of things was clearly seen in the public representations of normal family life.[63]

THE ENEMIES WITHIN

The purity of family life was set against both the danger from abroad and the debilitating presence of enemies within. Once the family had been identified with the nation, both were vulnerable, since the passage from the past to the future required, potentially, the sacrifice of the most virile men. The nation/family was under attack and had to defend itself. War was the path to salvation, but it was dangerous. If the real men were away at the front, who would protect the women and children, and what threat lay in those men who stayed behind?

One safeguard was the patriotism of the women themselves. As the *Daily Sketch* reported, they joined the soldiers in bringing the meetings of the 'peace cranks' under 'democratic control' by breaking them up, or by singing 'Keep the Home Fires Burning' after demonstrators set fire to a hall in which pacifists were holding a meeting.[64] A strange reversal took place: women now became fierce and warlike, whilst the police, in all the many incidents of assault upon pacifists, were invariably seen standing well back. Police, soldiers and women were actively and regularly engaged in illegalities for which there were no penalties.

Daily Sketch,
2 July, 1917.

Together they formed a mutuality of labour and family that matched the national need and seemed free of the control of either press or state. Their bellicosity was regarded in the press as a 'natural' eruption of feeling.

Popular resentment at the actions of pacifists easily found its way into the newspapers, which suited the government. But other 'natural' eruptions of feeling could work against government interests, and were widely reported in the press because they were of concern to readers. The government was engaged in breaking up home life, and it came in for criticism when it was popularly perceived to have made mistakes. The government had 'bungled' the Derby Scheme and conscription had begun. In March 1916 the *Daily Sketch* headline ran 'The Fight for the Englishman's Home', and pictured a hearth with father and son reading whilst mother and daughter sewed. Inset was a picture of a politician who was seeking state security payments so 'that the home which the married man is asked to defend shall not be sold when he goes to war'.[65] The appeal of the front-page story is quite precise in terms of class, since it would be the relatively insecure lower middle class seen in the photograph who found themselves in this position.

Daily Sketch,
24 June, 1916.

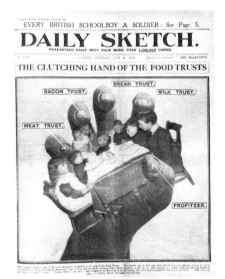

Besides a government reluctant to pay benefits, the poorer families had other enemies, notably the 'greedy landlords'. They were not identified, but space was given instead to the popular expression of hostility towards them. In the *Daily Sketch* a picture of wrecked houses in France reminded everyone, including rent racketeers, that without the bravery of the men of the Armed Forces who had left their homes behind, there might not be any property left from which they could gather profits.[66] Others were taking large profits from food. In August 1916 there was a demonstration in Hyde Park demanding cheaper food, or more wages. In the *Sketch* 'war' was declared on the 'Food Pirates', who were described as 'vultures', 'thieves' and 'traitors'. None was identified, but space was given to a photograph of the demonstrators whose 'indignation defied the rain'.[67]

The absence of the profiteers indicates they were not the targets of investigative journalism, but that the demonstrations against them had raised the issue into something that could be recognized by the press as newsworthy – a crowd, a fiery speech, perhaps a by-election fought on the case for social security at home – and as an issue profiteering took its turn amongst the rest. It was difficult to illustrate. One rare collage of photographs in the *Sketch* of 'The Clutching Hand of the Food Trusts' was very literal in its interpretation: it showed a giant hand

holding in its grasp the seven children of a mother whose husband had not been heard of since the latest attack, and who had no money for meat five days in the week.[68] The chief function of the stories was to highlight in dramatic fashion the family at the centre of the storm. It was a subject that could exist as 'tragic', or as the epitome of sentiment as in the *Sketch*'s homecoming story, 'From the Trench to the Yule Log'.[69]

There were more obvious targets amongst the men who shirked their duty, and failed to enlist. According to the author A. P. Haslam, in his book *Cannon Fodder*, the press described civilian men as 'emasculated vermin' and 'sexless worms'. Girls were advised to reject such lovers, and wives encouraged to desert

Daily Sketch,
15 March, 1916.

such husbands, though as soon as one of these 'monsters' enlisted 'he regained his character, his good looks, his courage, his sex and the good opinion of the newspaper men'.[70] A shirker might turn into a conscientious objector, which common sense said was naturally the least virile of men, and the law said was the most criminal. In a *Daily Mirror* story called 'Fighting "Conchies" Who Object to Being Photographed', these 'long-haired', 'truculent' and 'threatening' men had condemned themselves to 'Government House' on Dartmoor where they tried to remain hidden. They were traced by an intrepid photo-journalist who, to save himself from harm, was forced to spy on them from a distance.[71] In this way the enemies within were caught in the newsnet and presented as simultaneously dangerous and marginal.

German 'aliens' in Britain were similarly vulnerable. Once the passenger liner *Lusitania* had been sunk in May 1915 with the loss of 1,195 lives, the press carried many picture stories of the lost families and mass graves of the victims. In London, Liverpool and Manchester, mobs of soldiers and women with pickaxes looted 'alien' shops, tipping furniture from the flats above into the street. In photographs of the riots in the *Daily Mirror* the police were seen to stand conspicuously by, and so again may be said to have legitimized them.[72] Lord Northcliffe, who owned *The Times*, the *Daily Mail* and the London *Evening Standard*, was blamed for whipping up anger. A political opponent said that 'it must be a great satisfaction to him to feel that he has sold his country for a ha'penny'.[73] But the press was presenting no more than yet another German atrocity and the attacks that followed as part of their normal practice, their normal diet of excitement and scandal. The incidents made it politically possible to round up the enemy 'aliens' and intern them in the Isle of Man, which had all the advantages of a prison hulk: there both prisoners and gaolers were out of sight, but under the perfect control of authority.

The spies and armed enemies of the state were simply destroyed out of sight. Fears of an Irish rebellion had been uppermost in people's minds in the early summer of 1914, and when the Sinn Fein revolt took place in Dublin on 24 April 1916, the Irish press was silenced for about a week. The photographs of the scene were released in the mainland press on 2 May, and a little later in the Irish press. Over several days, the *Daily Mirror* showed the barricades and burned-out buildings, a convoy passing through the danger zone with rifles at the ready, the wounded British and Sinn Feiners, and portraits of the first rebel leaders to be tried and executed.[74] The signs were of destruction and an army which restored the peace, though exactly how they did this, or maintained it, was not the object of the photographs. They offered a story of a rebellion wrecked, an official, censored version of the aftermath, in which the enemy was hidden, silenced and rendered invisible by the state. The press, struggling under the censor, was unable to see

those so entrapped, or cast light upon their imprisonment and deaths. The press concentrated upon the external show, and set before the public the startling existence of bombing and soldiering within the United Kingdom. Because it was difficult, if not impossible, to photograph the inequalities in the relations of power that had made the rebellion, the public never *saw* any reason for it. All that was seen was its end in violence.

Photography was exactly suited to the disguise of causes, since it showed no more than damage to the city of Dublin. In every detail, this show was directed by the authorities, passed by the censor and inserted in texts that were themselves the products of the unexamined, internalized practice of the press. This routinely

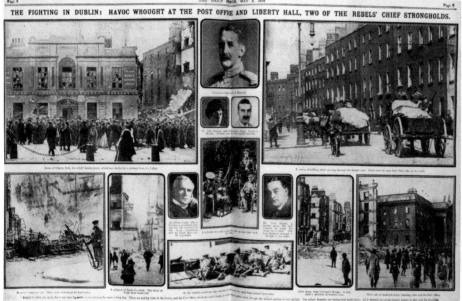

Daily Mirror,
3 May, 1916.

destroyed contrary opinion and thought, and made it impossible for an unpopular view to gain adequate expression in the public arena of the newsnet, at least.

To sell newspapers it had long been known that their contents had not only to be entertaining, but effortless to read, 'like mince-meat, which requires no chewing'.[75] The appearance of photographs in the press brought nearer the perfection of news as a commodity which could attract customers with a promise of ease and amusement, whilst instruction would be effortlessly absorbed through simple sentences and direct storytelling pictures. As the sociologist Walter Lippmann said in 1922, 'Photographs have the kind of authority over imagination today, which the printed word had yesterday, and the spoken word before that.

They seem utterly real. They come, we imagine, directly to us, without human meddling, and they are the most effortless food for the mind conceivable.' Words alone required an effort of memory before a picture existed in the mind, but in photographs in the press, or in films, 'the whole process of observing, describing, repeating and then imagining has been accomplished for you'.[76]

This common sense view of photographs as transparent and unmediated obscures the negotiations that take place between one sector of society and another to produce the authority that they have over the imagination. The complexity of the matter was by no means obvious to the people involved, who thought that they were simply reflecting an absolute reality or defending a necessary state of affairs. They would not have described it as the domination of the majority of citizens by the relative few who controlled the means of reproducing their own values while stifling their opponents'. A few people thought that this was indeed the case. As the sociologist Norman Angell wrote in 1922,

> Obviously what England thinks is largely controlled by a very few men, not by virtue of the direct expression of any opinion of their own, but by controlling the distribution of emphasis and the telling of facts: so stressing one group of them and keeping another group in the background as to make a certain conclusion inevitable.[77]

Angell's insistence upon the power of the press in the control of opinion no longer seems a sufficient explanation; nor does it account for resistances. None the less, he did question the newsmen's assumption that they merely reflected opinion, or reported neutral facts, stressing that every day they were choosing what they would say and how they would say it. After the Russian revolution of April 1917, for instance, and after the Russians had made a separate peace with Germany, the *Daily Mirror* called Russia 'a republic with five dictators', the 'tools' of Germany who shot their own women and children.[78] The constant framing of the 'Leninites' as enemies was itself a sufficient explanation for the continued use of the British Army and Navy against the Russians once the war with Germany had finished. It was as if the expectations of a continuous war had begun, a war in which the force of civilization would be transmitted through war-machines and continue to range across the world in search of its opposite.

If the Bolsheviks and the Central Powers threatened the stability of Britain and the Empire, there was another insidious danger: the perpetual frailty of the enemy within, the people of the 'abyss' infected with alcoholism, venereal disease and congenital poverty.[79] This creeping degeneracy in the life blood of the nation, made popular in the 'science' of eugenics' concern with the purity of the race, was made worse in wartime by spies, rebels, militants and profiteers. Opposing it

was the British race of virile men who gave their strength to safeguard women, reciprocally drawing strength from the sanctity of family life. It was a very simple model, but one that underlay the apparent diversity of stories in the press. Every day they would appear to be different, but every day they would repeat and reinforce the single refrain, the absolute necessity of raising the patriotic ideal of one nation above the antagonisms of class. As Norman Angell said,

> What is happening is that these papers are in fact – without conscious intention but none the less effective for that – carrying out a daily programme for securing the assent and acquiescence of the multitude in a form of society founded upon the principles of inequality. They do not merely habituate these millions to the idea that a special class, a tiny minority, should occupy a special position of power, or culture, or deference, [but they] get the mind habituated to the fact that this is the normal and inevitable, if not, indeed, the desirable organization of human society.... Have not titles been granted to workhouse boys? Inevitably there grows up a bias against equality. The defenders of the old order have already half won the battle.[80]

A common sense understanding of photography as unproblematic evidence of the real conditions of existence is the perfect counterpart of the press' claim to truth. Every day the popular papers carried a 'slice of life' in their centre pages, photographs laid out in a tidy pattern to mirror experience. A typical example in the *Daily Mirror* tracked across the military and political leaders, the armed forces, their equipment, their casualties and attendant medical support, and a French village destroyed by 'the refining influence of *Kultur*'; alongside the war effort were photographs of two military weddings, a revue star and an actress, a smart spring hat, a bicycle trick, an accident on the railways, the portraits of children who had died in accidents on the roads, women workers, and a new prize cup for the Grand National with the title 'Britannia at War'.[81] The pictures in the centrefold were always a nervous compilation such as this, flickering from day to day across the foreign and domestic scene, but the selection was never random. It always reiterated the core values of the pleasurable life that made the war worth fighting. Occasionally, and by way of contrast, sewn into the spread was the evil of the foreign enemy or the inimical behaviour of those Britons who were on the margins of society. It always left out those who were so reprehensible or so powerful that they could retain their anonymity and invisibility.

THE FRONT SOLDIER

By 1930 the anti-war literature that destroyed the propaganda of German evil also threatened to destroy the propaganda of British virtue. In his bibliography of war books, Cyril Falls said so many of them 'pandered to a lust for horror, brutality and filth' that there was a dangerous belittlement of British valour. The soldier who had liberated Europe from Germany and Austria, and saved the Near East from the 'unregenerate' Bulgar and Turk, was now commonly represented as 'a depressed and mournful spectre helplessly wandering about until death brought his miseries to an end'.[82]

During the war he had been a hero. According to a wartime writer in the philosophical and religious *Hibbert Journal*, the whole nation had thrown off its recent inclination to frivolity and self-indulgence. It had accepted the ideals of 'personal heroism and self sacrifice', creating 'a national consciousness, a real organic national life' in which 'the old concept of the State as made up of inharmonious entities and groups had given place to a sense, at once concrete and mystical, of the personality and supreme value of the Nation'.[83] War seemed to offer a return to a more chivalrous past, or at least a true liberation from the decadence of modern life. In this context, soldiering and death were orderly and positive in meaning.

After the war, in remembering it, it seemed chaotic, a slaughterhouse. Every sector of the front was a bad one, every working party was torn to pieces; if a man was killed his brains or his entrails always protruded from his body. At the time, the grim realities of warfare never reached the press: they were censored at various levels for fear that a description of the real conditions in the trenches would reduce the number of recruits.

At first, the government barred correspondents from the front. This proved difficult to enforce, as journalists were travelling to France and Belgium determined to break the silence imposed by the War Office and, in the words of one of the most famous reporters, Philip Gibbs, ready to print 'any scrap of description, any glimmer of truth, any wild statement, rumour, fairy tale or deliberate lie'.[84] They played cat and mouse with the authorities and were sometimes arrested and briefly imprisoned before being deported. The *Daily Telegraph* complained that there would 'not be an unofficial, full and independent account of any action fought in the war'.[85] As a result the order was partly rescinded and in May 1915 groups of six correspondents at a time were allowed to visit the front and remain there for about six days, under the strict guidance of the military authorities.[86]

Photography was less well served. The official disdain for photographs was connected to the disdain for the yellow press which used them, since it catered for a public that did not care to read. But the War Propaganda Bureau at Wellington

House needed photographs to illustrate its foreign language newspapers, and found itself in the embarrassing position of receiving an offer to supply them from the French government.[87] As this would have defeated the object of the papers, a beginning was made with official propaganda photography in the Dardanelles in 1915 and on the Western Front in 1916. During the period 1916-18 there were twenty-two official and semi-official photographers in the British and Dominion armies, while ten, of whom five were with the British Army, worked on the Western Front.[88]

There were complicated arrangements for producing and distributing photographs, which indicate their low priority in the military hierarchy and the scant regard for the needs of the press for topical pictures. The photographers travelled with the official film makers by car, which limited their operations to the approaches to the battlefield, and their subjects to the preparations and aftermath of the attack. In 1917 Wellington House asked an art editor what photographs the press was looking for, and must have been pleased with the response. The first rule was to get close to the subject, as this gave the spectator the feeling of 'being there'. Empty stretches of country were to be avoided, and picture stories were to be built up of men in full kit going to the front, or returning after two days of rain and mud to their billets, where they would play games or talk to the locals. People were supposed to want 'intimate' pictures of men relaxing or working on their tanks or building trenches and gun emplacements.[89] The result was dull photographs of the 'fixing of guns and the ascent of aeroplanes'. This meant that although only two British official photographers were at the front until 1917, by September of that

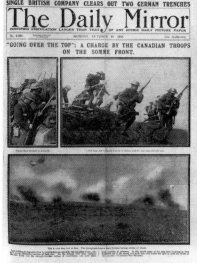

Daily Mirror,
16 October, 1916.

year they were still sending home far more images than the press was prepared to use.[90] This low-key propaganda work suited Wellington House and the British illustrated weeklies, but not the daily newspapers who wanted 'blood and iron', and were certain to be disappointed: the official photographers knew such pictures would be banned by the censors and so rarely took them.[91]

There was a strong and sometimes irresistible temptation to bring excitement into the official record. The Canadian War Record Office, which vied with the British for topicality and promoted successful touring exhibitions, suggested that since the public were tired of ordinary war pictures, 'all subjects should be carefully arranged, but avoiding the effect of having posed them'.[92] This type of 'innocent' deception had already taken place: a photograph, taken for the Canadians, was published in the *Daily Mirror* and described as men actually going 'over the top' in

battle,[93] whereas they had been practising at a training camp behind the lines.[94]

The British military censors were concerned about the posed shot. Early in 1918 they banned even the human interest story if it was an obvious fake. The ban was introduced after a photograph appeared in the *Daily Sketch* of a dog that was supposed to be 'Guarding His Master's Kit'.[95] This derived from a sentimental genre in Victorian painting; by 1918 it seemed to the censor to be such a false representation of the war that readers of the newspaper would treat it, and perhaps all official photography, with contempt.

These details indicate the different test of newsworthiness demanded by the government and the popular press. The government extolled the propaganda of facts. They were not prepared to sacrifice it for thrills and sentiment, and kept a very tight control over what they wanted to be perceived as the truth. The press, on the other hand, always preferred entertainment to instruction.

There were some facts that no one wanted published. In 1917 the official photographers were specifically forbidden to photograph 'gruesome' scenes.[96] The front was too harsh a place to suit the mood at home, or the usual practices of the press. In the words of a veteran, the front was too full of 'rough, licentious, foul-mouthed men', and too dangerous and dirty for the generals:[97] Haig had become so enthralled by his maps that he did not recognize the battleground when he saw it. After the capture of the Vimy Ridge in April 1917, he came to Arras in his Rolls-Royce, and had to ask one of his staff to point out the ridge to him.[98]

For home consumption, as one official in the Foreign Office put it, photographs of generals and 'other big wigs' getting in and out of cars, having lunch and dictating orders were supposed to be exactly the 'sort of twaddle' people 'love to gape at'.[99] Although the military authorities were suspicious of correspondents, they could be relied upon to describe a defeat as if it were a victory, 'the hero with a halo' on a charger waving his country's flag; whereas the cameraman or film-maker must show the soldier as he was externally – unkempt, unshaven and dejected.[100]

Yet photographic realism could never exist in a pure form. It was tied into convention, and it was conventional to see men cheerful before a battle, or to describe them (in the words of the *Daily Express*) as bravely 'smashing, hacking and hewing' their way through the enemy.[101] For years, illustrators had pictured soldiering as heroic and exciting, not only in the conservative history paintings of the Royal Academy destined for regimental mess-halls, but in popular prints, and in drawings and engravings in the press. When it came to picturing a modern war, the papers were prisoners of their own previous successes. As early as 1890 a journalist, in his article on illustration in books and newspapers, had said 'our artistic skill has led us into temptation, and by degrees engendered a habit of making pictures when we ought to be recording facts. We have thus, through our own cleverness, created

a fashion and a demand from the public for something which is often elaborately untrue.'[102]

In 1914 the older generation of bureaucrats, philosophers and other war propagandists who stayed in Britain were excited by the feeling of the past 'throbbing in our veins'. They were less interested in the contingent details of a photograph than in the general scheme of war heroics which corresponded to 'the very form and pressure of our national life'.[103] The comradeship of arms may have been one of the few liberating experiences of the war for the front soldier, and it is certainly widely represented in the press. The *Daily Sketch* in July 1916 published 'vivid pictures' of soldiers cheering on their way up the line, showing 'that the

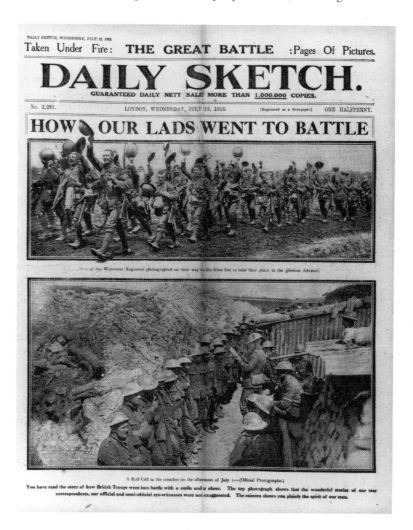

Daily Sketch,
12 July, 1916.

wonderful stories of our war correspondents were not exaggerated', and demonstrating how cheerful photographs could match the cheerful text. They showed 'the spirit that lives in the Great Advance, the soul of that host of heroes who with smiles on their faces and iron in their hearts are winning imperishable glory, as well as honour for our arms and liberty for our race'.[104]

Whatever the source of the photographs, the copy was invariably an account of 'thrilling warfare' (*Daily Sketch*),[105] 'a dog-like leap from trench with bomb and bayonet' (*Daily Mirror*),[106] or a 'walk through fire to thrash the Huns' (*Daily Sketch*).[107] In May 1915 when the government had released very few photographs and no cameramen were employed specifically to supply the press, the *Daily Sketch*

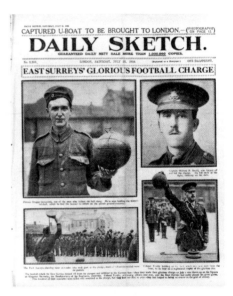

paid the large sum of £100 for an amateur photograph of men in a trench with bayonets drawn.[108] Two months later the paper used it again. They paid a further £500 to the photographer for the 'Finest Picture of the War' and added a glint to the nearest blade.[109]

Neither the reports nor the photographs came close to the experience of the troops who were later said to have been exasperated by the cheerful way in which the correspondents wrote, 'as though a battle was a kind of glorified football match'.[110] As far as the press was concerned, there were conventions in war reportage, and war news was very readily understood as sport. The war-as-sport could produce a lucky winner, such as the soldier whose story was printed in the *Southend and Westcliffe Graphic*: his watch stopped the bullet that would have killed

him.[111] Or there were unlucky losers, such as the man who took a photograph as he died, blown to bits even as he pressed the shutter (it was published in the *Daily Mirror*).[112]

Luck or misfortune were in themselves too commonplace for the front page. To merit that, the story had to be heroic and bizarre. One instance managed to combine every aspect of front soldiery – courage, sacrifice, leadership, discipline, death and football – when Captain W. P. Nevill began the assault at the Battle of the Somme with a ball kicked high towards the Germans' lines. He led on and was shot down. The *Daily Sketch* led with 'East Surrey's Glorious Football Charge', and a front page picture story which included a portrait of the officer, a wounded private who had joined in, the survivors cheering and the colonel holding up the famous ball. It was eccentric, but not mad: 500 of their comrades were killed or wounded in the charge but, as the caption said, 'they had not died in vain' since 'they helped to bring us nearer to the goal of victory'.[113] Clearly, the everyday practices of the press, its common language and its fondness for often grotesque puns all go some way to explaining the kinds of diversionary stories that were taken up and which became newsworthy events.

Even though the press had its own criteria for newsworthiness, which could accommodate the war, it nevertheless struggled with the government and military authorities over the details of censorship. The government set up the Press Bureau. Its role was to censor the press through DORA and the 'D' notice system of 'advice' to editors on sensitive subjects. The regulations were so strictly applied that an American correspondent said the Press Bureau had 'engulfed heroism and history', and made the nation 'appear poor in patriotism when it is not'. It had drawn a 'thick curtain' around British affairs. The curtain had blocked all forms of communication: it had 'put out the light' and 'broken the miraculous news machine'. The curtain meant that the world could not 'vocalize, interpret, assimilate your immeasurable silence'.[114]

Silence, to the Press Bureau, was welcome because it meant no contrary voice. The Director later said, 'a most remarkable feature of our newspapers during that time was that they bore no palpable trace of having been censored at all. An outside observer, if he chanced to miss the occasional tirades against the Press Bureau might reasonably conclude that there was no censorship in force.'[115] As far as the Bureau was concerned the censorship achieved its twin aims – a favourable projection of Britain abroad and a unity of purpose within the nation itself. The propaganda of unity of purpose emerged as the consequence of the elimination of contradiction.

Since journalists and government officials shared a common fount of patriotism, the press not only accepted but even desired control. How else was it to make sense of chaos and meet deadlines? Furthermore, this patriotism was part of a

shared and commonsensical perception of the world. Yet the consensual stories still had to be written and shown. In the popular press, especially, the acquiescence of the journalists to the official version of events had to be taken beyond flat statement and written in the special rhetoric of the paper. Then an important slippage took place, turning an historical event into reportage, into writing. Photographic realism, which had its own set of invisible constraints, could never contradict the texts, but was bound to sustain them.

In October 1916 photographs of soldiers marching to the front-line trench and waiting for the order to advance, were typically enmeshed in a front-page story in the *Sketch* with the headline 'The New Army's Walk to Victory'.[116] Though shells were bursting ahead, 'they climbed over the top with easy self-possession'. This kind of journalism, commonplace throughout the press and representing the soldier as hero, is hardly to be understood as a consequence of censorship; it is explicable only as the erasure of contradiction, the elaboration of hope into a completely new truth of mythic proportions, all pervasive, natural, patriotic, unassailable.

The battle over censorship, although experienced as a reality by the journalists and officials of the day, was not resolved by repressive legislation alone, or by the sudden appearance of a new bureaucracy. It was less a battle than a dance, in which the truth required by the government and that required by the press complemented and supported each other, occupied the available space, and actively excluded another type of truth – the agonies of front soldiering.

No photographs or texts appeared in the popular press that celebrated the discipline or hardness of the German soldier – though as a veteran recalled, they were his models, they were real soldiers, something he wanted to be.[117] Instead, German prisoners of war were shown in the *Sketch* to be figures of fun: 'Says Big Hans to Little Fritz – "The long and short of it is we're licked"'.[118]

Photographs of the desolation of the front, the 'eternal mud', did appear in the *Daily Mirror* in the later stages of the war,[119] and grim scenes of burial parties and corpses were shown in the popular film of *The Battle of the Somme*.[120] But there was no chance to express the horrors of handling bodies of the consistency of Camembert cheese, or the fear of falling into the rotting remains (and then reflecting upon the irony of surviving only to be poisoned by a man long dead).[121]

Hospitals and nurses were occasionally represented, with long shots of the limbless, the burned, the blind and the faceless, but the emphasis had to be placed upon healing and rehabilitation rather than distress and lack of facilities.

Army discipline was never an issue, save for the contempt meted out to conscientious objectors. From 1914–20 there were more than 300,000 offences dealt with by courts-martial, and around 3,000 men were condemned to death, of whom roughly eleven per cent were executed.[122] These events could not become

the subjects of investigation by journalists. No interest was shown in the rate of growth of the military police corps, a rate which exceeded that of the army itself. In 1914 the ratio of military police to servicemen was 1:3306, and in 1918 it was 1:292.[123] The British soldier appeared to be resigned to the war: 'the Russian armies collapsed, the Italians deserted, the French mutinied', but Tommy Atkins 'apparently did little more than curse his fate'.[124] The postal censor once failed to erase an account of a mutiny at Etaples in France, involving 10,000 men, but it was reported only in the suffragettes' *Workers' Dreadnought*.[125] Nothing appeared in the mass circulation dailies to suggest that there was any malingering and indiscipline (or active resistance to their fate); there was no mention of the tacit co-operation

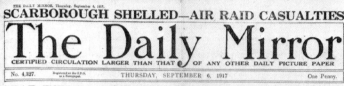

Daily Mirror,
6 September, 1917.

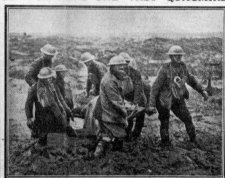
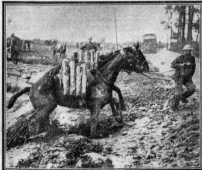
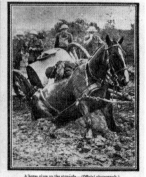

with the enemy, the rituals and routines of offensive activity in the 'live and let live' system that was used to keep out of harm's way.[126] No mention was made of the 28,000 cases of shell-shock recorded between 1914–17, or of the treatment of these 'moral invalids' who, no longer able to 'resist victoriously the agony of the battlefields', underwent the harsh therapies of isolation and electric shock.[127] All of these experiences of the soldier were passed over in silence, or treated as abnormalities, since death was a necessary sacrifice.

The pictorial press presented British civilians with a world of patriotism, honour and devotion to the ideal. Late in 1918 there had been a victory, but also a catastrophe: it looked as if a whole generation had been lost.[128] For this to become bearable, the war had to be represented in a way which would transcend the contingent details in photographs. The war needed a more heroic voice, one that would speak of that sense of fitness, necessity and permanence so central to a national history. The public face must have a steady gaze, and this could be achieved most easily in monuments which took on the connotations of agelessness. A sergeant who served with the Royal Hampshire regiment wrote, 'My platoon was all Hampshire men, and as they got knocked off I said to myself, "There goes Hartley Wintney or there goes Old Basing"'.[129] Knocked off they were, but once dead, these villagers were transformed: they turned into that glorious abstraction 'Names that Shall Live for Evermore'. As such, they were entered upon the memorials and returned to the villages, towns and cities of Britain for the symbolic purpose of redeeming the slaughter as sacrifice.

Overseas, the numbers of dead lying next to each other made the opening of cemeteries both necessary and possible. The graves began to be organized in 1915 by the Graves Registration Commission, which was a body with relatively low status within the army bureaucracy. By 1916 the volume of graves, and the recognition by the army that grief should have a public form and monumental scale, meant an increase of status for the Commission: this was given in the new name of the unit, now known as the Directorate of Graves Registration and Enquiries. Families were contacting the Directorate for information, and individual burial mounds were photographed: by April 1917, it had sent about 12,000 photographs to relatives. The greatest change occurred in May that year when the Imperial War Graves Commission was established by Royal Charter with the duty of marking and maintaining the graves of all Empire Services members who died in the war.[130]

The memorials that were built later reconciled two types of knowledge. Firstly, the Rolls of Honour were a record of names and rank, and submitted to the discipline of objectivity and truth. There was a literal figuring of the names of the dead, which were matters of fact, to be known and numbered. Secondly, the memorials were animated by the subjectivity and imagination of the survivors, many of whom sat on the committees of parishes and councils, and collaborated in

the formulation of national memory. From their deliberations came a standard of permissible gestures: abroad, the headstones in the cemeteries lay row upon row; at home, local authorities which had only the names of the 'fallen' to dispense used a variety of funerary forms, allegorical and literal, to deal with the complex co-existence of mourning and celebration.

This public memory had to fit into the churches and the various civic settings, but the most crucial sites were the village greens and the municipal parks. Placed there, the memorials were then overlayed with the symbolism of the greens. In England, this meant the memory of the nation as a perfect garden. Though edenic in quality, this garden of England had a past.

In a Batsford picture book of *The English Countryside* first published in 1915, the 125 photographs were accompanied by an 'afterword on the war' in which the character of the present was said to have evolved from special, olden days. The text said,

> It is the past that has made England of today, and the present is but its continuation. Prehistoric trackway, ancient village, sleepy town, the farmhouse in the hollow, the sheepfold on the hill – all have rendered their share in the making of England, and the building up of that race whose sons are emulating on the battlefield the deeds of their forefathers set forth in quaint inscriptions on the walls of many a village church or in the mouldering records of ancient boroughs.[131]

This is an England that has always been ancient, a place not mouldy but mouldering, which is a continuing and positive process. It produces a history that explains the look of the land in terms of the sacrifice of sons in some other place, the battlefield. In this language, and in the memorials, there is always the duality of meaning, a sense of loss met with the consolation of necessity. It is matched in the language by the peculiar double face of words, as in 'haunt' which suggests both love and loss: there are favoured 'haunts' which desiring people visit and revisit, matched by the haunting ghosts from the glorious past; and there is the endurance of unhappy spirits haunting, and of people being haunted by memory and fear.

The public memorials were both sombre and celebratory: they were new, but built upon the ancient heart of the village, or in a proud place within the city. There they became the popular emblems of the racial and the national, and the deaths they represented could be embraced with a degree of fondness. 'I cannot think of [England]', wrote Edward Shanks, chief leader writer of the London *Evening Standard*, in 1938, 'without remembering all her past.... Every English landscape is full of ghosts'.[132] That year was the last in which the ghosts of the Great War would be the newest war dead in the land.

3

THE SECOND WORLD WAR

WAR AS NARRATIVE

The story of the war as told by the British unfolds in the classic manner of a fable: it opens with a problem and ends with a happy solution. First, there is a threat, and a loss; then a new hero, and a victory; there follow more trials and defeats, but in the worst moment the hero calls upon a miraculous force, and with this aid final victory is assured and order restored.

With the delays and forward movements of a tale, the elementary history of the war goes like this: the fall of France laid Belgium open to invasion by the old enemy in its new guise of fascism. Military defeat was turned into victory when in June 1940 the army at Dunkirk was saved by indomitable spirit. People saw the public face of the war unfold within the rhetoric of heroic acts in fables. The *Daily Mirror* described Dunkirk as 'The Greatest Feat of Arms in History', carried off with aplomb by men who played 'football under enemy fire'.[1] One of the photographs showed the 'Unbreakables' in a romantic panorama called 'Miracle of the Deliverance', echoing the biblical ark that saved the 'world' from the 'flood'.[2]

The new leader, Churchill, took command and in July made a noble speech, which found support in the *Daily Mirror*: 'We will fight as Mr. Churchill says on the beaches, in the streets, and in the air.'[3] With courage the nation prepared for the worst. A handful of heroes won the Battle of Britain, but afterwards the people had to endure the blitz. In the *Mirror* the suffering was bravely met, with firemen ARPs going 'Through Fire to Heroism'.[4] The nation had united, and to prove it, the 'King goes to his bombed people' in the East End of London.[5] However, the enemy was vigorous still, and the war brought years of terror and austerity, whilst the outposts of Empire were lost.

There was a turn in fortune: the USA was drawn into the war, and with its material help a great victory was won in an unlikely place: 'The Guards go in at

El Alemein', said the headline in the *Mirror*.[6] Hereafter one victory followed another; a little more than two years later the *Mirror* showed 'Our Tanks in Germany',[7] and cheerful soldiers 'smiling through' in Holland.[8] Before long 'it's over in the west', and victory in Europe was celebrated.[9] Surrender was forced upon Japan, and peace and democracy reigned anew.

Collapsing the epic into a few phrases, or snapshots, in this way is merely to shorten the length of the line that dips and rises. The same trajectory is found in the longer versions, which only report more 'facts' and add more information to fix the epic as something absolute, given and known.

This version of the war, or parts of it, are to be found everywhere in books,

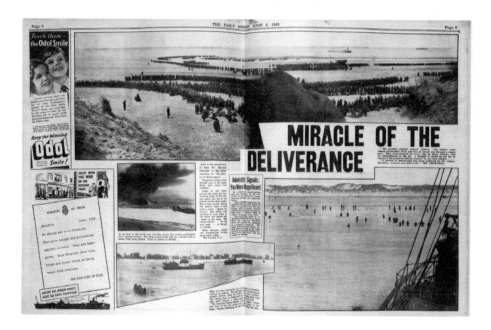

Daily Mirror, 5 June, 1940.

films and television series.[10] It is like other, much older narratives, epics or legends. Because real or imaginary wars had long been represented in this fashion, film and press photography were already fitted into conventions of meaning. These were separate from (but suitably dovetailed into) the special limitations of censorship.

For the government, the war became the subject matter of an advertising campaign.[11] The official account did not underestimate the difficulty of the combined effort but propounded its vitality. These messages were reproduced in the government's own heavily illustrated books and pamphlets on all the theatres of war.[12] The themes of unity and strength which informed the Ministry of Information publications[13] were in accord with the general public's estimation

of the war as the fight for 'freedom, liberty and democracy'.[14] People were able to understand the war upon these rhetorical and somewhat abstract terms but such abstractions were never enough: through photographic realism the great themes of freedom were constantly reified, instantly turned into the representation of work as productive and pleasurable.

The government's emphasis upon pictures of the hardware of war, and of clean action, was echoed in the press, as in the *Daily Mirror*'s picture of a battleship called 'The Lion Roars';[15] or in the *Mirror*'s portrait of 'smiling, devil-may-care ... aces of the air'.[16]

Hence the legendary account of the war was not a post-war imposition, but

Daily Mirror,
6 August, 1940.

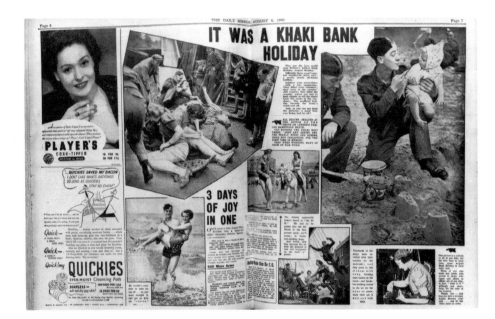

once the war had ended and more of the story was known, it became much easier to leave out some incidents and repeat others. This created an even greater clarity in outline, and turned the basic elements of the narrative into the bedrock of knowledge. Those contemporaries who read the newspapers, looked at the picture magazines, or watched the newsreels at the cinema also saw the war represented clearly as a fable. The instant creation of such a narrative form was possible because of past practice in writing histories, and because there was a delay between shooting film and its use. This delay was extended by the dictates of the censor, allowing the deployment of pictures to be moulded into the raised, optimistic tone that was normal in the public voice or posture.

One of the most heavily illustrated daily papers using official photographs was the *Daily Mirror*. In style the *Mirror* did not look like the official publications. Partly in an attempt to hold the interest of readers, the pictorial arrangement used odd geometrics, with pictures sliced and cut together almost as an analogue to urgency, modernity and entertainment. The arrangements were often kaleidoscopic, in a manner familiar from the First World War, but more in keeping with the syncopation of music, the motion of film and the fragmentation of news throughout the papers: 'It was a Khaki Bank Holiday', said the *Mirror* in August 1940.[17] There we see all the fun of the seaside, in pictures that are meshed together, offering different viewpoints as well as contents, with the emphasis upon movement – the ride, the roundabout, the helter-skelter, the man who carries the woman into the sea.

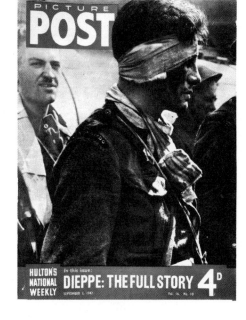

Picture Post,
5 September, 1942.

The mix of work and pleasure is a commonplace of the period, possibly because only in combination did either seem to have a future. Imagining the future allowed the *Mirror* sometimes to escape from the 'real' and use collage. In 1943 it combined a sketch of two soldiers charging with rifles and bayonets, almost in the manner of drawings from the First World War, with a photograph of a tractor-driver. We see the smile on his face, and his steady gaze suggests he is looking optimistically to the post-war world when 'the good food, the exercise and the health of the soldiers' should become 'the standard for every citizen'.[18]

Of the weekly illustrated magazines, *Picture Post* had the highest reputation for using documentary style photography in the hope of speeding up social reform.[19] Photographs were always printed in rectangles and regular grids, eschewing all sign of interference and so seeking to enhance the connotations of realism, the claims to near objectivity and the truth of 'eye-witness'. This sobriety in design lent authority, which benefited the official version of events as long as *Picture Post* accepted it, but the same authority sometimes led to clashes with the Ministry of Information.[20] An example of the use of realism to criticize the conduct of the war, though extremely limited, may be seen in the coverage of the raid on Dieppe in 1942. This was an experiment in large-scale landings in preparation for an invasion of France. Six thousand troops were put ashore, and although they were severely beaten, the *Mirror* headline the following day was 'Big Hun Losses in 9 Hour Dieppe Battle'.[21] *Picture Post* had longer to reflect upon the significance of this raid, and some two weeks later used a photograph to hint at

the criticism which was developed in the text.[22] When the photo-journalist met the returning troops, he did not know what the editorial stance would be, and there was little chance of taking pictures that could have been used later to add weight to a critical point of view. He felt constrained by the presence of an Information Officer from the War Office, who could have confiscated his film if it had been obvious that potentially damaging photographs were being taken.[23] So he photographed a large group of soldiers which happened to include a solitary wounded man. *Picture Post*, had it wished to stay within the official perspective on this story, would have cropped this exhausted soldier from the photograph, but the magazine did the opposite: it placed him on the front cover because that choice suited its hostile assessment of the raid.

Despite this type of criticism, *Picture Post* usually stayed within the official perspective, which is greatly resistant to change. When other historians discover facts that run counter to the general official or public perception of events, and then challenge the taken-for-granted meanings of, for instance, 'the Dunkirk spirit', the popular version remains in place.[24]

After the passage of many years, when changing conditions produce the opportunity for new perspectives, new popular versions can gain ground. In this way, in the pacifist 1930s, the Great War was popularly represented as a waste of life and, more than forty years on, the idea of the Second World War as a 'watershed' in the social and economic history of Britain is regarded as a misapprehension. Basic structures remained unaltered: for instance, there was an increased desire for marriage and the family.[25]

Against revision and all political change, the mythic and popular versions of the war remain intact. The mythic history has advantages. It is uncomplicated by detail, and is therefore easy to grasp. As a public memory, it is given solid form in institutions such as museums. It circulates in folklore, in the scripts of newsreels, in films, books and (more recently) in television narrations. The myth is beyond the reach of academic historians. This fabulous history is not just immune, but active – it is able to scoop up disaster and turn it into the stuff of *Boys' Own* heroics. The American historian, Barbara Tuchman, writing with some distaste of British accounts of their military performance in Burma, said, 'No nation has ever produced a military history of such verbal nobility as the British. Retreat or advance, win or lose, blunder or bravery, murderous folly or unyielding resolution, all emerge alike clothed in dignity and touched with glory.'[26]

We are entitled to add pictorial nobility to the formation of war as glorious, because in wartime the authenticity of the photograph as eye-witness was used to reinforce the authenticity of the elevated or public version of events. From the official perspective, photographs were so realistic that, properly gathered, displayed and utilized, they offered an appropriate truth, a truth fit for public consumption,

designed to maintain morale. Photographic realism also offered other kinds of knowledge: the revelations and the associated power of reconnaissance and surveillance.

THE DREAM OF KNOWLEDGE

In the Great War the advance in artillery and other arms was a technical surprise which bore unexpectedly upon the movement of troops: they were forced to entrench on the Western Front because improvements in individual inventions and their combination enabled armies to see and hit their opponents, but not to move rapidly away from or around them. By the 1940s, further developments, especially in petrol engines and the conveyor belt production of machines driven by them, made artillery mobile and freed the armies from fixed positions. On the mainland of Europe the German army passed directly to the heartlands of its enemies, and for a time was so commingled with them that the front lines were fluid, and so in a sense unknown. The absence of a fixed front line, with troops dug in, made impractical the terror weapon of gas which had been greatly feared in 1930s planning. Then the capitulation of the occupied territories rendered it unnecessary.

With no army in Britain, perhaps the Germans would use gas here? In planning civil defence, gas masks were a symbol of dread from earlier times, but it was never used, and the fear misplaced. Similarly, a more secret symbol of dread – the issue to the local authorities of paper and cardboard coffins for the urgent disposal of perhaps a million dead – was based upon early and erroneous estimates of the likely number of casualties per ton of high explosive.[27] The planners had expected mass air attacks because of the improved capacity of modern aircraft to fly over the disputed territories and drop explosives and incendiary devices.

In the beginning air attacks were inefficient; and the effects upon the destruction of morale and industry were always matters of dispute. In the British raids over Germany of 1940–1, the number of 'enemy' civilians killed was fewer than the number of RAF personnel.[28] And though industry could be damaged it could never be wrecked. Following the first air attack on Germany in 1940, the post-strike reconnaissance photographs showed no damage at all, because the bombs had hit a Danish island.[29] Again, a secret report of 1941, based on a study of reconnaissance photographs of the results of British bombing, concluded that 'one-third of the planes despatched did not attack the target. Of those that did, only one-third got within five miles of it.'[30]

There were similar disappointments for the German air force over Britain, though with the blitz they added a completely new experience to the wartime terrors of 'the island race': it created unprecedented numbers of civilian casualties.

During the first two years of war there were more deaths on the home front than in the armed forces.[31] Overall from air raids and bombing there were 62,464 civilian dead and approximately 234,544 wounded and injured;[32] this has to be compared with 1,260 civilian dead and 3,490 injured in the Great War.[33] These figures of the comparative heavy loss of life at home become sharper when placed in relation to the (incomplete) losses for the armed forces in the two World Wars, which were published in the *Daily Mirror* in July 1945. The British and Empire dead were calculated to have been half those of 1914–18: 532,233 killed in 1939–45, compared with 1,089,919 in the Great War. Of these Second World War deaths, some 233,042 were said to be British,[34] whereas the figure for the regular army alone for 1914–18 was 445,629.[35]

From 1939 to 1945, the civilian population in Britain was engaged more completely than in any previous war. The planners were concerned to keep up morale on the home front. There were two main plans of action. The first was to minimize the effects of the blitz, and in this regard the censorship laws were crucial. The second was to break the morale of the German civilian population with blanket bombing. After the disappointments of 1940–1, and the uselessness of trying to destroy German industry, the targets were redefined. Improvements in aircraft design and (from 1943) new radio aids to navigation led not to precision bombing of military targets but to the mass bombing of cities in which the destruction of factories, services and communications was regarded as a bonus.[36] Lord Cherwell, a close adviser to Churchill, wrote him a memorandum in 1942 which began area-bombing: he said, 'Investigation seems to show that having one's home demolished is most damaging to morale. People seem to mind it more than having their friends and even relatives killed.'[37]

Loosening the definition of legitimate targets led to more photographs of sites before, during and after raids. A measure of the importance of photo-reconnaissance is in the number of people employed. In 1940 there were 206 Forces people working in the Photographic Reconnaissance Unit at Medmenham in Berkshire; by 1944 the Forces contingent working there had risen to 1,715.[38] These workers had to deal with increasing numbers of films and prints. The figures vary, but by 1945 the unit had probably produced a total number of prints 'somewhere in the region of fifteen and a half million'. At the end of the winding-up period in 1946, 'it was found that the Print Library still held some seven million prints and eighty thousand sorties covering vast areas of the world. The map section alone held a quarter of a million map sheets all relating to the war areas.' The unit developed a great bureaucracy to control and sort the flood of negatives, prints, maps, traces and mosaics. These were 'named after the subject: Army, Navy, Aircraft and Aircraft Industry, Airfields, Bomb Damage, Industry, W/T and Radar, Camouflage and Decoys. What could be termed "supporting sections" consisted of

photogrammetry, Models and Target material, the Print Library, the Intelligence Section and a Press and Public Relations Section.'[39]

This great library, with all its sections, was in itself no guarantee of efficiency: rather it was symptomatic of the need to know which stemmed from the integration of systems that was taking place throughout the war industries. Photo-reconnaissance, seeing into the enemies' strongholds, was just another sector of the technicists' dream of precision and control.

The possibility of new powers in machines that would outreach the destructive achievements of arms in the First World War, had begun with the second scientific revolution: this involved the theory of relativity, quantum physics, advances in mathematics and atomic research. In the early 1930s there was a recession in world trade, and these scientific advances were put to use slowly. It was not until the arms build-up of the late 1930s that 'research and development' was built into the cycle of production. It was the imperatives of a wartime economy that induced the systematic and purposeful organization of science and the acceleration of technological innovation. The results were seen from 1941 after the start of the total World War that engaged the economies of the USSR, the USA and Japan. They were effective radar, sonar, radio communications; radical innovations in surgery and medicine; the proximity fuse, calculators, encryption machines, the miniaturization of electrical equipment and the development of new electrical components, such as the photo-cell, which led to automation.[40]

Once the benefit of combinations of new technology was recognized, the power of knowledge would be raised to the nth degree. The interrelation of systems meant that photography, which was amongst the oldest of the technologies, could be enhanced, made more realistic, could offer up more knowledge, and so approach the dream of technical perfection. Developments in miniaturization and electronics had been used by the photographic industry, so that by the time the war began it was ready to speed up the production of new cameras and emulsions. There were new machines to produce 3-D effects more accurately, and faster, and there were new devices to produce lithographic maps of post-strike damage.[41]

The benefits of aerial reconnaissance sometimes proved decisive for the military, as in the discovery and destruction of German radar on the Atlantic seaboard two weeks before D-Day. At other times, the strategic results were negligible, as in the destruction of the Mohne and Eder dams in May 1943. This raid had other uses: effective 'before' and 'after' pictures were quickly released to the press. Early in June *Picture Post* used them in a spread on 'How to Read an Aerial Photograph'.[42] The story was not simply about spectacular destruction. It brought together boffins, heroes and civilians, whose pre-war holiday photographs had been 'used to estimate the thickness of the concrete, the superstructure of the dam, features of the landscape and the height of the water'.

The integration of systems was rapid and indiscriminate. No scrap of information, no visual record was too humble. As *Picture Post* said, 'even holiday snapshots' had potential use. Photographic interpreters were experts, and they had access to experts in other fields, in engineering as well as in various branches of the military. In reading photographs, these experts were gathering knowledge about the enemy at a phenomenal, exponential rate. In June 1941, after the Admiralty placed advertisements in the press, 50,000 amateur snapshots flowed into the official circuit of record and knowledge. Soon after, the request was broadcast on the radio, and there were 60,000 replies offering four million prints. These formed the basis of the Admiralty Photographic Library of amateur snapshots of topographic detail on the continent, which was known as Ground Photographic Information.

Picture Post,
5 June, 1943.

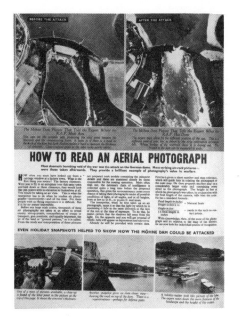

The flood of material must have been quickly organized, with an efficient system of filing and recall. The number of times the Library was consulted increased at a huge rate. In December 1942 it was used 5,650 times; in June 1943 it was used 64,300 times; in December the same year, as many as 176,100 times; and in just the first ten days of January 1944 it was used 125,000 times.[43]

These figures show that there was no essential difference between photographs obtained with sophisticated equipment from the air, and those obtained by amateurs on the ground. Photographs, any photographs, could be useful. They had only to be read, collated and cross-checked under the eyes of experts, all intent upon pursuing the dream of seeing and knowing the significance of everything.

The government was as interested in the practical application of photography as in the prohibition of censorship. Government action in requisitioning photographic goods and materials meant a lack for the High Street traders and their customers. At first sight, it seemed that this contraction in the photographic trade, especially in advertising photography and quality High Street portraiture, coincided with the general disruption of life due to the blackout, evacuation, tax increases and calls to cut out waste. After all, photography was a relatively luxurious hobby, and the trade must accept strictures in difficult times.

In many important respects, photography was also a very minor industry that scarcely warranted the attention of the government. The so-called 'concentration' of small industries, which was designed to free workers into the armed forces

(though it remained largely a paper exercise) in fact released fewer than a 1,000 workers. In the alphabetic list of minor trades that began with 'braces' and ended with 'umbrellas', the manufacture of 'photographic goods' was placed between the manufacture of 'pencils' and 'pianos'.[44]

Unlike the majority of small scale operations, photographic goods had an unusually wide specification and application. It was this usefulness that appealed to government. The limitations of supply and censorship which were placed upon photography as a private hobby were accompanied by an increase in the use of photography in every public sector of society. It infiltrated every aspect of the work of waging the war. Mention has already been made of reconnaissance, and associated uses in maps, plans, weather charts and official photographs for the press. In addition, the sense of danger accelerated the urge to record (and feel a sense of control) over parts of British life that might disappear. We see this in the work of the National Building Record, and the micro-filming of all manner of documents.[45]

Even these small concerns fell within the purview of government, for it was government that described the exemptions from the Limitation of Supplies.[46] By August 1941 photographers engaged in work that the Board of Trade agreed was of 'national importance' could obtain more film and paper than was given in the normal quota. There were three approved categories: firstly, those areas that were already controlled by local authorities, or were to be nationalized after the war, such as hospitals, education and public utilities; secondly, sections of big business or the professions, such as solicitors, insurance companies, banks and the engineering and manufacturing industries which used photography in templates, X-rays and radio metallography; and thirdly, those areas that provided information, namely the BBC, the British Council and the press and printing trades.

The increase in photographic activity was not felt in the newspaper industry, however, because the product was shrinking in size.[47] So the photographs that were published are of special interest as tokens of ideology. It was the newspapers that broadcast the knowledge of experts; but at the same time they appealed to the knowledge of their audiences, seeking to draw them into a consensus of what was significant. If 'seeing is believing', the public should also see something and feel they knew it to be true: in April 1940, soon after the German invasion of Norway, the *Daily Mirror* printed an aerial photograph and captioned it so that the viewer was privileged and placed imaginatively in the action: 'We are bombing Bergen below. When you look at the picture you're practically taking part in the raid – because you see exactly what the pilots saw from their cockpit.'[48] The secret world of intelligence was opened up for the delectation of viewers and, in a controlled way, was released into the illustrated press for purposes of persuasion. The shortage of newsprint and reasons of morale and security meant this outlet was severely limited. So the accumulation of evidence through photographs of one sort

or another continued at a pace greater than its assimilation or use.

The shadow of the state fell across everything, in an attempt to know and organize everything. The low-level technology of photographs meant they were relatively easy to gather. The volume of material in cabinets and on file testified to the faith in this work, and to the fear of overlooking something that might be useful. Since everything could be meaningful, nothing could be abandoned. The improved methods of accumulation and encoding of data registered these possibilities, but did not necessarily unlock the connections. The millions of photographic prints, and their doubling and redoubling in enlargements, illustrations, photocopies, lithographs and rota-prints formed a bewildering array of visual representation. These were filed away in archives, and though they were recoverable, the material and the archive were both intractable. The pictures had to be understood, and knowledge gleaned from them by specialists, whose memories and organizational skills enabled them to analyse the imagery for significance in traces, shadows, differences and disjunctures. The photographic archive, though useful, was cumbersome to unlock. The most recent developments in recognition were being pursued far away from photography in the language of cyphers, or in breaking the enemy's codes. The conundrum of finding meaning amongst too many possibilities was the exacting business of mathematicians working on the German Enigma machine, and cryptanalysis.[49] Machine intelligence, at this stage, could not encode pictures.

Since there was too much known already, a superabundance of knowledge, it scarcely mattered that the consequent mass (or morass) of photographs was mostly shut away in the archives. The great number of additions to the picture libraries was evidence of an horizon of knowledge forever retreating, never to be reached.

In a sense, the accumulation and filing of similar images was less important than the precise, and usually restricted uses to which a few photographs were put. In other words, the weight of pictures was ignored (perhaps it had to be) in favour of the propagandist uses of a few of them. This precision, as well as attendant difficulties, can be seen in the use of horror pictures in the press.

THE NAZI NIGHTMARE

Two conditions made possible the British propaganda story of 1917, when the Germans were said to have established a 'corpse-conversion factory' to reduce the bodies of their dead to useful oils. Everyone knew the Germans ran efficient railways, and the British believed (or wished others to believe) that the enemy applied logic rather than ethics to industrial warfare. By the 1940s, the historical conjuncture had changed: the trains were efficient still, but the war was to be fascist.

Whereas the trains of the First World War that passed from the Western Front to Germany were full of dead soldiers, from 1941 the trains that passed from Germany to the east, or through Germany from further west, or terminated in Germany itself, were full of the barely-alive, the soon-to-be-dead. The trucks held the old, the sick, the 'mentally defective', the gypsies, the homosexuals and the Jews, for whom the gas chambers were primed, and the incinerators newly fired.

The earlier, unrealized ambition that the remains of human beings might be recycled in the furtherance of the war was enacted in the 1940s, in order to cleanse Germany and its territories from 'degenerates', and to provide the 'final solution' to the presence of Jews in Europe. The division of labour now reached a conclusion that was perfect in logic and perversion: people who were not properly human at all could be immediately gassed, shorn of their hair and golden teeth and then burned; or if they could work, then they should be worked to death, introducing the cruelties of slavery into the heart of Europe. The normal, ordered wage slavery of industrial society was altered to make the work done less important than the deaths of the workers, who were themselves the raw material of the industry. The ideologies of racism and industrialism were united: capital was spent, with profit returned in the purity of blood.

A third and vital element in this conjuncture was the elaboration of bureaucracy that identified the people, funnelled them onto the trains, into the camps and out through the chimneys. Bureaucracy depends upon records, mostly in script but also in pictures. These records can be re-used in ways unimagined by those who first gathered the information. Hence the Allies used the Nazis' own records to condemn them in the trials for war crimes. This relocation of evidence was more than placing the acts of defeated enemies into the criminal courts of the victors. The acts of the Nazis were thought to be so barbaric that the trials had greater import: they were a declaration for world-wide consumption of the barbarity of fascism, a repudiation of its corrosion and the reinstatement of western civility and humanism.

A fourth element in this conjuncture, which is sewn into industry and bureaucracy as the publicity of good works, is propaganda. The propaganda value of the atrocities of the Second World War was at its greatest in 1941, when the Germans had overrun the USSR, and a pact with that country was possible for the Allies; and again in 1945, when the Allies sought from Germany an unconditional surrender.

In 1941 the *Daily Mirror* published a photograph of a woman weeping and the bodies of murdered Russians under the caption 'Her Hate Must Be Yours, Too', with the warning that 'If invasion ever succeeded in Britain, you'd see these pictures in reality.'[50] In February 1942, the *Daily Sketch* gave space to 'War pictures we have to print' of Russians being hanged.[51] These photographs were taken by Germans

and had been intended for their own purposes, which were now altogether obscured. In the British press these pictures became stark depictions of terror, devoid of ambiguity. In May 1945 the *Daily Express* held an exhibition of photographs from Buchenwald, Belsen and Nordhausen, and a Mass Observation survey of visitors recorded a variety of reactions that were all more or less angry and distressed. People felt sick, sought revenge, commended the wide publicity given to the death camps, accepted that the photographs were true evidence and said that the German people must have known what was happening. Some of the visitors said they had known about the concentration camps since 1933, and others had just heard of them – but none had guessed the scale or details of the crimes.[52]

Anger and revulsion were not always so clearly directed. The State Cinema in Kilburn High Street, London, showed a film of 'Scenes of Unbelievable Nazi Acts at Buchenwald and Belsen'. The advertisement said, 'See them – lest you forget'. But the angry reactions of some members of the audience, according to Mass Observation, were directed not only at the Germans but also at the British government, which 'must have known all about it'.[53]

One person placed the blame upon the media, probably not for creating the carnage, but for reproducing it too often, and thus inducing extreme boredom. People who had been horrified at first had now become hardened or indifferent, and were 'fed up with pictures of piled bodies'. A third reaction placed more blame upon the British authorities, and at the same time refused to believe in the systematic murder taking place in the camps. The Allied bombing of Germany, it was said, had so disorganized the country that there was bound to be a lot of starvation due to typhus and dysentery. Attributing it all to disease either spread the blame or even removed it from any particular group.

It was possible to refuse to believe what the Nazis did. One cinemagoer blamed the prisoners themselves for the way they looked. She claimed to be 'disgusted' by them, repelled by their 'cracked faces, sloppiness, skinniness and horribleness'. So that the apparently straightforward evidence of official films and photographs, screened in the cinema and hung in exhibitions with messages that nailed the Nazis to the dock, was not received with any unanimity of opinion.

The reason for this was a wide distrust of the news in the press because of censorship, which spilled over into a distrust of the purity of the evidence of cameras. In 1942 Mass Observation carried out an opinion survey amongst the people who attended an exhibition of photographs which included a section on atrocities. Someone said that there was no evidence that a picture was of a group of murdered Russian civilians other than its caption.[54] It is unclear, because of the episodic sampling techniques used by Mass Observation, how widespread was this scepticism towards photographic realism in relation to atrocity. Most people were horrified by what they saw, but there were dissenters.

The explanation may lie beyond the general mistrust of the press,[55] in the evidence of anti-Semitic tendencies in the British, hinted at by another respondent to the questions of the Mass Observation reporter. Although she was said to be atypical, her remarks were duly recorded: she wondered why so much publicity was given to this material now? She mistrusted the British government, and did not blame the German people as a whole. She had heard anti-Semitic talk here, and even felt something similar to the camps could happen in this country.[56]

An earlier report by Mass Observation, written in 1941, had already noted the casual acceptance of anti-Jewish feelings.[57] Recording the morals and attitudes of airmen, the author said that popular anti-Semitism was rife, and estimated that 40 per cent of the men on the air station had expressed vague or 'not-so-vague' hostility to 'rich Jews', as well as some admiration for Hitler who had cleared these people from Germany.

We should remember that the British antagonism towards rich Jews was not translated into death camps. Anti-Semitism was part of a groundswell of hostility towards the rich in general. A flight sergeant, who had been decorated, said, 'After we've finished with Hitler we can start on them [the rich].'[58] Whereas the volunteers of 1914–15 had packed their kitbags and 'smiled', content to fight for the restitution of the order of things as they were, the conscripts of the 1940s were unwilling to conceal their scepticism, at least, of 'brass and bullshit'. Along with that, there came a determination to seize the opportunity for a new post-war world. Churchill was regarded as a 'strong man' who 'stands up to Hitler', but he 'doesn't care much about you and me'.[59]

Against this background, and in the mixture of war-weariness and euphoria, perhaps we should not be surprised that doubts were expressed about government commitment to a new society, and about government propaganda on the essential evils of fascism.

This confusion was precisely what the propaganda had been devised to overcome. The demarcation between right and wrong, between 'them' and 'us', between the legal and criminal were supposed to be absolutely clear. The hope was that clear differences would mean that the post-war world would continue to be shaped by Churchill, who personified unyielding opposition to the fascists. That Mass Observation should have reported so much disbelief in Churchill's abilities to run the country in peacetime, so much disbelief in government propaganda, indicates that these simple demarcations were not acceptable as a basis for the future. People were not interested in hating Germany, and as a corollary raising up Churchill. Their priority was to defeat the enemy as a means to an end – the betterment of themselves and their families.

In this setting, atrocity propaganda was of marginal use. It could never be an engine for the maintenance of the status quo in Britain, or a locus for reparation

against Germany and its obliteration from world affairs on the scale envisaged in the settlement of 1918. Atrocity photographs were none the less useful in the furtherance of political objectives, although these tended to centre upon reprisals.

The unconditional surrender demanded by the Allies seemed justified once the death camps were overrun in the spring of 1945. The *Daily Mirror* translated this demand into '"Never Again" Fetters for Hun'.[60] In April the *Mirror* printed photographs of 'Heaped Evidence' – the five-foot heap of charred remains that were one day's produce from Buchenwald.[61] The newspaper followed this story over the next two days with more pictures from the camp, published first under the headline 'World Demands Justice',[62] and then 'Monument to Evil', which

Daily Mirror,
20 April, 1945.

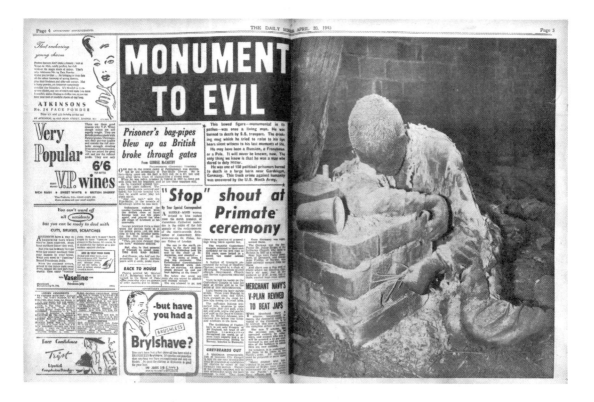

accompanied a photograph of one man among many deliberately burned to death in a fired barn.[63]

The photographs of the dead throughout April that year insisted upon the immeasurable evil of the Nazis, the sacrifices of those who opposed them, and British pleasure in the deaths of Nazis. On successive days the *Mirror* used

photographs of British MPs surveying the 'Huns' Crimes' in Buchenwald; the close-up portrait of a young Dutch woman who had been in the resistance and was now in her coffin (the headline ran 'Triumph, Death'); and a picture spread of what were police-style scene-of-crime pictures of the Mayor of Leipzig and his family, who had taken cyanide (the headline ran 'The End of the Party – Death').[64] The regular appearance of photographs like these, through rhythm and repetition, pointed the accusing finger at the guilty; and, in other cases, showed those to honour.

A photograph that the *Daily Mirror* published in May of a Japanese executioner beheading an Australian airman is perhaps one of the most complicated

APRIL 25, 1945

Triumph in Death

Daily Mirror,
25 April, 1945.

68

of signifiers in the category of atrocity.[65] The photograph offers all the voyeuristic pleasures of realism – the dramatic and appalling moment before the blow is struck. The moment remains there always, the sword always hanging in the air, never slicing through the neck, the man kneeling, not toppling, with ourselves as viewers always in that most sickening moment of waiting, never to be relieved of that anxiety of wondering about the Australian's repose, his final thoughts. As viewers of this photograph, we can never see what happened next, and are left to imagine it.

Being exciting and dreadful at the same time, the photograph has value as shock-news. It remains in this category because the caption gives the event greater import than the conventional thrill of morbidity. The words 'Lest We Forget' drag the picture into another frame of reference altogether: the archaic form of imperative is a memory of the Bible and the rhetoric of the First World War. At the same time as indicating the past, the call for revenge points towards the Allies' future relations with Japan – victory in the Far East was some three months away, and followed the use of atom bombs.

Daily Mirror,
18 May, 1945.

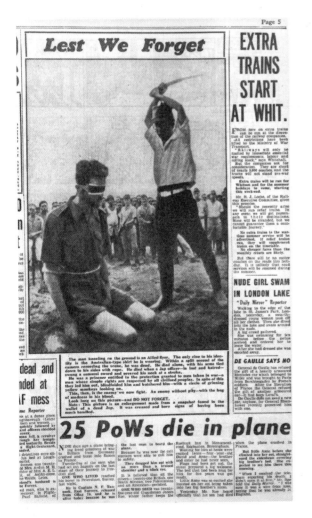

Furthermore, the caption describes the source of the original picture. We learn that the press photograph was an enlargement of a snapshot found in the wallet of a dead Japanese soldier – a trophy, and evidence of the enemy's barbarous habits. The horror is tinged with satisfaction at the news of the voyeur's own demise.

On top of this, the caption informs us of the condition of the photograph: 'it was creased and bore signs of having been much handled'. This handling and creasing is sufficient proof of the photograph as entertainment, a final mark of the barbarous. So significant is this evidence of handling that the picture seems to leave behind its conventional meaning in shock-news. The photograph had been taken as a celebration, had been much handled, and this in itself is worthy of remark, and forestalls any blame that might be levelled at the British press for

its part in further 'handling' the picture for the home mass market. Emphasis upon the picture as a private snapshot (rather than public window-on-the-world reportage), encourages the viewer to place the Japanese in the realm of taboo, where soldiers execute prisoners and take pleasure in it. In the British press, this snapshot demonstrates that the Japanese, on their own evidence, have shaken off the bonds of civilization. Even the manner of death is significant: it is the essence of the medieval – a pre-modern, machine-less execution, unseen in Europe for centuries.

The Japanese were represented as unusually ruthless, and their cruelty and unyielding ideology meant that they brought the horror of the latest weapons upon themselves. The power of the atom bombs would alone ensure their rapid surrender. Yet for the British public, the horror of Japanese swords was transferred to the bombs. A Mass Observation sample, recorded in August, noted the mix of public reaction to the news. Most people were horrified (62 per cent) and afraid (20 per cent); some were pleased (14 per cent), and a high percentage were indifferent (12 per cent).[66] At the same time, of those who commented upon the morality of this act (60 per cent), more than twice the number of people thought it was 'wrong' rather than 'right' (13 per cent as opposed to 6 per cent). Even so, the majority opinion (17 per cent) thought that the atom bomb was no worse than any other. Its use was justified for some (11 per cent) because they believed it would save Allied lives. Though the survey was taken at the time the news broke, it gave no more than a schematic picture of how people react to shock news: it revealed nothing about the bomb itself, since knowledge of its effects was severely restricted or simply unknown. The survey was a greater measure of attitudes before these bombs were dropped – beliefs about secret and awesome weapons, about the enemy and about ending the war. It measured war-weariness, ignorance, and wonder at the modern essence of power. It showed that if people have very little information, in this case no more than press descriptions of the devastation and photographs of a huge mushroom cloud, their opinions will be contained by earlier assumptions, contained by shock and then dissipated precisely because the information is so meagre. Given the opportunity to comment upon the claims of ends and means, some people (9 per cent) were able to express their unease, and say the Allies had now been reduced to the level of the Germans. This suggests that a significant percentage of the sample believed the bombings were unacceptable, perhaps even atrocities, though the survey allowed no room for this type of comment. On the contrary, the press held up enemy acts as atrocities and represented the Allies as establishing a new world peace. The first sight of the bomb clouds, reproduced from radio pictures on the front pages of Sunday newspapers on 12 August, was accompanied by news of the Japanese surrender.[67] The bomb, as an image and an idea, was replaced on the inside pages by representations of the peace it produced.

In the *Sunday Pictorial*, two photographs accompanied a biblical reference in the headline 'They Shall Inherit the Earth'.[68] The photographs depicted the innocence of children and the romance of pre-industrial agriculture. In this case the photographs of the English rural scene stood in for victory as well as peace over the whole world – whilst moving the sense of victory away from conquest towards the restoration of former values and the idea of inheritance. The editors separated pictures of the atomic cloud from their idyllic visions of the peace on earth: it was peace which irradiated the earth, not the bomb. When papers framed the news in this way, and the final enemy had surrendered, then it is not surprising that more people were either unwilling to see or unwilling to mention that deciding

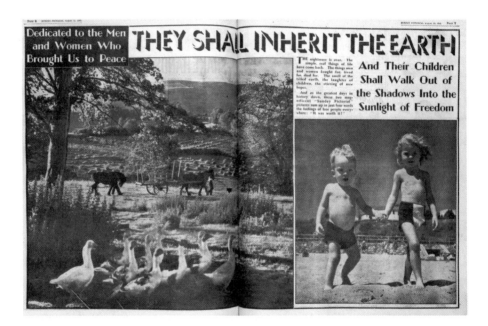

Sunday Pictorial,
12 August, 1945.

the morality of warfare is the prerogative of victors.

Despite news of war crimes, hatred of the enemy was tempered by suspicion of the government, and this scepticism can be seen in the reception given to photographic evidence of atrocity. It was both accepted and rejected by the British people, and was not always perceived in the ways that came close to the official perspective. People were either bored by it or did not believe it. It seems to have had little impact upon their support for the government, nor to have contributed to an implacable hatred of the Germans. Indeed, the photographic evidence of crimes, which was always released through official channels into a supportive press seems to have satisfied nothing so much as the propagandist urges of the officials.

Typically, they overestimated the capacity of photographic realism to move people wholesale this way or that. In using realism, the officials could never be certain of the results. The use of atrocity pictures for propaganda reflects on the officials, and points to their fears that the people might not unite against the common enemy, but create trouble on the home front. It also shows that officials understood the value of horror to the news industry, and saw a ready-made route and predictable framework for their messages.

THE DREAM OF COUNTRY

The disjuncture between the political systems of Britain and Germany was easily pictured in the favoured design technique of 'oppositional' layout. By placing side-by-side photographs of two contrasting scenes, it was possible to create a 'third effect'. An image of wealthy diners placed next to an image of a tramp scavenging in the bins behind the restaurant could be more ironic than either picture alone. Or a photograph of the subjugation of peoples under fascism could be unfavourably compared with freedom for Britons. In June 1940 *Picture Post* used 'oppositional' layout to demonstrate 'What We Are Fighting For'.[69] They were so certain of the power of the 'third effect' that they did not choose fascist brutality for the front cover but fascist narcissism; and this they compared with a young cricketer, the essence of grace and strength, Englishness in white.

Inside the magazine, one spread after another showed the regimentation of Nazi government. Hitler's command reduced the people to cyphers in a war machine. In contrast, the English were relaxed and responsible. Churchill was genial, the king was one 'who serves', and the people indulged their 'traditional enjoyments' of cricket, pub-sports and trips to the seaside. There was a single source for the values that the war was fought to preserve – and that was England: England 'where a man's home is still his castle, England where each one can work out his own life, England where it is still no crime to lie in the grass, to speak one's mind, to wear clothes instead of a uniform'.[70] The

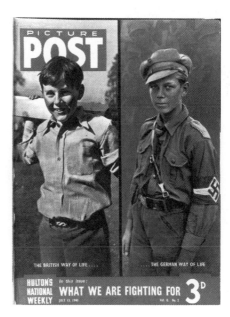

Picture Post,
13 July, 1940.

The ease of English life was in literal and not just metaphoric opposition to fascist regimentation. In addition, the fragmentation of English life was a virtue: 'the diversity of it, the chaos!' said George Orwell in celebration. He wrote:

> We are a nation of flower-lovers, but also a nation of stamp-collectors, pigeon fanciers, amateur carpenters, coupon-snippers, darts-players, crossword puzzle fans. All the culture that is most truly native centres around things which even when they are communal are not official – the pubs, the football match, the back garden, the fireside and the 'nice cup of tea'.[71]

The theme of 'unity in diversity' was diffused throughout English life, and thereafter through Britain, and was 'naturally' to be seen in pictures. By the 1930s, photographic emulsions were so improved that they captured more of the tones in a view of the landscape. Despite being black and white, photographs seemed more able than ever to represent the countryside in a faithful image. Since photographs looked like a reliable transcript of nature, they were put to work in showing and explaining the conserving purpose of the countryside. In photographs we see 'the rich man's castle and poor man's cottage' said *Picture Post* in 'The Land We're Fighting For' of 1942: they are both 'fitted snugly into our country's landscape'.[72] The heritage of the land is mirrored in the shape of ancient (and desirable) homes, and there seems to be no need to reconcile the contradiction between the collective urge of the race to retire to the countryside and the equally important privacy and exclusivity of country life. In a book published in 1945 we read, 'the average Englishman's dream is to retire eventually to the little place in the country, and to resume contact with the actual soil of England. It is this deep attachment of the whole people that gives to the English countryside its serene air of English well-being.' The 'orderly landscape' is not considered to be an achievement of 'political pressure or economic planning. It is an expression of the innate English sense of order translated from the individual self-ordered life of the people into the very face of England.'[73] The urge of the race is unmistakeably towards the rural – and if not to live there, then to see it conserved by those who may – for the rural in its pre-industrial aspects is the source of beliefs concerning the antiquity of the land and the reverence due to ancestors.

The popular author H. V. Morton who in 1927 had gone *In Search of England*, by 1942 had found that 'we have without realising it tapped the wells of satisfaction which had begun to dry up', and 'we' had done this by travelling back to breathe the 'atmosphere of the seventeenth century'.[74] The need to discover and photograph contemporary marks of pre-industrial order had long been a customary reaction to the modern world.[75] In 1930 in a book on *The English Scene*,

the author, R. Carton, had produced a characteristic list of 'simple monuments' that 'memorialise aspects of our national story'. These included 'windmills, watermills, canals, turnpikes, tithe barns, almshouses, whipping posts and stocks: they typify that unfeverish, but not uneager, way of life that men once had'.[76]

The 'unspoilt', pre-modern countryside had been well represented between the wars in such topographical books as Hodder and Stoughton's *King's England* series, Batsford's *British Heritage* and *Face of Britain* series, as well as in picture books, such as Odham's *The British Countryside in Pictures*, and the publishers Thomas Nelson's *English Counties*.[77]

By 1940 the taxonomy of the race, and therefore the necessity of war, was

Illustrated, 2 September, 1939. Courtesy of The Illustrated London News Picture Library.

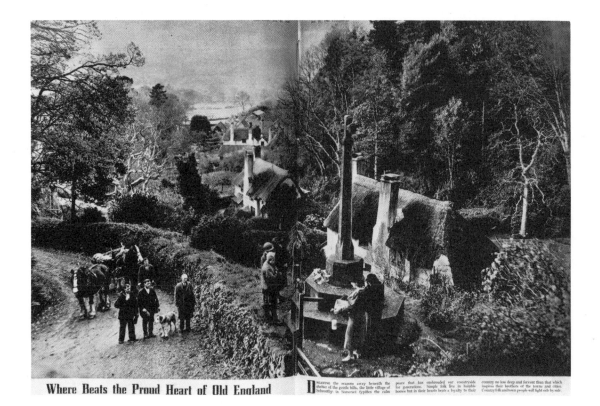

Where Beats the Proud Heart of Old England

BEATING the seasons away beneath the shelter of the gentle hills, the little village of Selworthy in Somerset typifies the calm peace that has enshrouded our countryside for generations. Simple folk live in humble homes but in their hearts beats a loyalty to their country no less deep and fervent than that which inspires their brothers of the towns and cities. Country folk and town people will fight side by side.

well understood. A soldier's song of that year, so it was said, reminded everyone 'There'll always be an England, Where there's a country lane.'[78] In *Picture Post*, in the same year, this England was typically represented in the rich downland and limestone regions of the south and west, reaching to Suffolk in the east and no further north than the picturesque 'Shakespearean' villages of Warwickshire. These

villages were the very heart of old England, and the picture spreads resonated with the benign institutions of schools and churches and the comfort of inns. The civilizing comforts of the southern and south-midland counties came from their access to the capital: those nearest to it were known as the Home counties. They were unmistakeably Anglo-Saxon, unlike western and northern regions which merge into the Celtic fringes. Moreover, unlike the wilderness of the north, which was also spoiled by industry, the landscapes of the south were domestic and managed. Interspersed and inseparable in this homely and ancient prospect were the memorials of the Great War – all of it together familiar and beloved, 'all just up the street, all just over the way'.[79]

The interest in topography and in the countryside was an index of new patterns in holidaymaking – and the readiness of the city-dweller to spend the weekend on the road, bicycling, walking, camping and caravanning. The war forced changes in holiday habits: more of them were spent at home, but at the same time more people were taking annual holidays of a week or more and long weekends, which began to spread the service industries across the whole country instead of concentrating them in the specialized resorts.[80] People were moving about more, movement for pleasure as well as enforced by the war, but when it came to looking at the landscape, or picturing it, they fell back upon standard types of representation. This was due less to prohibition upon open-air photography, and the scarcity of materials than the tendency to see 'England' in versions of pastoral.

In 1941, the annual exhibition of the Royal Photographic Society was opened, interestingly enough, by Colonel Moore-Brabazon, then Minister for Aircraft Production. He said, 'There need be no fear that photographers will contribute less to the national effort' because 90 per cent of the show 'conveys no suggestion that there is such a thing as a gun or a tank or a fighting aeroplane in the world'. Photographers were 'peacefully carrying on'. From the most seriously 'blitzed' cities in Britain came photographs of a zoo, a mill, a storm, a sea-creature and a misericord: 'this is the spirit of England, a country which fights none the less well – indeed, all the better – for its love of quiet valleys and rolling downs and mystic woods.'[81]

Even as the sense of idyll and peace was maintained, the forces pulling in another direction had to be acknowledged. In 1930 R. Carton had written of that 'unfeverish…way of life that men once had', and he went on to say, 'and might have yet again if they would be content to mark time by sundials and not by stop-watches'.[82] And *Picture Post*, in celebrating the pastoral, was attacking (amongst other things) uncontrolled industrial growth, private building, ribbon development and rural poverty: 'Britons love their country well enough to die for it', but 'do we love it well enough to prevent it being destroyed for profit?'[83] The people of the new age, the technicians, mechanics and skilled workers in the light industries, were

exactly the people who pressed, or caused others to press, upon the landscape. It was these people who seemed to worry George Orwell: they led a 'restless, cultureless life', he said, 'centred round tinned food, *Picture Post*, the radio and the internal combustion engine'.[84] These people seemed to have no attachment to the past, to the imaginary, to the native.

The photographs that were offered them in *Picture Post* should have allayed Orwell's fears, because they showed a deep attachment to the land, or recognized that the feeling was appropriate. In 'A Plan for Britain', *Picture Post* attacked those who let the land stand idle, and in contrast showed 'The Land of Britain as We Dream It'.[85] Typically, the dream could not incorporate modern agricultural machinery, but rested upon shire horses ploughing the fields in the time-honoured manner. *Picture Post* seemed to be looking in two directions at once: towards a planned future for agriculture, certainly, but a future drawn from the imaginary order of the past. The patriotic, wartime alterations to the land were not finally disruptive. They bore a recognizable and improving relation with what had gone before.

An ideal of the English landscape was preserved in the picture dailies. Unsurprisingly, in the search for respite from yet more photographs of military hardware and destruction, the popular press drew from the common emblems of romance. The government's plan to evacuate children, young mothers and others from the cities into the country towns and villages was a response to imminent air attack, and a symbolic transfer of innocence and maternity from urban damage into what the *Daily Sketch* called 'a rural fairyland'.[86] The problems of evacuation were not (or could not be) represented.[87] Instead, the papers began with the entry of children into village greens where they were pictured (in the *Mirror* and *Sketch*) celebrating their salvation in games of ring-a-ring-o-roses.[88] The children amidst 'rose-clad cottages' were enfolded in 'the peace and security of the countryside'.[89] The villages had become talismatic and redemptive.

In 1941, when the war was going badly for the British, the journalist C. Henry Warren claimed, *England is a Village*, and suggested that the landscape itself would refuse to be conquered: 'England's might is still in her fields and villages, and though the whole weight of mechanised armies roll over them and crush them, in the end they will triumph.' These miraculous fields and villages

Daily Mirror,
2 September, 1939.

were still intact that year; they were 'a dream that must be kept before our waking eyes',[90] and so it was in the picture press. In 1940 a headline in the *Sketch* ran, 'Mass London Night Raid as Goering Takes Over', but the rest of the page was a photograph of Shaftesbury in Dorset – a 'church tower, homely roofs, sequestered vale' which 'happily symbolised...the essential serenity of peace'.[91] The *Sketch* told its readers it wanted to 'take your mind off the war'. Two years later the *Sketch* (whose readership was older than the *Mirror*'s)[92] placed openly patriotic captions beneath some photographs of Suffolk and Wiltshire: 'The beauty of the English countryside that inspired England's sons, for God, and for England and for St. George'.[93]

Left:
Daily Sketch,
9 September, 1940.

Right:
Daily Mirror,
14 November, 1940.

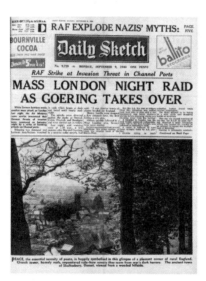

By 1940 the *Daily Mirror* was keeping a less-than-comfortable dream before the waking eyes of its readers. Its picture stories are more subject to the unreconciled forces of idyll and bombardment. They also look in two directions at once: back in time to the lost peace, and about them at the present experience of the people. In November, the *Mirror* published a picture story which suggested that the modern and still lovely countryside could be linked to the past in the poetry of Scott.[94] A photograph in the romantic vein, with hill, sky and horse, was wedded to the new iconography of soldier and gun; accompanying this were the deliberate archaisms of 'Breathes there the man with soul so dead/Who never to himself hath said/This is my own, my native land?'

The reader was not expected to remain at this exalted level, nor so deeply in the past: in its own voice, typically admonishing and peremptory,[95] the *Mirror* answered Scott's question with 'There doesn't. A nation has sprung to arms to defend it.'

The *Mirror* recognized two movements: firstly, the danger really did threaten the village, the deepest reservoir of Englishness. It used a photograph taken in a Kentish village of a frightened child clutching at the skirts of an air-raid warden, who 'says' to the child, 'I Won't Let Them Hurt You.'[96] Secondly, the certainties of village life were felt within the blitzed cities. They were said to be full of the 'New Yeomen of England' – the working class of the East End of London.[97] Maypoles were transferred from the greens and set up amidst the wreckage of Bristol, showing 'the spirit of the people' in the 'Heart of Britain'.[98]

Daily Mirror, 17 October, 1940.

The villages were intact in 1941, and remained so. In August 1945, the *Daily Mirror* proclaimed 'Peace on Earth', and pictured it with a village church and green, with girls dancing in a circle.[99] Pictures evoking ancient days, the gaze into the idealized English past, were standard practice in 1939 and again in 1945. The device of the rural scene suggested an unbroken line from the myth of the untroubled past into the new world. In sewing together the stories of 1939 and 1945, using the device of the pastoral, the editors seemed to suggest that either the power of the idyll had overcome the threat of fascism, or that because the idyll had not ruptured, nothing had happened. In either case, because the rural dream was untroubled by events and was essentially unmoving, it seemed that the present could be equally calm. Although everyone's experience told them something momentous had happened, through wishing it, through keeping the dream before their waking eyes, they might pretend nothing had happened. Perhaps time had stood still; perhaps there was no forward movement at all; perhaps, miraculously, time could appear to flow backwards, while people regained their composure and their sense of themselves as 'folk'.

By 1950, gardens and gardening were said to be national obsessions, indelible in British blood and race.[100] In the experience of the soil, people were seeking,

thout knowing it, what they had lost a few generations before. People discovered
emselves to be 'country folk at heart', who would 'dream of returning in later life
a cottage set in the garden'. More importantly, in so doing, they engaged in
the ritual discovery of their 'ancestors'. This was the purpose of the dream-work
in the garden, and could be extended over the country as a whole.

THE DREAM OF FAMILY

For some editors and readers, the perfected country scene was matched by the
representation of family life as equally harmonious. The idealization of this life was
a preserve against the experience of dispersal and mobilization, which precipitated
marriage and then divorce (which rose in 1947 to more than five times those
registered in 1938).[101] A danger to the ideal was the gap that opened in relations
between lovers. Service overseas created absences which were possible to number: it
was calculated that between 1940 and 1945 the years of life spent abroad by the
men of England and Wales totalled five million.[102]

These absences created a bigger market for portrait photography, or for
snapshots of loved ones; and these pictures reinstated the ideal. Many of the
men who were sent abroad had 'married early in the war service'. To help 'cut
the heartache and pangs out of
some lonely heart', said a letter in
the *Amateur Photographer*, 'chuck
landscapes and still life and exhibition
pictures for a while, and get the
fragrance of humanity and real
kindliness into your work....There were
long, distractingly long, periods' when
the soldier overseas heard nothing
from home, and then photographs of
his 'wife and baby' were a 'balm to his
feelings'.[103]

The author of this letter had
taken such family photographs, and
learned the pleasure they gave from
an airgraph sent from the Middle
East. Airgraphs were made by
photographing personal mail, which
so decreased the bulk of letters that
in this form an aircraft could carry

Daily Mirror,
18 December, 1939.

a hundred times as many. Kodak invented the process, and arranged with the General Post Office to process them at their Harrow works.[104] The first batch was sent from the Middle East in May 1941, and by April 1942 nearly ten million had been processed. Later that year the service had been extended to twenty-two countries and territories, and involved some seventy million messages. Each week more than one million airgraphs were sent from Britain, and a similar number received from overseas. One aircraft could carry rolls of film representing more than one and a half million letters.[105] Even better, by 1943 the airgraph was adapted to carry photographs. Through photography the messages and portraits were protected from the hazards of war, such as the destruction of the carrier: the serial numbers of the airgraphs were known, so if necessary they could be reprinted from the negatives held in store. In the few days between 27 November and 2 December 1943 over one and three quarter million airgraphs were sent, but 800,000 of them were lost when the aircraft carrying them were shot down. The airgraphs, however, were reproduced and arrived in time for Christmas.[106] It was as if the loss of the transport had never happened. In 1942 a flying boat was lost on a homeward flight, but because the airgraphs it had carried were reprinted, 'many thousands of people in this country heard from sons, husbands or fathers just as though no accident had occurred'.[107] Those who endured their portion of the millions of years of separation found themselves less lonely through this invention. From 1941 to July 1945 when the Post Office closed the scheme, some 350 million airgraphs had been sent.

In the Great War, photographs of families had been organized and sent overseas by the Snapshots from Home League under the aegis of the YMCA. In 1940 the League was reinstated by this Association,[108] and announced in the *Amateur Photographer*, which described again the procedure:

> the Y.M.C.A. organisation that accompanies the forces on all fronts provided the men with request forms for photographs of their loved ones at home; these forms were then circulated by the Y.M.C.A. among amateur photographers in every part of the country in the localities where the requests applied, and the photographs processed were forwarded to the men who needed them....And now that all fronts are one, at home and abroad, on land, on sea, or in the air, amateur photographers throughout the country once more could apply their hobby to a truly National Service.[109]

The *Amateur Photographer* published an enrolment form, and once again asked amateurs to provide prints free of charge.[110] The benefit to the photographer in the prevailing restrictions imposed by the War Office 'Schedule of Prohibited

Subjects'[111] was a continuous source of subjects that were anyway of greater human interest than landscape views.[112]

 Letters to the editor of the *Amateur Photographer* testified to the pleasures of the scheme as well as offering tips on how to deal with these 'strangers' – 'it is far better to make your calls in the afternoon, when the ladies are nicely dressed'.[113] The class tones of address of the earlier League carried across the twenty years between the wars: though the appeal emphasized the unity of the nation, it had also to acknowledge that owners of cameras were likely to be different from their sitters, or the families of 'those men', as they were called. Addressing the amateur, the advertising leaflet said, 'Man or woman, you can provide a human touch which may

Amateur Photographer magazine, 31 July, 1940.

well mean more to those men than gifts of cigarettes or other fugitive favours. You can send them snapshots of their own homes, or those near and dear to them.' The leaflet was 'now to be seen in every dealer's window', along with an 'attractive picture' of a young mother and child – as 'the soldier father will want to see how his baby son has grown while he has been away – the husband will like to know that his wife can still look cheerful – they will all cherish a photograph which shows its subject near and clear and happy'.[114]

 The amateur volunteers were reminded of the preferred limits of such portraiture: in the mode of advertising, the 'attractive' mother and son were an idealization. In their smart clothes and spruce appearance, the combination of

mother and son were objects of aspiration; they were not so much guides to the look of the camera-less clients of the scheme as an 'attraction' to persuade those who could to give their time and money. The advertisement assumed that the volunteers would have both time and money. This separated the photographers from their clients, and flattered them into association with the values of the poster. At the same time, the poster suggested an absence of class difference, or a levelling of class, and that the photographer would find the subjects to be essentially decent.

For some volunteers the expectation of levelling in the poster campaign was spiced with the excitement of difference in real life. Bringing together the camera-owning and camera-less classes was the promise of adventure. It might involve a long journey to an 'outlandish place'. On arrival, though, the photographer saw nothing alien at all: on the contrary, the people were 'the true gold of this country and to meet them does one good'.[115]

Amateur Photographer magazine, 9 April, 1941.

Instructions were given so that the photograph would come close to the ideal. It had to be 'homey', encompassing 'the brightly glowing range, the kettle hospitably singing, Dad with his paper, Mum with her sock, the portraits of the young soldiers on the mantelpiece...a scene such as the sons would instantly recognise as the essence of their home'.[116] The exquisitely narrow compass of types was a modern equivalent of the interiors favoured by the Victorians. The aim was to make something coherent and picturesque from the welter and ugliness of the particular. Some Victorian photographers combined different negatives in the darkroom to build up a picture: they did this partly because photographic emulsions were so slow that it was technically difficult to take complicated pictures indoors. By the 1940s, when it had long been possible to photograph the scene in a single shot, it was no less important to arrange suitable poses and symbols. Only, in modern times, the sentiment of the Victorian scene could fade before the immediacy and bathos of newspaper and sock.

The essence of home life was that nothing had changed: 'the garden is still flourishing, the apple tree thriving and the old log still waiting to be sawn up'.[117] This final detail was an acute observation, mindful of the speed of the call to arms,

with the promise that once the war was over there was the certainty of starting whatever had been left at the self-same spot. The emphasis upon sameness was, of course, directly contrary to experience, but the Snapshots from Home League was not set up to record difficulties in family life. Its purpose was to give continuity to events that were discontinuous, and which threatened to disturb the order of gender-typing, in which women did homecraft and men relaxed or took part in 'manly' pursuits.[118]

Though the photographer had the thrill of difference in the discovery of other styles of living and speech, the resulting picture was predictable.[119] Everyone expected this to be so – the servicemen who had requested the free snapshots, the sitters, and the photographers too. The 500,000 photographs specially taken by the volunteers and then sent overseas,[120] comprised a framework through which the war could be perceived and understood as the face of the family. In these half-million meetings of photographers and subjects, photographers and sitters each worked to make the accepted images of 'loved ones', reproducing a multitude of similarities.

The fascination felt by the photographers for these grateful people was occasionally recorded in their accounts, a fascination that emerges in the details of things seen in the kitchen or the 'living room', in what these people said and how they said it.[121] The visit and the differences were marked in life-style and language: even closer to home, in a bombed 'suburb of London', this other life of the camera-less classes could be observed amongst the terraces of the East End. The houses were described as in rows and 'exactly the same'. Once inside, the amateur volunteer noticed the pride in an integrated and almost elemental Englishness: the polish in the hall, the small back living-room, the children 'with great slabs of bread-and-dripping in their hands', and the tea poured from a 'china teapot with a rubber spout'. All of this was matched in the account with an attempt at writing their speech, so that it was colloquial, and therefore indicative of class; but it was stagey or stereotypical enough to be as fictive as the photography. The wife was supposed to have said, 'Very proud of his kids, Alf is, always showing 'em off to somebody or other, he was.' The photographer took the pictures of the family as it was, at the table, and imagined the husband receiving them. He saw 'Alf wiping the sweat and desert sand from his eyes to take a quiet peep at his wife and kids, having tea in the old home just as they used to do when he was there'. Then the volunteer saw the soldier come alive to the war and to his wife: Alf was made to say, in the comic tones reserved for jokes about strict women in the home, '"Gawd! If I don't knock these ruddy Nazis off the face of this ruddy earth so's I can get home soon there'll be an almighty ... row!" Good old Alf!'

The Snapshots from Home League had a mission to advertise the positive aspects of family life in a way similar to the use of BBC broadcasts to the Forces.

Indeed, the League was publicized not only in the press and photographic journals but also in radio programmes.[122] Each means of communication publicized the work of the other. A snapshot taken in the East End of London at the home of a corporal serving in the Middle East and published in the *Amateur Photographer* was the visual record of a family whose conversation was at the same time broadcast by the BBC. The caption to the photograph drew attention to the 'microphone on the tea table'.[123] In one sense, nothing could be more surprising, but here it was presented as homely.

Despite the publicity for the work of 'this helpful service', late in 1942 there were areas of Britain between St Austell and Perth where 'no amateur photographer has risen to the occasion and volunteered'.[124] The greatest indifference to the scheme lay in the big industrial areas where the families of most of the serving men lived.[125] The reluctance amongst amateurs to participate may have been due to the scarcity of photographic film, which had been severely limited by the Board of Trade.[126] Once the government had recognized the importance for morale of the family network, and the relative ease with which the ties could be maintained through radio and photography, the Board of Trade encouraged this scheme of 'national humanity' by releasing film to the YMCA for the use of volunteers. By the spring of 1943 the concession was said to have produced a tenfold increase in the number of free prints sent out, although it is not clear whether the increase meant a greater participation from amateurs in industrial areas.[127]

These materials and the publicity made the scheme practicable, though it could never approach the ideal of catching the families of every serving man and woman in the land. Nevertheless, the League continued its work throughout the war, and was not officially wound up until May 1946.[128]

It had stemmed from, and remained within, the ambit of middle-class patronage. In addition, its project was essentially bland, since it was the programmatic extension of the cosy view of family life commonplace in all photographic albums. Recalling this view in photographs should bring nothing but 'happiness and pleasure to the men who are defending the homeland'.[129]

Those who promoted such ideas were unable or reluctant to speak of the legal and political reasons why photography during the war was so restricted, and why orthodox representations of the family were politically useful. In 1940, the editor of *Photograms of the Year*, F. J. Mortimer referred to the 'almost total absence of the war theme' during 1914–18: he said, 'There is a natural revulsion at the ugliness of war, a desire to be reminded of the things of permanent loveliness which remain'.[130] Mortimer was also the editor of the *Amateur Photographer* throughout both World Wars, and this magazine, in selling photography to the mass market, publicized the benefits of family life as if they too were natural and obvious. There was no reciprocal mention of the family as contributing to the

buoyancy of the photographic trade.

Family life in the picture press was less constricted. The readers of the popular dailies expected hard news stories, laced with entertainment in the form of feature articles, letters and strip cartoons.[131] Registering the category of 'family' in the *Daily Mirror* meant inserting it into this mixture of fact and fantasy. And photographic realism was used to anchor the idea of family life closer to the experiences of the mass of people than could ever be discovered in the conventions of the album and the Snapshots from Home League. At the same time, realism was firmly harnessed to patriotism.

In the *Mirror*, the experience of the mass of people is a story of disruption.

Daily Mirror,
9 September, 1940.

The examples are numerous, but cluster around certain types of disintegration, such as conscription, mobilization, evacuation and the effects of bombardment on housing.[132] None of these scenes, no matter how disturbing they may be, means the dissolution of family life. The opposite is seen to be the case – the harsh realities of war, such as breaking up the home, are seen as releasing the older sense of community that in the folk memory had bound everyone together.

The *Mirror* covered the aftermath of an air-raid and said the bombed-out Londoners had 'taken it', 'with chins up'.[133] The caption to the photograph emphasized the capacity for pulling together:

> Typical of the kindly East London, this picture could have been repeated a hundred times yesterday. The woman on the left and the girl third from the right live in the house you see in ruins across the street. Into her home, windowless and deep in debris, Mrs Bidecant (serving dinner) took the family. The two housewives built a fire of wood and coal, gipsy fashion, in the basement, roasted beef, boiled veg and served a dinner beneath a hanging ceiling to their families. That was the spirit of London in the raid. They carried on...in a grin-and-bear-it mood, each helping the other.

Daily Mirror, 28 February, 1941.

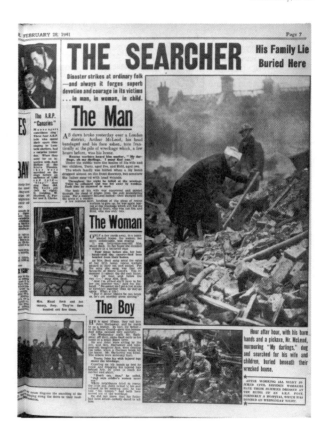

In representing an exemplary response to bombing, there was no room for images of night-trekking, when, in anticipation of air-raids, thousands of people decamped from the cities of Plymouth and Liverpool, for instance, into the surrounding villages and countryside. Nor was there room for pictures of emigrants bound for America. It was the role of pictorial realism to advertise steadfastness. In November 1940, after the devastation of Coventry, and when government intelligence reports described the people as demoralized,[134] the *Mirror* pictured the scenes of ruination, but captioned them with the uplifting message of a city keeping faith, a city which went on working.[135] Carrying on regardless was a necessary and typical refrain, as were the stories of lucky escapes.[136]

The *Mirror* did not baulk at stories of death. In 1941 it carried a photograph of a man who had lost his young family.[137] Headlined 'The Searcher', it showed him scrabbling amongst the wreckage of his home, searching 'hour after hour, with a

pick-axe and his bare hands', murmuring 'my darlings'. Affecting as the scene is, especially with details in the text naming the man and letting him 'speak', it is not of misery alone, but misery joined with courage, which somehow redeems the hopelessness of the situation. 'Disaster strikes at ordinary folks', said the caption, 'and always it forges superb devotion and courage in its victims.' Such loss is sad, but it is not meaningless. Of course, in picturing death at all, or its effects, the *Mirror* placed itself outside the family album, which traditionally avoids death altogether.

Love is represented in the album, but in a restrained, muted form. Similarly, and not surprisingly, love takes on a proper, decorous face in the press – often reduced to scenes of union and parting as emblems of the most poignant moments.[138] These moments are bearable only with the hope of their ending, with the promise of a renewal of the old ways, though in a world shaped by victory. The new setting for traditional family life was discussed and represented in the *Mirror*, and encompassed, amongst other things, full employment, education and health.[139] As the war progressed and drew to a close, these promises could be meaningful only if families were quickly reunited, and so there were calls for, and pictures of, the swift demobilization of the Forces. More magical, but not unusual, was the picturing of 'lost' soldiers who had returned from the grave to their wives and mothers.[140] Missing from the family album, and disregarded by the press unless they satisfied the criteria of newsworthiness, were tales of forbidden love, infidelity, and sex outside marriage.[141] These experiences had various effects, but could not become part of the publicly expressed delight in close family life.

That separation and even death would continuously break in, and break up families, was the fear and experience of millions of citizens. The atmosphere of dread, the sense of foreboding that too often was made real in postings overseas or the receipt of official messages of regret and sympathy, was also too defeating of both the sense of self and of community to be allowed full rein. Fear had to be removed to the edge, and the centre held with messages of hope. A measure of this need, and of the drastic times, is that often the uplifting messages in headlines and captions accompany photographs of great material destruction. These captions seek to shift the realism of the photographs away from the paradigm of despair. To do this, they pass through anger to pride, seeking out that 'bulldog' tenacity that encouraged the people to believe that through force of will they could take fascism and crush it.

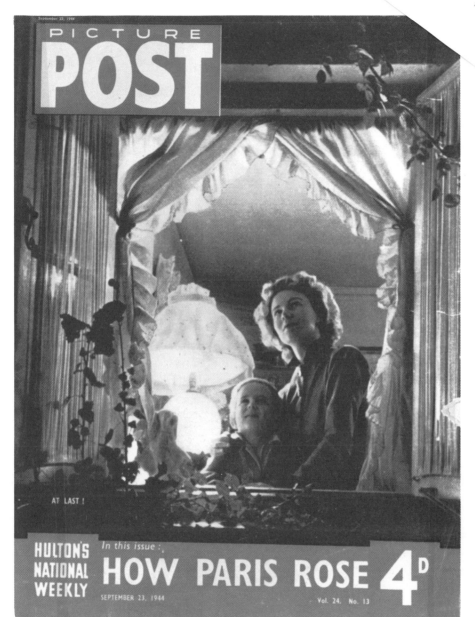

September 23, 1944

PICTURE
POST

AT LAST !

HULTON'S
NATIONAL
WEEKLY

In this issue :

HOW PARIS ROSE

4D

SEPTEMBER 23, 1944

Vol. 24. No. 13

4

THE FALKLANDS CAMPAIGN

'HANDLING' THE MEDIA

In the struggle of 1982 to recapture the Falkland Islands from the (fascist) Argentinian invaders, the legendary events of 1939–45 were points of reference for a military solution to a political crisis. Though much time had passed since 'the last war', nostalgia for it could still bathe the Falklands issue in that clarity, a clear separation of right and wrong. What a few people felt to be a disproportionate reaction (the despatch of the Task Force), for the majority took on the fervour of a crusade.[1] The legitimacy of the action was assured because the armed forces were sent against a foreign enemy who had seized territory no less sovereign because it was distant. British might was set with purpose against the resurgence of iniquity.

Once the Argentinian battleship *General Belgrano* was sunk, victory or defeat in the military campaign was the heart of the matter and decided the fates of the Argentinian and British governments: General Galtieri fell from office and was put on trial, while the Conservative Party was returned to Parliament with a massive majority, in part a vote of thanks from the public for saving national pride. For operational reasons the military commanders needed secrecy, and this suited the two governments, both of which 'handled' the media. In Argentina, there was a wide gap between the actual war and the reported war, so that the military defeat came as a shock to a nation which believed itself to be close to victory. This disparity of fact and reportage was commented upon in the British media: it was used to underline the ruthlessness and cynicism of the fascist government towards its people, and by contrast to highlight the respect of a democratic government for public opinion.

Yet the actual war, as experienced by the British Force, was equally unavailable to the British media.[2] The constraints on reportage arose from a mix of technical difficulties, deliberate exclusion of journalists for operational reasons, and

censorship. Moreover, there were constraints on documentary realism: the government and military authorities were afraid of its potential effect on home morale, as they made plain in the official reports published in the aftermath of victory.

The conflict of interest that always existed between the newsmen and the Forces was resolved so overwhelmingly in favour of the military that the press, increasingly frustrated, concluded that the government did not want the war reported. Correspondents were uneasy with the extent and machinery of censorship. Once the campaign was won, they were able to express their disquiet to the Defence Committee of the Ministry of Defence (MoD). The aim of the

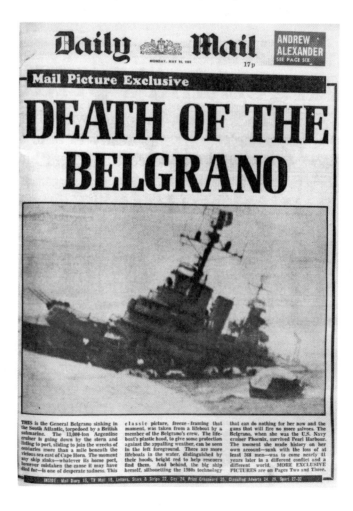

Daily Mail,
10 May, 1982.
Courtesy of Mail
Newspapers PLC.

Defence Committee was not to mollify journalists, but to clarify the rules of censorship and the place of the media in military planning for future wars and the future framing of morale on the home front.[3] It published a lengthy report on 'The handling of public and press information during the Falklands conflict'. With similar intentions, there was another report by the Ministry of Defence Study Group on Censorship on 'The protection of military information'. These reports were followed by the government's replies to the recommendations of the Committees.

The MoD submitted a Memorandum on Information Policy to the Defence Committee. It was anxious to show that there had been the 'fullest possible flow of information compatible with the overriding dictates of national and operational security',[4] and the protection of the lives of servicemen and women. Opposition to this official version has centred upon the management of censorship, or upon questions related to the transmission of television pictures. Of all the systems of reportage, the least considered has been photography.[5]

Although the MoD controlled the release of photographs, it could not dictate to the press the particular uses to which they would be put, nor did it need to do so. The press was starved of front-line photographs for much of the war: it lasted 74 days, 'and for the first 54 there were no British pictures of any action'.[6] The press was anyway engrossed in its own practices and expectations of warfare, and used home-front photographs: these were crucial to the theme of unity. It is the separate but related roles of the government and the press that we shall now review.

CONTROL OF THE WAR AS TEXT

At first the aftermath of the Argentinian invasion was a confusing scandal; then it became an occasion for righteous indignation and finally produced the exemplary gathering and despatch of a liberating force (all grist to the media mill). Then the war was lost to sight and sound as the fleet sailed south. Once the liner-turned-troopship *Canberra* had joined HMS *Hermes* and HMS *Invincible* at Ascension, twenty-eight all-British journalists were in the armada (two returned home at this point: a TV engineer who was ordered home by ITN to cover the Pope's visit to the UK, and a news reporter who was taken ill and replaced by another). There were sixteen press reporters, two radio reporters, three TV presenters and five crew, and two photographers.[7] They depended for their communications on the Armed Forces who controlled them. They were sometimes aided and often thwarted by the five Press Officers (known as PROs or minders) from the MoD who vetted their copy, and censored it for military details. They were not to censor for style or tone, though the military censors sometimes did this.[8]

Normally, censorship at the front or in London excised every detail that might conceivably endanger operational security, a procedure that was either too zealous or too inconsistent for the journalists. In addition, they were writing text with officialdom in mind so they had to practise self-censorship. Such speaking and writing formed most of the reportage of the war. Six hundred despatches and half a million words of written copy were transmitted from the Task Force.[9]

The secure lines of communication between naval carriers and Britain were largely for military use and military language. Journalistic speech and writing, though not prohibited, was effectively blocked: the inaccessibility of transmitters, the priority of military signals, the encryption of copy, and the time taken to

Daily Mail,
6 April, 1982
Courtesy of Mail
Newspapers PLC.

Daily Mirror,
21 April, 1982

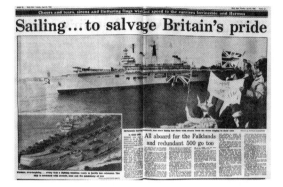

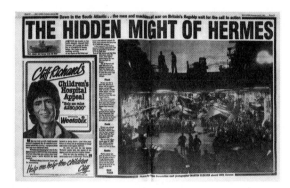

transmit them meant that reports were in danger of becoming Dead Sea Scrolls. The vetting by minders also delayed texts and altered them, sometimes in trivial ways that infuriated the journalists.

Once copy had been censored it could be transmitted more quickly on the commercial marine satellite facility (Marisat), which was not secure and so the terminals were fitted only to auxiliary vessels. The memorandum from ITN to the Defence Committee said that without Marisat the 'war would have gone unreported'.[10] To reach the terminals the journalists had to undergo the hazard of cross-decking, or flying by helicopter from carrier to auxiliary and back again. The *Daily Express* correspondent, Robert McGowan, said that without the helicopters, the journalists were 'just one step up from using a man with a cleft stick', like ancient messengers.[11]

Another inhibition was the separation of the journalists from each other and from the front line. Although ten newsmen from *Hermes* and *Canberra* went ashore with the landing troops, the five press correspondents on *Invincible* were transferred to the Royal Fleet Auxiliary vessel *Resource* which was carrying ammunition and stayed off-shore until the ship sailed into San Carlos Water (also known as 'Bomb

Alley') to unload its cargo. After four days their minder found a helicopter to take ashore the four who wanted to go (one stayed on board for one more day to use the Marisat and report the action at sea); but, denied the kit they needed to survive on the Falklands (they had no sleeping bags, camouflage clothing or rations), they were rounded up within a day and sent out to sea on a landing ship, the RFA vessel *Sir Geraint*, where they were joined by their colleague from *Resource*, who had made an unsuccessful attempt to get ashore and remain there. The *Sir Geraint* had no Marisat, and the journalists had no access to information or means of communication for another eight days. They finally went ashore two weeks later.[12] From the journalists' viewpoint, it 'would have been difficult to imagine a better piece of mismanagement in the arrangement for coverage at the height of the war',[13] but the arrangement suited the military and the MoD, and was entirely consistent with the low priority afforded to the media. There were only sixteen or eighteen of the twenty-eight journalists ashore during most of the war.[14]

Once there, the signals companies set up communication terminals but the journalists had no access to them. Their voice pieces and copy had still to be sent via Marisat. A despatch would be written from pooled experiences, and the copy taken to the terminal by a journalist or given to a pilot. Often copy was lost or overlooked due to the pressure on officers or minders, or perhaps because of rivalry amongst the writers.[15] So the oral and written account of the war was hard won, squeezed through a series of gates, some depending on the force of law whilst others represented the daunting force of circumstance. Journalists either could not always say what they had seen, or could not see anything much at all.

CONTROL OF PICTORIAL REALISM

The Defence Committee said 'there was an unfortunate impression that had the MoD wished it to happen, television pictures could have been available'.[16] But independent observers said it 'required no human conspiracy to prevent the transmission of television pictures of the war: the technical problems alone conspired to take care of that'.[17] To transmit even black and white pictures via the terminals on carriers and the military satellite would have closed all navy communications for half an hour, an unacceptable military risk. And to stay within the 'footprint' of the satellite, a naval ship and escort would have had to leave the fleet as it sailed on from South Georgia – again, an unacceptable risk.

There were two other possibilities of television transmission. The first would have required that the USA tilt its military satellite to move its 'footprint' from the surveillance of Central America to cover the Falkland Islands. The response to informal approaches was so negative that no formal attempts were ever made.[18] The

second involved the use of a US commercial satellite system which was too big to store on the decks of the carriers and, at a million pounds, too costly for the MoD or the television networks.[19]

Government was absolved of active conspiracy against the medium because sending television pictures was technically difficult, and there were no satellites for reasons of cost or international politics beyond its control. Nevertheless, the MoD was relieved at the lack of television pictures, which forestalled the laborious business of censorship and the arguments that might ensue from accusations of political motivation and management of news to conform to official views on matters of 'taste and tone'. A constant flow of television would have created 'problems of what could and could not be released', which 'would have been very severe indeed'. The degree of criticism from the media was 'a small drop in the ocean compared to the problems we would have had in dealing with the television coverage'.[20] Since the MoD was bound to be criticized by the media whatever it did, it was simpler to have fewer pictures than to become embroiled in their censorship.

The Secretary of State for Defence, John Nott, was asked whether or not the censorship of film should take place at the front. He thought it was better to have no pictures at all. He said, 'If the television cameras are there, there is not going to be a "minder" who makes sure they put themselves in the right position. If cameras are there they will take pictures of the realities of war': ... 'then the sheer task of running through every film that was taken and censoring gory details out of it would be impossible.' Realism was a quality of television pictures and realism was bad for morale. He said, 'If you had television [coverage] a lot would be shown that would be distressing to families and would be upsetting to morale.... If you cannot stop television being transmitted, this is something you will have to live with.'[21]

In the Falklands there was no direct transmission, and the film that was shot was very much delayed. Still photographs of the British Forces' repossession of South Georgia were held up for twenty-three days, as was film of Pebble Island. The shortest delay of nine days was for film of the shelling of Port Stanley, and that was from an Argentinian source.[22]

Another device was to keep television crews away from the front. The crews on *Hermes* were 'forbidden to leave the ship for about ten days or so after the landings had taken place',[23] and the three ITN crew on *Canberra*, once ashore with the initial landings, had a 'long wait' of about two weeks for their unit which was still heading south on the *QE2*.[24]

The fear of the power of television pictures in particular was informed by a more general fear of realism in pictures, which had a direct bearing upon the production of still photography. The Task Force sailed with no commercial facilities for transmitting black and white photographs. Some six weeks later the two press photographers had been able to return just two batches of pictures to London. This

material was shipped to Ascension; and because there was reported to be no darkroom on the island to develop the prints for wiring, they had to be flown to Britain.[25] Only three lots of photographs were received at the Press Association before the Falklands were retaken in May. Then two ships with terminals were brought forward for the first landings. One photo-journalist went ashore at this stage, but the other 'had no landing facility for approximately twelve days after the initial assault', having been told there were 'enough press ashore', and (erroneously) that his editor had agreed he should stay on board ship. His task then became to 'develop, print, edit and wire' the photographs that the service photographers and his colleague sent back.[26]

Yet the number of pictures received was 'never more than a dribble'. The 'appalling service' surprised even the minders, one of whom said 'there are hordes of photographers down there but we are just not getting any photographs'.[27] The hordes of photographers were servicemen attached to each unit and their work was released to the newspapers, but mostly seen later in the pictorial histories of the war and in postcards. They took anodyne photographs of military hardware and celebrations of professional forces in control. In all, the number of photographs transmitted was only 202.[28]

The memorandum by the *Scotsman* noted that many photographs were sent back with 'apparently unequal speed'. The Defence Committee quoted this assertion directly in order to rebuff it. It repeated the journalists' view that 'as the conflict wore on, bad news was taking far longer to come out than good news, presumably in the belief that the effect would be dulled'.[29] The journalists had claimed 'that it wasn't simply chance that the celebrated picture of San Carlos villagers offering a marine a cup of tea achieved such instant currency',[30] whilst the photograph of HMS *Antelope* exploding[31] suffered a delay of three weeks.[32] It seemed to the *Scotsman* that the war was being deliberately 'sanitized'.[33] The slow emergence of bad news and of pictures seemed to be a matter of policy, an extension of censorship by other means. In his interview before the Committee, the defence correspondent of the Press Association, Bob Hutchinson, said that journalists were told by the Prime Minister's Press Office that 'Number 10 felt that enough bad news pictures had come out.'[34]

The media said the MoD had grossly misled the people. The Defence Committee dismissed this accusation: the claims were 'flimsy', 'not convincing', or 'only very thinly substantiated'. The Defence Committee was equally sanguine about the manipulation of opinion, stating that 'it would be easy to argue that such a cushioning of bad news was a legitimate means of sustaining public morale in the circumstances of the conflict'. When journalists complained of news management for political motives, they were told by the Defence Committee that the recapture of the Falklands was arguably an agreed political objective. Or when they

complained that narrower party rather than national interests were being served, the Defence Committee accused them of being too innocent: it would be 'naive to suppose that the government could have wholly dissociated in its mind the successful prosecution of the conflict from the party advantage which might accrue'. At the same time, the Committee argued that 'allegations that news was released during the campaign on this crude basis have never carried great conviction'.[35]

What took place, as far as the Defence Committee was concerned, was nothing so crude: 'the media's readiness to jump to conclusions and to look for machiavellian rather than simple explanations for decisions has affected the quality of their evidence.' This, in its view, made the evidence easier to discount. The

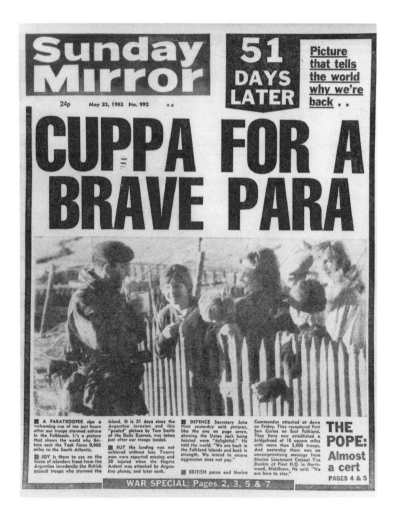

Sunday Mirror,
23 May, 1982.

absence of factual evidence of conspiracy to mislead, or even of news management, allowed the Committee to admit to the lesser fault, which it clearly felt was no fault at all, of 'media handling', massaging the news to secure not truth but victory. The Ministry had felt justified in allowing very few journalists at the front, and then delaying whatever the censors passed. Referring to the misleading information given to the press on the landings at San Carlos, Sir Frank Cooper, the Permanent Under-Secretary at the MoD, said, 'We did not tell a lie – but we did not tell the whole truth.'[36] The Committee endorsed this conduct: it said even 'misinformation is not a practice which should be deplored ... unless its use can be shown to be counter-productive in terms of ultimate operational success'.[37]

DEATH IN THE FORCE

The battles were similar to those of an older pattern in which military force was pitted against itself and did not cross into the world of civilians. In this case, the British press regarded the effectiveness of the Argentinian forces to be compromised by the corruption of the Junta. In contrast, it attached all chivalry and honour to the Task Force. Despatched with none of the unfortunate connotations of the title 'overseas expedition', but represented as a retaliatory Force entrusted with a mission, the British were the very model of efficiency and discipline. This was signalled in the constant picturing in the press of the hardware of war – the planes and the ships – and of paratroops and commandos as hard men, 'the elite and deadly loners who strike out from a secret world';[38] or as Action Men, who included the most famous of them all, the Royal Prince, 'Action Man Andrew'.[39]

The press represented the Task Force as an efficient unit, but in keeping with its normal practice of centring stories on human interest, it looked for individuals to emerge, for whatever reason, from the generally faceless Services. In contrast, the British government wanted to emphasize the idea of teamwork in the Force. Still, this does not explain government's reticence about the fate of individuals. For operational and political reasons, both the Argentinian and British governments were occasionally vague about numbers of dead. This vagueness was temporary in the case of the British casualties at Bluff Cove, when British officials circulated to the press exaggerated rumours of 750 (and not the actual number of 50).[40] The government intended the rumours either to mislead the enemy, or to soften the eventual blow to public opinion at home. This is what the Defence Committee accepted as the justifiable 'handling' of the media.

On the other hand, the Argentinian authorities were consistently vague about their losses. What had been an operational ploy by the British government, and of limited duration, was contrasted with the cynicism of the Argentinian government,

who were reported to have criminally misled their people into believing they were about to win a famous victory even when they were on the point of defeat.

While the Argentinians were considered to be careless of individual life, the British press greeted death in the Force as heroic sacrifice and the essence of enterprise. Individuality might have to be subsumed in a fighting Force, but when death broke up the team it released these unknown hard men into a second system of meaning: the acceptance of death in the national cause (rarely voiced but anyway implicit in enlistment), turned individual members of the Force into heroes. In this process of dying in war, they moved from being the nameless members of a team to a place of invincibility when their names were entered in the Roll of Honour.

This transition from nameless to named, or invisible to seen, was not instantly achieved by each of the victims of the fight, nor evenly bestowed on all the dead. Even naming and numbering them was a business fraught with military and political implications, though what the press published was in line with their everyday practices. The solution evolved from the normal procedures and expectations of the press in matters of warfare, nationalism and human interest.

Denied any access to the battlefields at all, and then denied pictures of them, the press – especially the tabloids – had the problem of keeping up interest. The war was rapidly becoming an overseas story, taking place at an ever increasing distance, with military routines disrupting the routines of news gathering. In response, they anchored their coverage to the home front, telling the story of the Task Force as if it were the story of a family. Reporting the deaths of servicemen now involved an unusual emphasis on bereavement and grief within the families. This solution resolved the problem of the absence of front-line photographs, and brought the war within the compass of family life.

However, the standard forms of irony, pathos and 'tragedy' in human interest stories were unsuitable to the war. This, after all, was an endeavour sanctioned in the name of the Queen. Death, like the reign of the Monarch, was glorious, and glory had a long association with military history: the two came together easily, as in the *News of the World* headline 'Death and Glory of SAS in White Hell'.[41] Though a stock phrase, the unity of death and glory moved private individuals to an exalted level of service, where their loss had national significance.

It was important to officials that such language as this, with its tendency towards noble sentiments, should not be spoiled by unfettered realism delivering pictures of the dead looking anything but glorious. Photographs of British corpses, from the official perspective on documentary realism, would have unsettled confidence in the texts about the value of the dead. Loss of life had to have meaning, and its public image was of heroic death 'in action'. Most relatives had no means to dissent in public from this rhetoric. The few awkward ones who refused to accept that death was worthwhile in this national cause were largely

ignored. The power of consensus and the authority of official versions of events was proved by one family in particular who put it to the severest test. They refused to accept the explanation of their son's death 'in action'. They pursued the authorities for years, eventually forcing them to reveal the actual circumstances of his death. In the process they stripped away the patriotic rhetoric, exposing the raw waste. In 1988 the *Guardian* said 'an inquest verdict that an army helicopter pilot died "as a result of enemy action"...was quashed by the High Court yesterday after the judges heard how the aircraft was shot down in error by a Royal Navy destroyer'.[42]

During the conflict, the euphemism of 'killed in action' was convenient. At that time, especially, military deaths could not be prised from their public meaning which admitted no error, and gave little room to dissenters. Whether their voices were heard depended on the editorial stance of each of the newspapers. For example, the *Daily Mirror* had more reservations about the war and its conduct than the *Sun*, and these could be signalled in the choice of front-page design and the use of pictures and text. This is evident in the way the two papers displayed the news for 6 May.

The *Daily Mirror* on its inside pages, reported contrasting remarks by parents of two of the dead – a pilot 'who had died doing a job he loved for the country he loved', and a cook who 'never joined the Navy to die for something as wasteful as this'. At the same time, the *Mirror* showed other conflicts of interest and interpretation in its three-part front page. One headline ran, 'For God's sake, are our men alive or dead?' This referred to the destruction, on 4 May, of HMS *Sheffield*, and drew attention to the fears of families and their anger at the delay in releasing information. Another headline, '2 A.M. – Junta agrees to U.N. peace plan', referred to urgent diplomatic moves and offered the hope of an end to the fighting. The third text, which was the caption to the only photograph, said, 'Outside No. 10 where last week she was saying "Rejoice" Mrs Thatcher shows the strain of desperate days'.[43] Placing the photograph of the Prime Minister (looking worried) among these stories suggested she herself was at the centre of several types of conflict.

On the same day, the *Sun* used the front page quite differently. Under the punning headline 'My Son', it carried news of the death of the pilot who 'had died doing the job he loved'. The story of the cook's death and the response in the family was silenced. Furthermore, placing this heroic story on the front page pushed the report of the destruction of the *Sheffield* onto pages two and three.[44] Without necessarily being conscious of its actions, the *Sun* stood close to the official view on 'bad news' stories. Officials believed that shocking pictures of any of these scenes, had they been available, might have lent force to newspapers such as the *Daily Mirror* which had reservations about the disproportion of response to the crisis. Had there been pictures of many disasters, this may have had serious

effects upon public opinion.

In spite of these differences between the *Sun* and the *Mirror*, there was a way of covering the dead which was common to all the papers that carried photographs to tell the story. For the numbered dead to be named, some special circumstance of irony or pathos was attached not to themselves but to their families. The stock tragedy of cruel fate was detached from the husbands and placed on the survivors: examples include the young widow who mourned the husband of three weeks;[45] the eight-hour bride who became a widow;[46] the 'teenage bride' who lost her husband and their 'best man';[47] the sisters who lost their husbands within hours of each other, the irony being in one sister travelling to comfort the other only to learn of her own loss on returning home.[48] This transference of interest from the dead husbands to the widows met several requirements of the news story. The circumstances were unusually cruel or bizarre; the conditions were examples of the-same-but-worse; the stories were essentially home front or domestic, and so enhanced the value of the family.

FAMILY LIFE AND PATRIOTISM

Commonly used throughout the campaign were photographs of the dead in happier times, professional portraits or snapshots borrowed from the family album. Their use is standard practice in representing the victims of ordinary catastrophe, and realistic photographs of warfare would not have dislodged them from the papers. In the absence of horrific pictures which may have been used to influence opinion in favour of a ceasefire, the widespread use of family photographs of the dead give a quite different emphasis. Death was not merely horrible, as seen in photographs of corpses; death was not only an individual loss but, more importantly, it was a loss to a family. The *Mirror* published a photograph of a woman holding the portrait of her husband and called it 'missing presumed dead';[49] the *Express* published 'The last portrait of a dead hero' – the man, his wife and baby son.[50]

Though all the dead were classical or modern heroes, described as 'fallen warriors' or 'the real James Bonds',[51] they achieved a special impact if they were happy family men. The representation of the death of Lieutenant Colonel Herbert 'H' Jones is the most vivid example of the double use of soldier heroes. Leading his men in the attack on Goose Green, he was in advance of an enemy position and was shot down from behind. Ironically, he was already known to the media, having threatened to 'sue everybody' over the premature announcement of the fall of Goose Green,[52] and though bitter irony can be an important part of a news story, in this case the press made nothing of it. Instead, the press latched onto the family's shortened form of his Christian name. In the *Star* the headline ran,

'H is for Hero'.[53] To be known as H was fortuitous, and all the papers except the *Telegraph* used it immediately. The name suggests the elemental, giving the colonel a firm outline – something which has its graphic equivalent in the square-jawed heroes of comic-book stories and the logos used by the papers to give this chapter of the never-ending Empire story a unity of design.

In these stories and in reports of military action, the death of a hero must be avenged, and a loss of a hero demands unusual gains. Here, part of the compensation was in prisoners. The *Star* told 'the incredible story of Colonel H and the 600 paras who captured 1,400 Argentines';[54] the *Guardian* carried the same figures without presenting them as unbelievable: indeed, it reported an officer saying, 'The victory is entirely his. It was his plan that worked'.[55]

Yet paying for a hero's life with great numbers of prisoners is not a fair exchange: the loss is incalculable and so the gain must be huge and imprecise. The papers achieved this by using the mundane idea of paying a price but linked it with the valued act of bravery. 'Red Berets' Hero Pays Price of Courage', said the *People*;[56] 'The Price of Victory', said the *Mirror*.[57] 'Courage' was invested in the Colonel, and is drawn from him by the ideal but demanding goal of 'victory'; he 'spent' himself to buy it. These terms of bravery, courage and victory, though standard rhetoric, are more uplifting and spiritual than the measured advantage of captured arms and ground. It is this rhetoric, rather than the numbered captives, which signals the transformation of the Colonel from the category of alive-but-invisible to that of dead-but-larger-than-life.

In addition to his high military rank and his bravery, the Colonel was newsworthy *because* he was a family man. His wife and children were essential to his appearance on the front pages of the tabloids: in the *Mirror* 'The Price of Victory' was paid by a 'family man' who, in his wife's words, 'died as he lived – a soldier'.[58] The Colonel's wife, Sara Jones, moved closer to centre stage in the *Sun*: as if she were speaking, the Colonel became 'My Hero', and she was seen with him in a snapshot of a holiday in Switzerland.[59] The broadsheets chose a photograph of the family at Buckingham Palace in 1981 when he received the OBE. Photographs from happy times, when viewed in sad ones, make something strange of that earlier experience. Viewers are in the position of playgoers who already know or quickly learn what is withheld from the characters – their fate. Similarly, the photograph shows us the man who is lost, the loss of that loving or familial bond, making strange the possibility of happiness, making readers conscious of its fragility or transience.

This event did more than map war onto the family: it introduced in an acceptable form the element of class. Colonel H was educated at Eton and Sandhurst, and was the highest ranking officer to be killed on land. Within a fortnight of his death, when the war was over, the *Daily Mail* leader said, 'Neither

class, age or politics created any significant divide, there has been a coming together and a dying together', restating with almost the sonority of a cleric, the myth of the classless, united nation.[60]

The myth was made manifest in stories of families grieving, which were the index of national grief. The plight of orphans, weeping mothers and wives, distress at the withholding or exaggeration of the news of casualties were of public significance. Death fell on the whole Force and beyond (three islanders were killed), enfolding soldiers and sailors, airmen and merchantmen, rank and file, officers and gentlemen. Its even-handedness meant that Prince Andrew, a helicopter pilot, was in danger too, rendering 'The Queen in sombre mood', and making even more authentic 'her prayers as Britain hears of tragic losses'.[61] Whilst the men were 'sailing to salvage Britain's pride',[62] the 'women who wait' included not only the wives of captive marines,[63] the women who shed the 'Tears of war',[64] but also the Queen herself.

The roles of men and women were thus sharply defined – a photograph of a 'mother who waits' with her baby was juxtaposed with the 'men of war', the commanders of the Fleet deliberating amongst themselves.[65] The Victorian family virtues, with rigid differentiations in labour and in the interest of patriarchal power, were the 'counterpart of the emulation of Palmerston's gunboat diplomacy'.[66]

Daily Express.
14 April, 1982

So the narrow world of political decisions to recapture the territory was easily extended across the nation as a whole, as long as it could be imagined as an orthodox family: politics, the nation and the family seemed to overlie each other, to have similar interests and to be mutually supporting.

The dream of unity mingled with the fear of loss, and suffused it with hope, in both politics and the family. Anxiety about bereavement and breakup was matched by the promise of pleasure in homecoming. The newspapers reproduced pictures that showed the sadness of farewells, and the joy of reunions. As a standard practice, a paper might follow a particular story in detail, and turn it into a feature running over several days. For instance, on 8 April the *Star* published the

photograph of a wife waiting for news of her husband who was one of the marines held as prisoners of war in Port Stanley; on 19 April he was freed and the *Star* printed a photograph of his wife on the telephone, supposedly talking to him. Along with the others, he was quickly flown home, and on 21 April the couple were pictured kissing, with the caption, 'Home to the Arms of Love'. This happened before any Britons had died and it anticipated victory.

Fear of the worst and hope for the best flickered across the papers week by week. 'The Agony and the Hope' were mingled even as the *QE2* returned and sailed up the Channel, since the Secretary of State for Defence was refusing to give the figures for the casualties at Bluff Cove.[67] And there was agony on the release (under

Daily Mirror,
8 June, 1982.

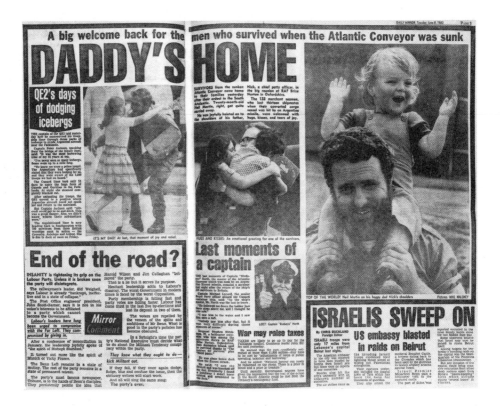

the Geneva Convention) of the Argentinian officer wanted for questioning for alleged crimes against French and Swedish citizens. The release of Captain Death (as he was known in the tabloids) did not test the strict legality of the British authorities as much as it represented the symbolic capacity of the force of Evil to escape, possibly to inflict more hurt on 'our boys'. The escape of 'Death' added a bitter twist to the bad news that awaited some: the denouement of the action was to

come, and many yet would not escape. The uncertainty of the result (the language of sports' reporting was 'shot' through the whole campaign) became the focus for the press. It played upon sudden changes of hope and despair, remembering the dead alongside the living, mixing heart-warmth and heart-break. On 8 June when the survivors of the cargo ship *Atlantic Conveyor* arrived in England, the headline in the *Mirror* was 'Daddy's Home', in *The Times*, 'Family Reunion' and in the *Mail*, 'Home are the Heroes'. The pleasure could not be pure, however, since many had been lost. In the *Express* this was indicated by photographs of the 'tearful reunion for survivors of lost cargo ship'. In the *Mail* the 'heroes' had come 'home' but with their 'tales of horror'. 'Hugs of delight' for the 'men who came back' were set against a portrait of Captain North, skipper of the cargo ship, captioned with the stark words, 'he vanished'.

Daily Mail,
8 June, 1982.
Courtesy of Mail
Newspapers PLC.

Joy and misery stood side by side, and one could turn into the other: a family 'rejoiced' at the announcement of the ceasefire minutes before they were told of their son's death.[68] Moving in the other direction, a man 'came back' from the dead, and turned up at a memorial service held in his honour.

However, his story did not emerge until August when the issue of survival in the freezing Falklands was of little interest. That tale alone was not enough for the *Sunday People*, which turned its report instead upon the twenty-five girls at the service mourning 'the Romeo soldier'.[69] Though interest in individual soldiers

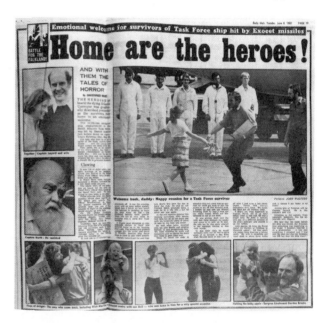

had waned long before, they could become news if associated with sex, and here was a man with blood hot enough for survival and for a famous number of lovers.

Sexual life floods the news, and during the campaign the *Sun* and the *Star*, newspapers whose imagined audience is young males, turned the Task Force into a sex force. A settled family life, these papers recognized, was irrelevant to these readers, so the formulaic practice of picturing women as sex objects, weaving stories around bare breasts, sexual slang and *double entendres*, was transferred to the war zone. Among the *Sun*'s notorious headlines were, 'Stick this up your Junta',[70] and 'Garters for Tartars'.[71] The *Sun* placed 'Invincible garters' on nude models who were then described as 'shipshape Bristol fashion' in 'nautical naughties'.[72] Another

staple of the whole industry is alliterative language: 'QE2' and 'cutie' was irresistible to the *Sun*, which reported on the sexual allure of soldiers on board the troop ship in 'Sexy capers on the ocean rave! QE2 cuties fall for heroes'.[73]

The *Mirror* has always distanced itself from the sexism of the *Sun* and the *Star* – it does not print photographs of nude models – but it did report stories of women who bared their breasts, and printed photographs of the scenes. It pictured a half naked woman who bared herself at the quayside with the caption, 'A big lift for our boys'.[74] What had been a report in the *Mirror*, next day was turned into a feature by the *Star*. It drew the same half naked woman away from news into the category of erotic entertainment, persuading her to pose as a '*Daily Star* bird'.[75] She

Daily Mirror,
8 May, 1982.

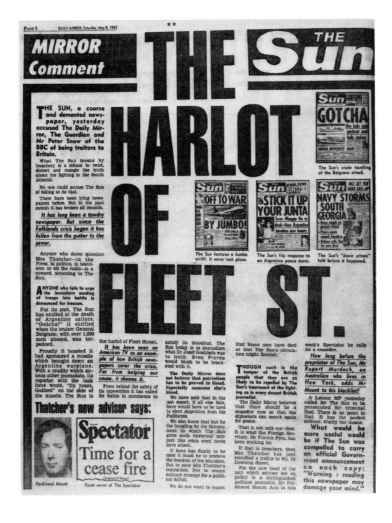

was one of a series of women, some of whom were generously given over to Prince Andrew as 'Andy's *Daily Star* birds'.[76] The Prince was doubly famous as an 'Action Man':[77] the tabloid press had long applauded his sexual prowess, and now, as a helicopter pilot, he was said to have been a decoy for the Exocet missile. All the tabloids reported on this, but only the *Star* collapsed the military and sexual abilities into each other, in its headline, 'Decoy Andrew, "I lured exocet"'.[78] The Prince became the emblem of young manhood in a Royal Family already rich in exemplars of orthodox ideas about femininity and fecundity.

The tabloids used sex as a unifying principle, levelling men in the enterprise, banishing differences of rank or fortune. Sex, in its stereotypical forms, subsumed

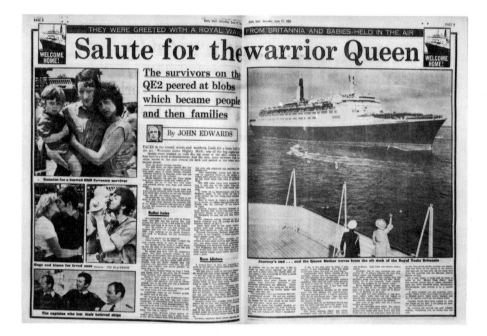

Daily Mail, 12 June, 1982. Courtesy of Mail Newspapers PLC.

the whole project in pin-up coyness, or dressed it in the familiar and comfortable humour of the seaside postcard.

When it returned, the Task Force was reunited with the both their families and the nation. This was shown in a double-page spread in the *Daily Mail*.[79] Unusually, the readers were given two points of view: firstly, in the photograph and the headline 'Salute for the Warrior Queen', they had the view from the royal yacht *Britannia*, where they saw the Queen Mother waving to the *QE2*; secondly, the rest of the caption gave the view from the troopship. The returning 'survivors' were described as having 'peered at blobs, which became people, and then families'.

The presence of the Queen Mother is important here, and the symbolic nature of this convergence turns upon her and the *QE2*. The Queen Mother is the epitome of a conservative idea of womanhood and Royal women and, in waving to the ship that carries her daughter's name and which helped save the nation's honour, she signals that the men are not simply returning to their private lives but to the orderly nation/family.

This order had been put at risk. Ironically, the quest for the release of our 'kith and kin' from the enemy and the protection of hearth and home in the dependency demanded the break up of family life for the members of the Force. Accordingly, during its absence, the press represented the family as incomplete, a place for domestic concerns and the essential passivity of women who must wait. With the return of the men, freshly blooded and proven, family life could begin again, though not as it once had been. The renewal and regeneration of Britain was the prize, nothing less. Renewal in the nation began with the reunion of families, or better still with the inauguration of family life – Princess Diana gave birth to an heir to the throne on 21 June, a timely and symbolic act. The *Mirror* headline, 'That's Our Boy',[80] was directly reminiscent of the language used to refer to men in the Task Force, and a further recognition of the Royal Family as 'our very own'. Within days, the Queen, in neighbourly fashion, 'drops in to meet the wounded'[81] and, a little over a month later, Princess Diana was seen to be 'united in sorrow' with a woman who had been widowed through the war.[82]

At a Conservative Party rally on 3 July, less than three weeks after the surrender on 14 June, the Prime Minister made a speech in which she used the sense of national unity which the press had fostered. The keynote of the speech was 'working together'. The expertise of 'our commanders in the field' was to be the model for the managers of factories, whose duty it was now

> to lift [their] sights and to lead with the professionalism and effectiveness [they] know is possible. If the lessons of the South Atlantic are to be learned, then they have to be learned by us all. No one can afford to be left out. Success depends upon all of us – different in qualities, but equally valuable.[83]

The Falklands factor, then, was intended to energize managers and workers alike, supposed to reorder the industrial affairs of the nation by appealing over the many heads of difference to the idea of one nation. This had been the lesson of history, was lost and now rediscovered: 'Britain found herself again in the South Atlantic and will not look back from the victory she has won.' There were 'waverers and fainthearts', people 'who thought we could no longer do the great things which we once did'. But they were wrong.

We have not changed. When the demands of war and the dangers to our own people call us to arms – then we British are as we have always been – competent, courageous and resolute.... The lesson of the Falklands is that Britain has not changed and that this nation still has those sterling qualities which shine through our history.

So the Falklands affair became a historical event that took its place alongside the other fabulous events of 'our' past. It reaffirmed the old ways, the lesson and purpose of history. To find 'ourselves', 'we' re-enact the past, a past which 'we' are encouraged to commemorate and even to remember as hopeful, intelligible and unified. Hence the disparate individual memories of the Second World War can be drawn into a special British form, endowing private lives with significance and incorporating them into the grander scheme of public 'life' that informs 'our' national mythology. Being in Britain in the spring of 1982 was like passing through a time warp that gave onto the fabled past, making history live.

The interweaving of these themes was at the heart of the press treatment of the Falklands war. This model of the nation made outsiders very easy to identify. The Prime Minister's immediate concern was a 'tiny group' of militant train drivers in the railway union ASLEF. A national rail strike had been scheduled for Monday 28 June, but a quarter of the NUR had turned up for work. The following day, the eight leaders of ASLEF called the drivers out. That Saturday, Mrs Thatcher said these men had 'misunderstood the new mood of the nation'. She said they were trying to defend an inglorious relic from the past ('manning practices agreed in 1919'). To encourage them to work she borrowed the language of the Labour movement for the higher national cause. She said, 'we appeal to every train driver to put his family, his comrades, and his country first.... That is the true solidarity which can save jobs and which stands in the proud tradition of British railwaymen.' Clearly a special history was in the process of forming, one that was unproblematic, and in which family life and tradition fed from each other to become obvious and commonsensical. In the press during the conflict there was no documentary realism to disturb the illusion of a clean war, and plenty of emphasis upon the family in order to naturalize it. The importance of the family took on enormous proportions for the Conservative MP Julian Critchley: compared to the family, even the Empire began to look like a dangerous detour in civilization. He wrote,

I believe the Empire did more harm than good to the genuine patriotism of the English, Scots and Welsh, genuine precisely because it is grounded in the home.... It will last, because it is the bedrock of the national character which was not invented in a moment of crisis, but was, quite simply, rediscovered.[84]

Grounded in the home, patriotism was unconsciously lived, or if made conscious then made natural too: either way, it was unavoidable.

In the newspapers, the springs of patriotic sentiment were coiled to fit the forms of censorship and established political allegiances. Exerting its influence from outside the industry, censorship ensured that the campaign was unreportable as hot news. Instead, it had to be imagined and seen only in its peripheral forms, and after the event. The silence and invisibility that lay over the military campaign forced the press to expand its cover towards the home front, and so towards the familial. Censorship, then, was productive: by its refusal to allow documentary film or photography, or journalism that was even informative of the military situation, censorship created a void. The press filled this with stories that drew from the stock types, but which were this time inflected with the imaginary unity of nationhood.

THE STRUCTURED ABSENCES

The Select Committee of the MoD in its Report was uninterested in the forms of news that were actually published, but it was concerned to hear the complaints of journalists about the practice of censorship. The necessity of censorship itself was never in doubt, and where military secrets were necessary to safeguard the Force and win the victory, the newspaper industry was compliant. The Defence Committee was also satisfied that, despite all the difficulties and necessary strictures, the Ministry had allowed a great volume of despatches and broadcasts to be made; that this could never be enough was because the media were 'insatiable'.

In its submission to the Defence Committee about television, the MoD could say that many hours of film were shot, and also that the medium had fallen foul of insuperable logistic and technical difficulties. The Committee accepted the Ministry's point of view. In relation to the low-level technology of photography, there were no great technical difficulties and yet very few photographs were returned, and they were often delayed or bland. The Committee recognized an issue of principle worthy of discussion. This revealed much about military and governmental attitudes towards documentary realism, and towards the gap in the pictorial record of the war. It was this gap that produced the most debate – the absence of photographs of the dead and the surrender.

The Surrender

The absence of photographs of the Argentinian General signing the surrender was considered in the military's evidence to the Defence Committee to highlight two linked considerations: the chief minder had no authority with the commanders, and there was a responsibility towards the historical record.

General Moore first banned news of the ceasefire and kept journalists away from the area of the surrender in Port Stanley. He then banned film of the surrender negotiations because he thought it might disturb the Argentinians and prevent their signing. Photography was not specifically banned. Preparations were made for two service photographers to take pictures, and they flew into Stanley with the General. There they were briefed by the chief minder 'to keep under cover within the helicopter until it was felt the situation was not delicate enough to be prejudiced by their presence'; when the minder judged the situation to be favourable, 'they left the helicopter and went to the headquarters and indeed were in the building when the surrender was taken'.[85] They were unable to enter the commanders' room, so the minder sent a verbal message via an officer to remind them that photographers were present, but there was no response.[86] The General seems simply to have forgotten about them. He later claimed the low rank of the minders was not the reason for this forgetfulness: the main factor was what he called their lack of 'persuasiveness'. He felt that the issue of policy was not to create PROs of military rank, but to have men of experience who might impress themselves upon the preoccupied operational commanders. He did not make clear to the Committee how persuasion might be divorced from rank and still be effective. But in the Falklands, there had been no persuasion and the moment passed. As soon as the surrender had been signed the Argentinians left. Instead, a photograph was taken of General Moore holding the document.[87]

The success of the whole campaign rested on the surrender. In the words of Rear Admiral Sir John Woodward,

> If there was the least smidgin of risk with that negotiation, that it could go astray because somebody wanted to pop lightbulbs and take pictures, I would not have had it. We were in a very poor way by 14 June: he [the Argentinian commander] was down to six rounds per gun that night; I had had three frigates badly situated in terms of capability; we were running out of steam.[88]

The officers were concerned with the authenticity of the legal moment itself, its documentary proof – and not with any secondary proof of legitimacy that a photograph might provide. For them only a signed document was enough, though it could be publicized in a photograph of the thing itself. The drama of the moment (in so far as a photograph might suggest it) was of no consequence to the commanders. The theatre of war, always an allusive and ambiguous term, was now shrunk to the proof the military sought and demanded, something in writing and signed.

The lack of a photograph of the surrender was mildly regretted because there

was now a gap in the record of surrenders: otherwise it had no importance. What is revealed is not the consistency of the military appraisal of the unimportance of the media, but a breakdown in the military's own appraisal of the importance of photography in preserving certain set-pieces, specific theatrical and even spectacular events that redounded to the credit of the Forces. The commanders were now reminded of the use of public relations which would have allowed them to use press photographs in ways they understood – the unproblematic use of photographs as evidence. Yet this simple understanding created in them the characteristic fear that the depiction of the war in progress, or even of the bloody aftermath of battle, would be uncontrollably effective in destroying morale at home, with the consequent loss of essential political support. The widespread and internalized suspicion of photographic realism had relegated it to the margins, thus ensuring the loss of an heroic set-piece: but this was a small price to pay for the maintenance of morale.

Horror Pictures

The media reproduced no pictures of the British dead, and very few if any of those of the enemy. This was remarkable in a war in which 777 Britons had been wounded, with 255 dead, and with perhaps 1,800 Argentinian casualties. Photographs of the dead were taken, and did reach the Press Association. As Martin Cleaver said,

> There are pictures of dead bodies, gore and red meat in the PA library, which were released by the Ministry, but people obviously did not want to see it....I suspect that the PA edited some of the blood and gore out. I know for a fact that they did issue some of it, but what they did issue did not get published, which did not surprise me.[89]

Newspaper editors decided not to use them.

In response to points raised by journalists in their written submissions to the Defence Committee, the Labour MP, Dr John Gilbert, asked questions about the possible dangers to morale of picturing a war as unbelievably clean. Dr Gilbert pursued the journalists, commanders and politicians with the question of whether the press and television during hostilities ought in principle to show pictures 'of what a British soldier looks like with his brains blown out or his stomach hanging out or when he has had a leg blown off'.[90]

In reply to Dr Gilbert's questions, the Defence Correspondent of the *Guardian*, David Fairhall, felt the principle at stake was that the public should not be dependent on a military view of the campaign, or a politician's view, but should have an 'independent description of what is going on'.[91] The editor of the *Guardian*,

Peter Preston, said the restriction and selection of photographs and the absence of pictures of dead bodies 'deodorized' the war. This was inappropriate in a 'mature democracy': 'people are not so foolish as to think that the only pictures that should be available during a conflict of this sort are pictures of victory flags being run up or grateful villagers greeting troops. Everybody knows war has many sides.'[92]

Peter Preston believed that photographs of the dead would not affect the morale of troops, who knew the reality of killing.[93] Michael Nicholson of Independent News said images were unlikely to damage morale at home: the 'devastating pictures' of the IRA bomb blasts in Regent's Park and Hyde Park in London on 20 July were said to have increased people's resolve, not diminished it.[94]

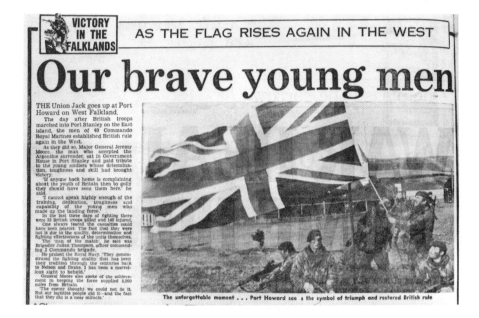

Daily Mail, 17 June, 1982. Courtesy of Mail Newspapers PLC.

Not all the journalists agreed with this point of view. David Chipp, editor at the Press Association, believed that home morale did indeed benefit from the absence of 'horrific pictures of dead and wounded'.[95] At the same time, he felt some such pictures should have been seen (though 'not every day') to give an 'overall pictorial coverage of the campaign'.[96] High morale was supposedly related to balance in the reportage of war, a balance that was expected to be discernibly objective and believable, and would include pictures of casualties. Peter Preston said that to see none at all was 'eerie'.[97] It invited suspicion of laundering the facts, or a cover-up for political reasons. On the other hand, David Fairhall acknowledged that photographs of casualties could be used against the government. He said that to

reproduce too many of these pictures, or enemy photographs of the British dead, would have been to make 'a political point on one's own behalf'. This would have been to travel too far from the notional objectivity of documentary realism in photo-journalism towards an active anti-war polemic.[98]

The military commanders voiced their belief in documentary realism as objective record and discussed its effect upon their own families and the families of their men. Major General Sir Jeremy Moore judged this effect to be 'severe'; and Brigadier M. J. A. Wilson said, 'Thank heaven we did not have unpleasant scenes shown. It would have been singularly debilitating to our wives and our families'.[99] Morale was immediately attached to matters of taste, and the

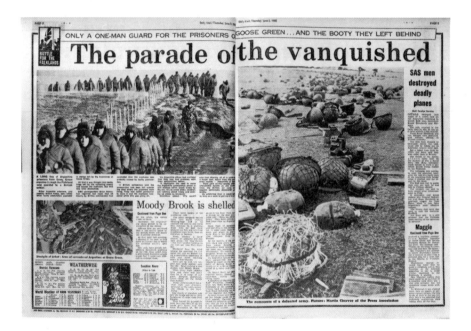

Daily Mail, 3 June, 1982. Courtesy of Mail Newspapers PLC.

absence of 'unpleasant' scenes was said by Sir Jeremy to come from 'the good taste of our journalists'.[100]

The disturbing effects of shocking photographs remained a hypothetical question because there was none to be seen. The Defence Committee believed this arose not just from the 'good taste' of journalists, but from their professional ability to meet the expectations of the newspaper audience. In a typical official expression of consumer sovereignty, the Committee said the public also had 'good taste'. So government and media were alike in that both had their 'freedoms circumscribed by public pressure' which 'will ultimately impose standards of taste

and decency on the media if any elements are tempted to concentrate on the more lurid and distressing imagery of war'.[101]

The absence of the lurid war let in the illusion of a clean war. This was compounded by technical difficulties and by the deliberate manner in which the press was dispersed and faced with practical difficulties which they had no means to overcome. Servicemen were killing and dying beyond the limits of reportage. What remained for the journalists was only the news that troops had advanced or that territory had been captured; this was no more than a catalogue of action that was already complete. The efficiency in removing reporters from the front line, entirely plausible and necessary on operational grounds, made the military an extension of the government's will and insulated both against hostile criticism. The management of the conflict interwove the political thought and the military deed. Beyond that, the reputedly matchless military strategy was an extension of the reputed legality and morality of the government, the success of one feeding off and sustaining the other. Managed in this way, the war sat within a patriotic framework that was already supposed to bind the nation as a whole.

PAST AND PRESENT

Stories make sense above all in their endings. The crucial questions are 'How will the enemy be defeated?', 'Who will win?' and 'What will be saved?' An idea of the nation has been built around a selection of such stories with endings, so that its history is another kind of fable. The Falklands campaign made sense as an updated story of the *Boys' Own* kind. In spite of the unprecedented limitations imposed on the media by censorship, broadcasters and press were able still to bridge the gap between onset and finish because the conflict was brief. It could be contained within a story-book of national history as progressive: the decisive victory of the Task Force had its perfect analogue in the representation of flags, captives and military hardware. Once it was over, the heroes returned, and there were celebrations at the quayside and later a parade in the capital. Medals were won, the dead mourned, and their names entered upon the war memorials. The political decision to resolve the problem by force of arms not only inhibited the media, but forced it to set the positive tone of national pride and coherence that was then supposed to inform public and private life in Britain.

In this campaign, history had flowed backwards. Though the outcome of the adventure must lie in the future, the manner in which the story would unfold was scripted upon the ideal past, that particular set of victories that make up the essential history of the nation. So 'the last war' was not the only reference point. Reaching further back in time, the fabulous past of St George and the dragon was

translated into the age of computer technology. The paradigm of action that could be drawn from the historical past was found in the stories of Empire and before, of Victorian values and Elizabethan adventurism. These stories, already stitched into a simple tableau of patriotism, first taught in the kindergarten and then held in common as the history of the nation, were now put to immediate use. Writing about schools in the *Daily Telegraph* after the victory, Julian Critchley provided a summary of patriotism and its purpose. He wrote,

> Compare the shared emotion at home and the superb morale of our fighting men in the freezing Falklands with what we know of the spirit of Agincourt, of the Elizabethans' response to the Spanish Armada, of Trafalgar or Waterloo, the flood of volunteers at the start of the First World War, or of the Battle of Britain in the Second. It is the same inherited, untaught devotion to one's homeland which has survived all the changes and chances of our national life, untouched by all the plans of the Twentieth Century to ensure peace and the proliferation of international organisations....What is surprising about this resurgence of patriotism is not only that it is quite out of tune with the whole liberal and progressive gospel and obsession with politics which is the secular religion of the media, but also that it runs counter to almost a generation of teaching in the State schools [which had urged non-national causes such as] the United Nations, Europe, Third World, anti-apartheid, anti-white racialism, anti-American capitalism and 'Ban the Bomb'.[102]

Critchley's litany of nationalist landmarks and the context for them addresses those who have been educated in the public schools, though the symbolic value of these incidents are not irrelevant to the curriculum of the comprehensive schools. It suggests a teleology of military endeavour from the medieval to the modern that is oversimple and even ludicrous; at the same time it frames the patriotism of 1982, but only because the story had its proper ending.

The Star,
15 June, 1982

DAILY STAR

TUESDAY, JUNE 15th, 1982 14p (15p C.Is, 18p Eire) ★★

The moment the whole nation has prayed for

THEY DID NOT DIE IN VAIN

Victims of the war

THEY unselfishly gave their lives, like so many others. Left, from top: Captain Ian North, of Atlantic Conveyor; Acting Leading Marine Stephen White, of HMS Ardent; Staff Sergeant Jim Prescott, Bomb Disposal; Private Stephen Illingsworth, Parachute Regiment. Right, from top: Lieutenant Colonel H. Jones, Parachute Regiment; Bosun John Dobson, of Atlantic Conveyor; Able Seaman Sean Hayward, of HMS Ardent; Lance Corporal Anthony Cork, Parachute Regiment. Bottom centre: Lt.-Cmdr. Gordon Batt.

FALKLANDS ARE FREE ONCE MORE

BRITAIN can today celebrate victory with pride. The Argentinian defenders dropped their weapons and fled last night, and white flags fluttered over Port Stanley. All that remains now is the final confirmation of the surrender terms.

5

NORTHERN IRELAND AND TERRORISM

THE UNITED KINGDOM

The colonial role of the British in Ireland, and the consequent partition of the island as recently as 1922, presses most forcefully into modern times. Belief in the United Kingdom (which includes Northern Ireland), or in Britain (which does not) as a civilized nation, moral and legitimate, depends on past victories and upon the concept of sovereignty. This penetrates, saturates and binds together all the places it touches into the history of a nation, into 'our heritage'. The sovereignty of the nation is maintained by law, but is not inviolable. Though it cannot be rationally divided, it can be fought over. Of all the annexes of Empire, it is in Ireland that sovereignty is still so bitterly contested and virulently defended.

Sometimes, this idea of our heritage, of 'we-ness', is difficult to maintain. On the occasion of the Royal Jubilee celebrations in August 1977, the Queen visited Northern Ireland for the first time since 1966. For days before the visit, the press anticipated a violent reception, partly because the visit fell in the middle of a week that began with the sixth anniversary of the introduction of internment, and ended with the Protestant marches.

Reporting on the event, the *Daily Mirror* spoke of 'Two Faces of Ulster on a Day of Tension'.[1] It published a photograph of the 'tranquil' Queen with a posy, smelling the 'scent of peace', and opposed it with a 'violent' scene of 'A Taste of Blood' – a photograph of a soldier with a head wound. On an inside page, the *Mirror* described the part of Belfast kept hidden from the Queen: it was there that Her Majesty's subjects 'staged a grotesque Jubilee carnival', with a mock queen, a mock trial of the 'oppressor', and with black flags flying to chants of 'We don't want your queen, your murdering troops, or your Jubilee.' These disloyalties were opposed by stories and pictures of 'a touch of royal magic for the city under siege'.

Reports of the anti-royalist demonstration were useful to the *Mirror*: they

were part of its long campaign of opposition to 'our' presence in Northern Ireland. In 1976 it had asked, 'Ulster, Bloody Ulster, Should We Get Out?'[2] Yet questions such as this are always asked from the position of loyalty to the Queen. The concept of sovereignty is conventional for the press, and within its logic there is no way of simply 'getting out' of Northern Ireland. The need to 'stay in' is most easily explained in the concept of a United Kingdom. In the press, the indivisibility of the Queen's domain and her government's jurisdiction is never seriously in doubt.

But, as this *Mirror* story shows, there is a question about Britain and Northern Ireland which is not satisfied by the appeal to sovereignty. The interruptions in civil life stemming from the unresolved contradictions of Britain's

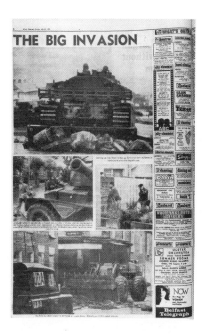

Far Left:
Belfast Telegraph,
13 July, 1970.

Left:
Belfast Telegraph,
31 July, 1972.

place in Ireland mean that the government and the press are engaged in delineating the conflict (as it exists in texts) in ways which differ from, but are as complex as, narrating the Falklands crisis. Reporting an untidy and lengthy civil war has been fraught with complexities, because explicit state censorship of the media in 'peacetime' is theoretically unacceptable in a democratic society. Nevertheless, the government has made frequent use of injunctions or 'gagging writs' issued in advance of publication of reports or books which the government decides are against its interests. In 1988 broadcasting freedom came directly under threat when 'direct statements' by 'extremist groups' were banned by the Government (see page 120). In 1989 and 1990, the 'threat to press freedom' was presented as self-inflicted,

because of 'falling standards' of journalism in the popular newspapers, notably concerning the invasion of privacy: this enabled the government to warn the press that it was 'on probation', and that should it fail to set its house in order, further legislation on the press would follow.[3]

THE LANGUAGE OF TERRORISM

Sovereignty is already in place in Northern Ireland. It is not an abstraction, and is most commonly observed in pageantry. In relation to the media, however, it is the people who attack and defend the concept of the United Kingdom who are most newsworthy. The language used in the media, whilst not chosen by the state, corresponds to official and semi-official perspectives. In 1974 a memorandum in the BBC television newsroom log said that the word 'terrorist' rather than 'guerrilla' should be used to describe 'politically motivated violence'. Commenting upon this, the sociologist Philip Schlesinger noted that in the 'coverage of Ireland, the term "terrorist" is the one pre-eminently used: "guerrilla"...suggests a degree of respectability and more quasi-legitimate military status for the insurgent side'.[4] The language of terrorism is important because it provides the frame within which 'media discourse may routinely reproduce dominant meanings'.[5]

There is no difficulty amongst 'conviction' politicians, counter-insurgency experts (whose very title betrays the premise of their thought) and military philosophers in providing a definition of terrorism that exactly suits that of the state. According to Professor Paul Wilkinson, who writes from within the official perspective, terrorism is systematic murder, destruction and threats used against individuals, groups, communities and governments.[6] Above all, he says, terrorism is what the dispossessed, alienated or quasi-millennial fanatics and bigots use to unsettle liberal democracies. This definition is itself a limitation of the term 'terrorist' to delegitimize the marginal political groupings, and enables the category to be self-fulfilling. The monolithic good state

Today,
31 July, 1990.

has enemies beyond the borders – and increasingly within them. Liberty can be protected by the state becoming 'strong', by framing laws and deploying army and police to protect the ordinary citizens from the enemy. What may be called 'state terrorism' is either ignored or justified as merely reactive.

Although state and media can disagree about the meanings of words, they tend to settle upon a similar core of values. When the questions are posed, 'What is happening in Northern Ireland? Is it a war or a rebellion?' and 'Are the British Army and the RUC peace-keepers or oppressors?', the choices made also represent the choice of verdict. From the orthodox perspective, and in the British media, the IRA and other republican groups such as the Provisionals (Provisional IRA) and the Irish National Liberation Army (INLA) are never described as 'commandos' engaged in a 'liberation struggle' against the vestiges of colonialism. Instead, they are variously represented as both terrorists and criminals.

DIRECTION AND CONTROL

From the government's perspective, it would be most satisfactory if there were no ambiguity between the legal methods of the state and the illegalities of terrorists.[7] Yet the distinction between state and terrorist illegalities has presented problems, especially for the broadcasting media. The BBC, once it was perceived to have offered a platform to loyalist and republican extremists in the 'Real Lives' programme of 1985,[8] or to have endangered the security of the state in the spy-satellite programme of 1986,[9] had changes forced upon it in 1987 through its Governors that ensured it would more effectively control itself.

The Independent Broadcasting Authority (IBA) was the next target. In March 1988, in Gibraltar, the SAS shot Danny McCann, Mairead Farrell and Sean Savage, members of an active service unit of the IRA, and Thames Television made a documentary called 'Death on the Rock'. This questioned the official version of events – that the soldiers had been forced to open fire on the terrorists because they had made suspicious movements when challenged, as if they were about to detonate a bomb. The programme was broadcast in April despite government attempts to stop it before the autumn inquest. Mrs Thatcher claimed it was 'trial by television'. Following criticism in the House of Commons and from sections of the media, notably the *Sunday Times* 'Insight' team,[10] Thames Television set up an independent report into the affair. After three and a half months, it concluded that the programme was not 'trial by television', had not prejudiced the inquest nor contaminated the evidence of witnesses.[11] Thames Television said, 'investigative journalism is alive and well in broadcasting', but the Prime Minister dismissed the report and effectively repeated her earlier statement, strengthening her resolve to

shake up the ITV companies and the IBA.[12] It was significant that in January 1989 she appointed the 'right-wing ideologue' Lord Chalfont as deputy chairman of the IBA and its successor, the Independent Television Commission.[13] The government, though with some initial difficulty, has been able to control broadcasting when it more nearly touches upon political groups: it has claimed the overriding need to deny them the 'oxygen of publicity'.[14] In October 1988 the Home Secretary told the Commons 'he had issued formal notices to the chairmen of the BBC and the Independent Broadcasting Authority requiring them to stop broadcasting "direct statements" made by supporters of extremist groups'.[15] Some confusion and embarrassment arose because not all proscribed groups are legally defined extremist groups. The legally-banned groups are the two wings of the IRA and its women's and youth movements; the Irish National Liberation Army; the socialist Saor Eire; and three Protestant groups – Red Hand commando, Ulster Freedom Fighters and the Ulster Volunteer Force. But the direct reporting ban also listed Sinn Fein, Republican Sinn Fein and the loyalist Ulster Defence Association. There followed a week of uproar from the media, protesting at the infringements and confused by the inconsistencies and loopholes. The government then issued a letter of clarification. In sum, the words of statements by members of any of these political organizations could be broadcast verbatim; but there was (and is) a ban on the 'actuality' reports of those speaking on their behalf or in support of them. The notice also forbade 'actuality' reports of speeches by foreign leaders or politicians giving specific support to any of the groups, including in the European Parliament and defendants in a court anywhere in the world; it included shouts of support from any crowd, and the acceptance speeches by members of listed organizations who are successful in elections. The refined ban was extended to include certain historical documentary film footage of members of listed groups.[16]

Official beliefs and fears about the effect of documentary realism or 'actuality' reportage in television had an impact upon the representation of the Falklands campaign, and continue to have a similar effect upon news of the political and civil unrest in Northern Ireland. Whereas reports from the Falklands could be said to have fallen foul of technical hitches, no such explanation is available in the case of Irish affairs. Here, government's motives for unusual measures of control of media and civil liberties are political; yet the controls can be announced as 'reasonable', calling on the electorate's imagined and actual fears. Except where it presses upon journalistic 'freedoms', there is media acquiescence to the idea of the 'reasonable'. People working in the media who share this idea can accept control from governments, and they can believe audiences will unite against what are represented as terrorists' cruel, futile and inexplicable murders.

The reporting ban does not cover still photography: for instance, in January 1989 the *Independent* published a picture of Gerry Adams, president of Sinn Fein

and MP for West Belfast, speaking to the annual conference in Dublin. He was reported to have 'warned IRA units not to alienate nationalist voters by killing civilians', and in the photograph readers of the newspaper could see a banner attached to the platform which said 'Censored'. The broadcasting ban was said to have given the party a civil rights issue, but to have 'hurt': 'its leaders would clearly prefer to be heard as well as seen on television'.[17] The *Independent*, which re-established photo-journalism as a feature of its front page – with the other broadsheets following after – continued to keep the broadcasting ban and Irish affairs before its readers through the use of photographs. In March 1989, one week after the IRA killed two senior RUC officers as they returned across the border

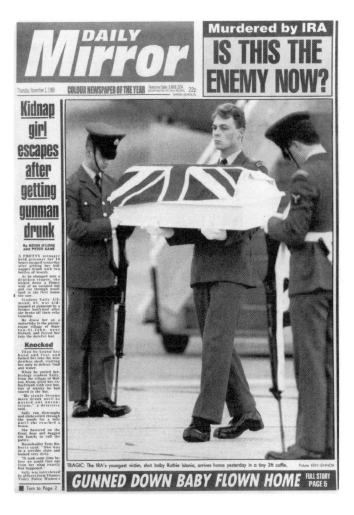

Daily Mirror,
2 November, 1989.

from a meeting with Irish police, the newspaper carried a photograph of Gerry Adams with 'A masked IRA man addressing a small republican rally held at the border village of Crossmaglen, south Armagh, ... to commemorate the 1916 Easter uprising.... After Mr. Adams spoke, the IRA man sprang from the crowd to pledge that the Provisionals would continue to resist British rule in Northern Ireland'.[18]

Photo-journalism can be used to move audiences in a direction which is politically opposed to the stance of the *Independent* on the broadcasting ban. It can be used to discredit the IRA as savages: in March 1988, caught in a cycle of reprisals, the Signals corporals Derek Wood and David Howes drove into the funeral cortege of an IRA member who had himself been killed by a loyalist a few days before at the funeral for the three killed in Gibraltar (see pages 142-7). The corporals were attacked, stripped, and shot dead. Two men were accused of their deaths, and when the trial started the *Sun* and *Today* both carried front-page pictures of the soldiers being dragged from their car and beaten. The headline in the *Sun* was 'Drenched in Blood'. In *Today* it was 'Last Savage Minutes of a British Soldier', and in the centre-fold was another picture of the same scene taken a split second later with the headline 'Trapped and Cut down in a Circle of Blood'.[19]

As the uses of these different pictures demonstrate, once information enters the public domain, the editorial policy of the newspapers determines the ideological use to which it will be put. The dual tendencies of the press, to remain close to the official perspective, and yet on occasion to resist it, were already established at the time of the outbreak of the 'troubles' in 1968.[20]

PRESS PRACTICE AND THE STATE

Press reports, both in their content and in the ways the stories are written, are scripted upon the past practice of the newspapers. The conventions of the industry, and those of language itself, exert their own inertia. These conventions allow occasional, almost ritual, disagreements between the government and the industry. In 1976, *The Times* printed a story with the headline 'Army Regards Press as Destructive in Ulster', which gave examples of official misinformation and false stories.[21] There was some controversy over whether, by publishing these revelations, the newspaper had betrayed the national interest. In response, *The Times* said that the army's 'propaganda war' against the 'urban terrorists' was necessary in the national interest but had nothing to do with the press. On the contrary, *The Times* sought to distance itself from 'propaganda'. Its task was to see that 'the readers are informed as fully and clearly as possible', and 'sometimes that would suit the security authorities, sometimes not'.[22]

The press always denounces any attempt by the state to control it, or to turn it into a mouthpiece: the press is not a vehicle for state 'propaganda' in any direct sense. Instead, in the words of *The Times*, the press seeks a 'picture' which is 'complete and accurate'. It claims to draw a precise map of reality, which may sometimes lead to clashes with the state. When this happens, and there is obvious state interference, it is relatively easy for the press to distance itself since propaganda is identifiable and contestable. On the other hand, there is often a consensus between press and state about the precise map of reality. This does not mean that there is a conscious conspiracy amongst influential individuals, but rather that both groups share many beliefs about what reality is. This consensus is much harder to identify and disrupt than a conspiracy would be, because, as in a hall of mirrors, the values of one group are reflected by the other. In addition, the convergence of ideas about reality is intensified by the structure of news gathering and state control of much of the crucial information. The press cannot easily give up its normal practices, which rely heavily upon information provided by officials. So without becoming the puppet of the state in a simple way, the newspapers can remain close to official accounts. As the journalist Eamonn McCann showed, in his 1971 pamphlet on the press in Northern Ireland, this structure consists of

> reporters who know what is expected of them; news editors and sub-editors trained to recognise and eliminate 'unhelpful' references; editors appointed with 'sound' attitudes; boards of management composed of substantial businessmen: the whole sprawling machinery of news gathering and publication automatically filters, refines and packages the information fed in and works to ensure that the news, as printed, is fit to print.[23]

Journalists take official communiqués and then inflect them with their own voices, or rather with the voice of their newspapers, elaborating and inventing, removing the text from its original form of officialese of army or police force. Thus, although the press uses official sources, it translates them to accord with its own predetermined needs. In so doing, the press is actively engaged in producing versions of the real; or rather, the press makes *reversions* to it, since the present reality is scripted upon a stereotypical sense of the past. The production and reception of the 'complete and accurate' picture is both an illusion and a mystification. The illusion is contained in the idealism of news as fact, reinforced by the power of eye-witness photo-journalism. This illusion conceals the manner in which the realism of fact is a production. Sealed within the conventions of the medium is the type of 'fearless exposé' that ritually separates the media from the state, while still maintaining the clear distinction between terrorism and the law.

Another contributory factor in naturalizing the dominant meanings of the 'troubles' is the long period they have been running. In 1968, when the Catholics of Derry marched in protest at their oppression by the Protestant majority, there was something vital and novel about their action. Protest marches for civil rights and other causes were fashionable. They took place across the western world, and were a contemporary measure of democracy. As time went by, without political resolution to the impasse in Northern Ireland, the publicity of the 'troubles' in the media began to harden from a combination of boredom and shock at the bombing in England, to an attitude which aligned coincidentally with the state perspective.

The press preserves the 'mind-set' it has, which is in line with the semantic division between terrorism and the state. Usually the press seals up any possible disjuncture by carefully stating the matter-of-fact as if that were enough to fulfil the need for a 'complete and accurate' picture. A captioned photograph is useful because it naturalizes the phenomenon with the aid of an explanatory (and limiting) text. To some extent, and through repetition, this makes sense of terror: it appears in random, unreasonable order, and is always answered with the order of the state, from the rescue services, the police, the courts, and the military. In looking for pattern, there appears to be sequential movement, the response following the terror.

The only discernible pattern within terrorism itself is in a spate of murders for revenge: these are known in the British media as sectarian murders, or tit-for-tat killings, which tend to relegate them to the inside pages of newspapers as scarcely credible acts of religious bigotry. These have become 'normalized', and arouse most fear and media interest when the circle is widened to include a new category of victim – when, for instance, loyalists killed Patrick Finucane, the solicitor well known for his defence of members of the IRA.[24]

The theme of revenge has two major variations. Firstly, there is slaughter within factions, especially of the Provisional IRA, when devouring each other is proof of madness.[25] Secondly, there is the killing of republicans or members of the IRA by the SAS or RUC which, depending on the circumstances, may be greeted with pleasure or alarm. As an example of pleasure in republican deaths, some ten days after eight 'rookie' soldiers were killed by a bomb on the Ballygawley road in August 1988,[26] three members of the IRA were 'killed in hijack shoot-out': this was reported gleefully in *Today* as 'Revenge of the SAS'.[27] As an example of alarm or discomfort, the shooting by the RUC of three IRA men, two unarmed INLA men and a youth with no paramilitary connections in a series of incidents in County Armagh in 1982 led to accusations of a shoot-to-kill policy. Attempts to investigate this in 1986 led Deputy Chief Constable John Stalker to the heart of the RUC.[28] Just as he was about to close in, Stalker was himself placed under investigation for misusing police property and, although he was eventually cleared, his career in the police force was ended. The subsequent investigations of the shoot-to-kill

allegations appeared to press commentators to be less than searching. They laid the responsibility for this with government: in November 1988 the *Independent* reported that Tom King, the Secretary of State for Northern Ireland, 'pulls veil over backdrop to IRA deaths'.[29] Some months later, in March 1989, eighteen RUC officers peripherally involved in the shootings were reprimanded, and the murky affair was closed, seemingly for political reasons.[30] These cases indicate the linkages between legal and illegal systems.

Readers of newspapers are not encouraged to see the forces of the state and the forces opposing it as dependent upon each other. There is no hint that the army or legal forces and the terrorists are in fact deeply enmeshed with one another. The forces of law and order are supposed to be responsive or pre-emptive, their actions always distinct from the guilty acts of the enemy. Nevertheless, each relies for its success upon the presence and subjugation or disarray of the other. The terrorist has to exist, otherwise the actions of the army would be inexplicable.

An infamous case of this dependency occurred in the official explanation of the events that took place on 'Bloody Sunday' in 1972, when troops opened fire upon a civil rights march in Derry, killing thirteen people immediately (another died later of his injuries).[31] The following day, the government announced plans to hold an enquiry. When the Widgery Report was published, it said that, although none of the dead had used weapons of any kind, there must have been a sniper, otherwise the troops could not have returned his fire. The headline in the

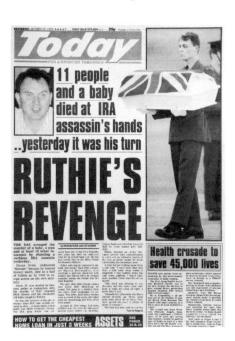

Daily Telegraph was 'Army Did Not Fire First, says Widgery'; and, in the *Daily Mirror*, 'Sniper Blamed for Bloody Sunday'.[32] The expert on counter-insurgency, Maurice Tugwell, has gone even further. In his determination to save the idea of a blameless army, nine years later he rewrote the history of 'Bloody Sunday' as if the IRA had mounted an ambush. He said that the event was an 'IRA inspired civil rights march' which 'ended in a shootout between troops and gunmen hidden in an apartment block, and 13 Catholics, mostly free of guilt, were killed in the mêlée ... precisely the sort of tragedy the Provos needed and had possibly planned ... with the help of the Russian secret service'.[33]

Today,
10 November, 1990.

FROM WAR TO CRIME-WAVE

The criminal republicans are useful: they are the plain enemy and are beaten by a steady stream of successes. These range from killings, to the discovery of arms, the disposal of bombs, the detention of suspects and the continuing marginalization of the IRA. The search for a political solution between Dublin and London, through the Anglo-Irish Agreement of 1985, was fraught with difficulties for both governments.[34] But it led to more policing – and here the struggle of Irish nationalists benefited the forces of law and order in Britain. This was described by Roger Faligot in his book on the British Army in Northern Ireland:

> as an experimental field [the country] was a godsend to counter-insurgency strategists. She belonged to Europe and yet was separate from it because of her geographical isolation, her economic underdevelopment, the originality of her culture, her traditions and her history. The British played upon this unique ambiguity, which they had created: Northern Ireland is simultaneously foreign – thus military methods can be used against her people without shocking British public opinion – and an integrated part of the United Kingdom....There is a sizeable Irish community on British soil. More than anyone else, the Irish are the *internal enemy* that enables the infiltration into Great Britain of techniques used in their own country.[35]

These techniques became 'essential' once bombs exploded on the mainland. On 5 October 1974 IRA bombs in Guildford killed five people, and the responsibility for catching the 'enemy within' the United Kingdom fell to the police. The police have always had a major responsibility for controlling terrorism, but the shift from war to crime-wave that took place in the 1970s can be seen in reports of events in Northern Ireland printed in mainland newspapers (even allowing for their different political colours). For instance, in 1971 the investigative journalist John Pilger, writing in the *Daily Mirror*, had said 'Britain is at War!', and showed photographs of soldiers on patrol.[36] But in 1983 the *Sun* declared 'IRA Thugs Gun down Law and Order Man', and illustrated the story with a photograph of 'security force members' covering the body.[37]

The impetus and main lines in the shift of perception are seen in the Labour Government's introduction and realization between 1974 and 1979 of its policy of Ulsterization, or the return to 'normality'. After 1984, especially, the policy was 'to portray terrorism in the province as a threat to public order rather than the creation of a public emergency'.[38] The transfer of responsibility for 'peace-keeping' from the

army to the police was achieved in a number of related movements. The RUC became more like the army in their equipment and their specialisms – they were armed with plastic bullets and trained in counter-insurgency. Establishing the RUC in this role was the Deputy Chief and then Chief Constable, Sir Kenneth Newman (knighted in 1978) who in 1982 moved to London to head the Metropolitan Police. From that time the British police have been strengthened in line with the practice of the RUC, with new powers, new training, new equipment, and new anti-terrorist specialisms. At the same time, the secretive intelligence gathering and anti-terrorists agencies in Northern Ireland have their counterparts on the mainland: GCHQ, MI5, MI6, SO13, Customs & Excise, and local Special Branches of the Police.[39]

When Sir Kenneth retired from the 'Met' in 1986 he was replaced as Chief Constable by Sir Peter Imbert (knighted in 1988) who had spent sixteen years in the Special Branch. He had spent two and a half years as deputy operational head of the Metropolitan Police Force's Anti-Terrorist Squad. The flow of police experience from Northern Ireland to London, and the sophistication of anti-terrorist strategies within the British police, shows that acts against the state have become a matter for the police. In this way, what the IRA takes to be the practice of war, is moved by the British authorities towards the concept of crime and crime fighting.[40]

The policy of Ulsterization defined the IRA as terrorists and criminals. In 1974 the *Daily Mirror* had been able to publish photographs of 'The Most Defiant IRA Parade of All' inside the Maze Prison. The military parade had shown the IRA as prisoners of war inside an 'enemy' concentration camp.[41] But in 1975 'internment' was abolished as unnecessary, since the policy of criminalization was in full operation: no-jury courts were used to translate those whom the nationalists considered to be PoWs into common felons and murderers.

Writing in the *New Statesman* in the same year, the author and journalist Paul Johnson charted this transport of the IRA across a range of semantic barriers into the category of the criminally insane in a virulent form. He said,

> In Britain, as well as in Ulster, we face in the IRA, not a nationalist movement, not a league of patriots, not 'guerrillas' or 'freedom fighters', or anything else which can be dignified with a political name, but an organization of psychopathic murderers who delight in maiming and slaughtering the innocent and whose sole object and satisfaction in life is the destruction of human flesh.[42]

The British press has another way of distancing itself from the affairs of Northern Ireland, derived from its practice of reporting mainland events more fully than those that take place elsewhere. This was clearly seen in the newsworthiness of the Guildford bombs. During the three-week period from 23 September to

11 October, 'twice as many people were killed in Ulster as died in Guildford and, as well as incidents involving fatalities, there were a series of other incidents in the province resulting in injury, property damage or simply a disturbance of the peace'.[43] The Guildford bombs, however, occupied 'two thirds of all the space in the British media reporting violent events'; the remaining third was devoted to incidents in Northern Ireland. Furthermore, the Guildford bombs became a running story, with coverage of the messages of sympathy from the Queen and politicians, stories about the injured in hospital, the relief fund, the funerals and the impact on the town. In contrast, reports on Ulster produced only a 'staccato procession of incidents' that were given neither cohesion nor meaning.

Captured and convicted, these murderers (if that is what they are) are sealed up in high security prisons. Once there, no matter how their convictions have been won, they are invisible and almost inextricable. The British authorities were notoriously reluctant to reopen the cases of convicted 'bombers' despite thin evidence, notably in the cases of the Birmingham Six and Guildford Four gaoled for life in 1975, and the Maguire Seven gaoled in 1976 for between five and fourteen years for possessing explosives. Eventually the Guildford Four were released in 1989,[44] the convictions against the Maguire Seven were quashed in 1990,[45] and at the time of writing the case of the Birmingham Six is under review.[46] These people always maintained their innocence of the crimes for which they were convicted, and the miscarriages of justice which took so long to correct have shaken the credibility of British policing and appeal procedures. Against this background, members of the IRA who are convicted have consistently maintained their demands for political status, and have resorted to various strategies to foil the penal system. They have escaped from the prisons or escaped extradition from Eire to Britain; if imprisoned they have lived in excrement and (especially in 1981) carried out hunger strikes to the death. From the official perspective, all these acts deepen the crime.

THE PHOTOFIT

Downgrading a small war to a crime-wave has not been a simple or coherent process, and remains incomplete. For instance, in September 1990 the IRA shot and badly wounded Sir Peter Terry, the retired Governor and Commander in Chief of Gibraltar at the time the three IRA members were killed by the SAS. Departing radically from the usual position, Mrs Thatcher referred to the IRA's campaign as 'guerrilla warfare', appearing to give ground to the attackers' point of view. As if realizing her mistake, she immediately altered the emphasis and restated the orthodox position by saying, 'They are acting under what they regard as the rules of war and we are acting under the general law of the land.... They are at war with us

and we can only fight them with the civil law'.[47] This slippage was front-page news in the *Independent*: under the headline 'PM Condemns IRA "War"', the report said that Mrs Thatcher 'later denied...that she had conferred military status on the IRA. She said: "They are thugs – that's all".'[48]

Governments have found this distinction between war and crime easier to place in speeches and thereby promote through the media than to maintain the idea in international law. Despite the movement to 'normalization' between 1971 and 1984, successive governments were in danger of breaching the European Convention of Human Rights, and used derogation powers to free themselves of its obligations and protect their 'emergency provisions' under the Prevention of Terrorism Act. The Labour Government introduced the Act in 1974 following the Birmingham bombings which killed twenty-one people. The 'temporary' Act was renewed in 1976 and 1984 and made permanent, with increased scope, in 1989, extending over the whole of the United Kingdom.[49] It gives the state powers to ban organizations, to seize 'laundered' money from banks and to deport or detain individuals for seven days without judicial scrutiny. After 1984, with the emphasis upon public order, derogation was withdrawn until 1989: a clause was then introduced into the Act which enabled suspects to be detained for a week without a court order. The European Court of Human Rights ruled that the British government had breached the Convention.[50] In response, the government did not abandon the provision, but once again derogated from the Convention, moving away from Europe and the judiciary and towards increased powers for ministers of the Crown in 'emergency'.

These contradictory moves between war and crime-wave have been in some cases ignored by the press, possibly because they are legalistic and therefore difficult to represent. It is much simpler to picture the 'enemy' as different. One strategy arising from the policy of 'normalization' was to enmesh the terrorists, especially the republicans, in the codes of criminality through routine procedures of police investigation. Picturing them has played its part in this, notably in the artist's impression and the identikit or photofit. The latter can be built from photographs, or a similar image can be produced by computers: it looks like a photograph, but is made electronically – and is known as an E-fit.[51] The avowed function of the photofit is to make a likeness of the 'wanted' person to hasten their arrest. It has other uses, signifying police activity and the co-option of public support: in 1974, the *Daily Mirror* declared 'BLITZ on the Bombers' and reproduced 'faces on the terror file'.[52] In 1981, following the Chelsea nail-bomb, the *Sun* published photofits of the 'Evil Faces of the Nail Bombers', and said, 'Yard Pleads, Help Us Find IRA Fiends'.[53] More importantly, the photofit gives a 'face' to the terrorist. It is made up of bits that may or may not resemble the individual, but the appearance of the terrorist as a social type carries weight since it was constructed by experts.[54]

The police file shot is, as Stuart Hall says, 'a universal mythic sign – the face of all the "hard men" in history, the portrait of Everyman as a "dangerous wanted criminal".' It can make the subject look like the author of violent crime: 'This, it says, is the face of one of the "bombers and gunmen": this is what today's headline of another "senseless" explosion in downtown Belfast is all about.'[55]

The style of photograph is not new, but it marks the change in the perception of republicans as 'misguided patriots', whom Paul Johnson described as having 'far more in common with [the Moors murderers] Ian Brady and Myra Hindley', whose cadaverous faces recur in the tabloids as the embodiment of evil.[56]

The press, although seeking clear distinctions between 'good' and 'bad', has been confused by the move from war to crime-wave. In July 1976 the British ambassador in Dublin, Christopher Ewart-Biggs, was killed by a car bomb, and his death was announced on the front page of the *Daily Mirror* in an unequal mix of the signs of crime and terrorism: '£20,000 Reward for the Envoy's Callous Assassins'.[57]

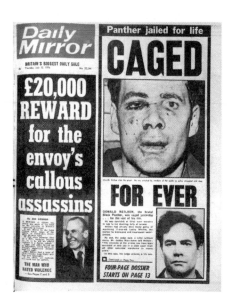

Daily Mirror,
22 July, 1976.

At one and the same time the headline is a typical police appeal to betrayal in the underworld, and a recognition of the political nature of the killing (the secretary who also died had no meaning in this dimension). A second headline inside the paper restated the political level of the killing with the word 'Executed!' – but immediately moved away from it to establish the irony and irrationality of the act in the phrase 'The Envoy Who Hated Violence'. Only two words in the headlines connote a political act, but they are at odds with the story which closes upon the senseless and the criminal. On the front page, the Mirror reproduced a portrait of the ambassador, which is standard practice; but it bolstered the meaning of the killing as the act of criminals by juxtaposing on the same page the photograph of a kidnapper and multi-murderer, the Black Panther, who had been sentenced to life imprisonment. Linked to the story of the envoy's 'assassination', the portrait of the Black Panther is fuller in meaning than a 'mug-shot': it stands for the unknown killers of the envoy in an unusual way, because it promises their fate (beaten and gaoled 'for ever').

As the *Mirror* commented, there is 'No Hiding Place', a phrase in common use and the title of a television series about fictional crime-busting by tough policing. The diplomat was pictured in happier times, as a family man. Squeezed between powerful signifiers, the linguistic hint of a political act is almost unreadable. It would not have been clear to a British audience that the IRA killed the ambassador because of his record in British intelligence, and because he was suspected of having been sent to Eire to co-ordinate the activities of the SAS in South Armagh.[58]

The absence of this information in the story is not necessarily a conscious desire by editors to dupe or deflect their readers from knowing that the IRA had a strategic reason for killing an intelligence 'spook'. The lack of depth and historical understanding is normal for the tabloids, and for the television news when it is tabloid in form. The event is presented as a bald fact and then as a personal tragedy. Omitted from the dominant structure are the inter-relations that may not justify it but may make it comprehensible.

THE SYMBOLIC USES OF THE DEAD

History was present in the story of the death of Christopher Ewart-Biggs, but it was a special kind of history – ceremonial and public, or apparently private, as in the family. These two levels are often brought together to give a death these particular meanings and no others.

Whereas the deaths of soldiers in the World Wars, and in the Falklands campaign, could be understood and celebrated as heroic sacrifice and honoured in inscriptions, no similar remembrance exists for the dead soldiers of the 'troubles'. In the most literal sense, their passing is unscripted.[59] The omission of their names in public places, on war memorials, is an official policy of refusal. This has no precise correspondence in the press, where dead soldiers do have a function, although it is one that foregrounds them partly as 'defenders' and partly as ordinary citizens, upholders of freedom and family men. Their absence means a new widow, a baby with no father, or unusually a mother who writes a letter of 'natural' reason against the madness.[60] The insanity of the IRA, the destruction of life, the misery of bereavement extend across society, regardless of differences in class and station.

When Lord Louis Mountbatten was assassinated by the IRA in 1979, the photographs of his life, which were on file in the newspaper picture libraries, realized their potential in the obituaries. The press chose to represent him as a symbol of the finest British qualities, including his life as a supreme family man. On 28 August, the *Daily Mail* deflected attention away from his controversial political

life and pictured him in the 'boat in which he died' on a 'happier family outing'. More importantly, Mountbatten had been a noble lord; and a soldier, statesman, hero. In the *Daily Mirror* he seemed powerful enough even to have returned from the dead to speak for himself in 'My Glorious Life – How a Royal Hero Recalled His Years of Triumph and Devoted Love'.[61] The man had always led a symbolic life. It was reproduced in photographs which gave him a perpetual presence, as if he would always be there.

In a combination which is typical of the press, the *Daily Mirror* countered his eternal presence with the ironic prediction of death: Mountbatten was reported to have said, 'I can't go on forever.... I'd rather snuff it out in a hurry.'

So his catastrophic death was both eerily predicted by the man himself, and countermanded in the display of pictures offering a kind of after-life, a postponement of that moment of forgetting, when the life and its meaning are irredeemably lost. What we see, through the unseen production of picture spreads in the newsroom, is the re-entry of the viceroy onto the stage, or the re-incorporation of a dead man into a loyal subject.

The story becomes a 'ritual of affirmation', in which the press reflects on 'the stability of the social system by showing it under threat, overcoming threat or working in a united consensual way'.[62] In the press the ceremonies of death recall an order that promises the general protection and prosperity of the people. They make sense of the appeal to nationalism, which is felt in a mystical way but is made material in photographs of Mountbatten in the trappings of high office. Opposed to this visible order is the violence of the IRA, reducing a public man to something fit for a shroud, making themselves 'evil men' (*Daily Mail*), 'wicked assassins' (*Sun*), 'psychopathic thugs' (*Daily Express*) and men with 'diseased minds' (*Daily Telegraph*). Only the *Daily Mirror* printed in full the IRA communiqué which talked of the assassination as 'one of the discriminating ways in which we can bring to the attention of the British people the continuing occupation of our country'.[63]

On the same day, 28 August, eighteen soldiers were killed in an ambush at Warrenpoint, but much less prominence was given to these deaths. The following day, when a photograph of the scene was available, the *Daily Mirror* reproduced it inside the newspaper with the caption 'Devastation: the mangled remains of an ambushed army convoy stands grotesquely amid the beautiful scenery of the Ulster countryside.'[64] This turned the usual theme of order/chaos into the disjunction of beauty and ugliness. Thus an address upon a planned act of war was obscured by the ritual language of ambush and wreckage, of treachery and despoliation. In this incident, the soldiers themselves and what they represented were nowhere to be seen. They were not re-incorporated because there were no ready obituaries of ordinary soldiers; instead the *Mirror* chose the theme of 'devastation', or the *absence* of soldiers (thus echoing, in a curious way, the official policy of disavowal).

More conventionally, on 29 August, the *Sun* reproduced portraits of some of the paratroopers, repeating the word 'dead' under each of them and again in the headline, 'Paras Mourn Their Dead'.[65] Still no link was made between their deaths and that of Mountbatten.

 Only the *Mail* made the link. It carried a 'picture story of the life and family' of a soldier whose album they had obtained. The headline declared 'He Also Served', and the soldier was said to have been a man who 'had a lot in common with Lord Louis'.[66]

The IRA conflated the lives of Mountbatten and the soldier as symbolic and actual oppressors, and saw them, therefore, as legitimate targets. The *Mail* refused this particular reading, but used the same device: it conflated the lives of an aristocrat and a commoner. Although it is impossible to make a perfect match between the lives of people from such different strata of society, the press room ignored the contradictions in order to highlight the service of family men. The family is used to foreground the humanity of both, while their other attributes are tied together in public service.

The portraits of the dead in happier times are taken from a variety of sources: snapshots from family albums, photo-booth self-portraits, or head-and-shoulders passport photographs, taken with the sitter's consent. Invariably the people are either smiling or apparently contented. These expressions are in direct contrast to those in photographs a pathologist might use, or which might be produced in a coroner's court. Yet they support, rather than contradict, the brutality of sudden death. The portraits represent the character of the lives that the dead once possessed, and the reproduction of what has been lost can be more affecting than shock at photographs of broken bodies. The happiness which we see, conventionally, in portraits of people now dead is an ironical measure of the crime

Daily Mirror,
28 October, 1987.

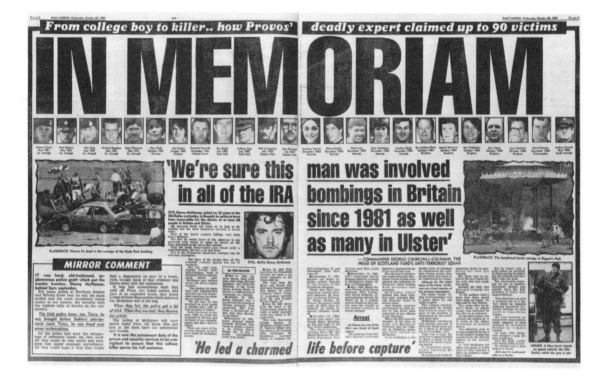

that killed them. Because similar family photographs of dead republicans may be withheld from the British press, they are often seen through police file mug-shots, which are another measure of their criminality. When available, snapshots of dead republicans in happier times can be turned against them. In August 1988 an SAS 'hit-squad' killed three members of an active service IRA unit, and in the *Star*, they were called 'Laughing Monsters', and 'smirking IRA savages'.[67]

PICTURING TERRORISM AS EVIL CRIME

The media are drawn into fighting the enemy. In picturing violent incidents in 'plain photographic evidence', they show how (in the words of Paul Wilkinson) terrorists have 'failed to observe any laws or rules of war, how they have murdered women and children, the old and the sick, without compunction'.[68] Photographic realism reproduces images of death and injury which are the correlatives of disorder, the proof of madness and mayhem. This is clearly understood when the dead are not soldiers but innocents and unfortunates, represented in the *Daily Mirror* 'Like Lambs Led to Slaughter'.[69] Acts of terrorism are routinely seen to be the opposite of the forces of law and order, embodied in the police and paratroopers who offer comfort to the wounded.

Daily Mirror,
15 August, 1984.

Children are the most innocent of victims, caught in a web of events not of their making, and beyond their understanding. In 1970, in Belfast, they were pictured in the *Daily Mirror* playing 'The Riot Game', which the Bog-siders always won;[70] and in 1984 they were again at play in the *Daily Mirror* in 'Ulster – The Truth and the Tragedy'.[71] Children are evacuees and refugees, seen to scrabble in the wreckage of the family home for an improbable but meaningful memento, as we see, for example, in the caption, 'a little girl salvages her parents' wedding picture' in 1971.[72]

However deeply felt, the 'natural-ness' has to be represented, and in this process is shaped and so overlays the event with a particular colour, an ideological closure, an emotion or a verdict. The revulsion at the death of innocence in children may, in the media, become a campaign which furthers the political aims of the state without its direct interference: this can be seen in the press coverage of the Women for Peace Movement. The Movement began in 1976, with the deaths in early August of three children of Mrs Maguire (two died at once and another later in hospital).

Accounts of how the children died vary, according to the perspective of the author of the account. Alan Hooper, a military expert on the media working within the official perspective, said only that 'The [peace] movement grew out of a tragic accident in which three small children were knocked down and killed by a car containing IRA gunmen, which was being pursued by the army'.[73]

This is a minimal and misleading account. There was more official information in the press reports of the incident. The *Daily Mail* headline was 'Runaway Provo Car Kills Baby and Child'.[74] The text at first gave the impression that the driver of the car was shot dead after he had killed the children, though later made it clear that the driver was shot during the chase and lost control of the car when he was dying. All other press reports, following the official sources, also said that a gunman in the car had opened fire with his rifle.

Not all the press saw this event as a momentous story: for instance, in the *Belfast Telegraph* it was relegated to page nine.[75] But the *Daily Mail* and the *Daily Mirror* carried different photographs of the scene on the front page. The *Mirror*'s use of its photograph lifted the deaths out of the usual 'staccato procession' of events into a different order of signification, in which a crushed pram, a shattered bike and railings became a 'monument' and a 'symbol' of 'hatred'.[76]

For the BBC journalist Martin Bell, who arrived soon after the incident and interviewed a child straight to camera, 'the whole of the Peace Movement ... began out of one picture of a smashed tricycle and an interview with a nine year old boy'.[77] Martin Bell was speaking at a seminar on terrorism to an audience of military personnel who were concerned as usual with what they perceived as the damaging bias of the media and were doubtful about the BBC in particular. Anxious to put his professional practice in the best possible light, Bell said, 'simply by reporting it we had a pacifying effect on the situation. The Peace Movement took off and became widely known'.

The story seems straightforward. After being ambushed, the army fired upon a getaway car and killed the driver; the car then struck the Maguire children and killed them. The media played down the role of the British Army and reported the event as arising principally from IRA action. The deaths of the children alone were mourned, and given special significance as more than an accident. The deaths were a 'tragedy', but meaningful: 'hatred' was turnrd into a movement for peace.

Roger Faligot gave a different account of the circumstances surrounding all the deaths. The rifle in the car was dismantled; according to Mrs Maguire (who later killed herself) and the post-mortem (which is not open to scrutiny), the children were hit by army bullets before the car crushed them; the army need not have fired at all, as the street was blocked by an armoured car.[78]

The deaths of the children were unexpected, but they could be used as part of a larger design. This had been described in 1971 by (General Sir) Frank Kitson,

Daily Mirror,
11 August, 1976.

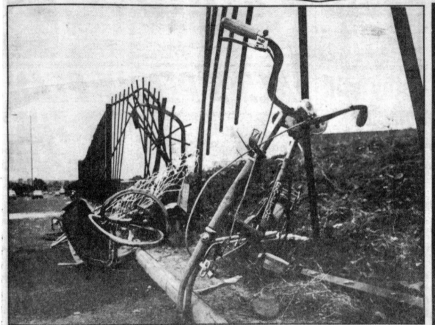

Daily Mirror

BRITAIN'S BIGGEST DAILY SALE

6p Wednesday, August 11, 1976 No. 22,561

DATELINE ULSTER

A crushed pram .. a shattered bike .. and two children are dead

MONUMENT TO HATRED

EVEN in tortured Ulster, where sudden death is commonplace, this picture stands as a stark symbol of hatred.

A baby was being walked in that crushed pram yesterday . . .

A little girl was riding that shattered bike . . .

Then a terrorist getaway car careered out of control—and their young lives were snuffed out. Their mother was critically hurt. So was their brother.

One terrorist died and another was gunned down by troops.

The first act of the tragedy was the ambushing of an Army patrol in the Republican Andersonstown area of Belfast. Three men fired at troops from a butcher's shop. When the troops

fired back they fled. Two jumped into a car. Troops chased them in a Jeep.

One of the terrorists opened up on the Jeep with an Armalite rifle. The soldiers shot up the car, hitting both men.

The badly injured driver swerved into Finaghy Road—and lost control.

The car crashed across a pavement, pinning seven-year-old cyclist Joanne

Continued on Page Two

━ BELFAST REPORTERS ━
JOHN HICKS and
MALCOLM NICHOLL
Picture: STANLEY MATCHETT

then the leading strategist on fighting terrorism (he was knighted in 1980 and in 1982 became Commander in Chief of UK Land Forces). In his book *Low Intensity Operations*, which became the standard work on the subject, Kitson had written of three ways to separate the mass of people from the enemy leaders: first, to implement concessions; second, to 'discover and neutralize the genuine subversive element'; and third, to 'associate as many prominent members of the population, especially those who have been engaged in non-violent action, with the government. This last technique is known in America as co-optation and is described ... as drowning the revolution in baby's milk.'[79] The purpose was politically to isolate the IRA from the population of the ghettos.

A number of small-scale and short-lived moves for peace had been made amongst civilians before 1976, but none of them became running stories in the press, nor met the requirements of Kitson's strategy. The Women for Peace Movement was quite different. It seemed at first to unify the communities, but this phase ended later in August. On the day a big peace march took place in Belfast, the army shot dead a twelve-year-old Catholic girl. The leaders of the Peace Movement refused to be drawn into the controversy and to denounce this killing. Two days later they said, 'We totally support law and order in Northern Ireland. The RUC and other security forces are the legitimate defenders of law and order.'[80] This position alienated and isolated the Peace Movement from the Catholic population. The Movement's continuing publicity broadcast their belief that the enemies of peace were the armed republicans – 'We Back the Army Say Peace Women' in the *Daily Mirror*.[81]

The spotlight of media attention shone on the Peace Movement, obscuring the policy of Ulsterization. Relatively little publicity was given to plastic bullets, the withdrawal of political status in the gaols, the use of torture (redefined in the UK as 'inhuman and degrading treatment' by the European court)[82] and the official extension of SAS activities announced earlier in the year.

The views of the Peace Women were given an international platform in November 1976 when the Labour Government, for the first time in four years, lifted the Trafalgar Square ban on demonstrations related to Ireland.[83] The peace rally brought together many of the leaders of the British establishment. Airey Neave, the Conservative Shadow Minister for Northern Ireland (who was later killed by the INLA) said, 'The Peace Movement in Northern Ireland has provided a splendid opportunity to mount a more effective counter-campaign against expert left-wing propaganda.'[84] The pictures of the Peace Movement, taken in the framework of Trafalgar Square and with the support of establishment figures, offered the evidence of realism in support of the dominant meaning.

The official point of view is commonsensical and so believes that pictorial realism is strikingly useful in altering behaviour. To provoke anger and

enlist support for the actions of the legal forces, a government recruiting campaign for the RUC used a shocking photograph of a victim of terrorism – a body burned beyond recognition. At the same time, and still within the official perspective, there is a countervailing opinion which has limited the use of shock photographs. Realism might have unforeseen results: it might induce a crusade of reprisals. Another reason for restrictions in the representation of violence is 'good taste': in 1979 the RUC decided not to use photographs of the fragmented corpses of bomb victims in recruitment posters 'out of respect for the families concerned'.[85]

The constraint of decency may vary according to the preferred meaning of the crime. In 1974, when bombs exploded in Birmingham, the *Daily Mail* used a photograph of a policeman carrying a plastic bag containing bits of a body, a scene so outrageous it justified the headline call for a return to capital punishment.[86] The shocking picture is used to signal the rupture in the even-toned decency that is taken to be customary in British life.

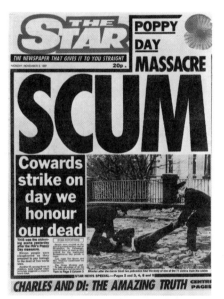

The Star, 9 November, 1987.

Photographs prove that foreign mayhem has arrived in the country, that an alien presence is amongst 'us'; they can be useful in the clamour for revenge. '"Hang 'em" say *Sun* readers' of IRA terrorists after eleven people were killed by the Provisional IRA in Enniskillen on Remembrance Sunday, 8 November 1987 in what the popular press called the 'Poppy Day Massacre'.[87] The tabloids made the link in various graphic images of the poppy: the *Star* and *Daily Express* printed it in red: in the *Daily Mail* it was red and broken; the *Sun* had it dripping blood. In addition to these devices and the obvious naming of the 'massacre', the photographs of the wreckage and the covered bodies in the foreground were placed in ironic and bitter contrast with the ceremony of Remembrance. In the typography, text and layout of the popular press there was no mistaking the public face of anger: 'Poppy Day of Blood' and 'Bombers "Are a Blot on Mankind"', said the *Daily Mirror*; 'Scum', said the *Star*.[88] The bomb had unusual symbolic resonance, which can be traced in the photographs that accompanied the story.

For the tabloids, the sign of the poppy was used to emphasize the violation of a national day of mourning. In the photographs, it was the sense of shock and outrage that was to be dominant. In most of them the dead were covered but still lay in the street. One of these pictures, used inside *Today*, the *Sun*, the *Guardian* and on the front page of the *Daily Express*, contained the peculiar detail of a survivor (half-turning towards the cameraman), who appeared to be strolling in his 'Sunday best' beside the rubble and a corpse. This surreal oddity pointed to the immediacy of the photograph and served to emphasize the chaos and disorientation of those at the scene. This man had gone to mourn the dead in *general* and found himself amongst the dead in *particular*. In the *Guardian*, this photograph was placed alongside another, taken from an 'amateur' video used on the television news: on the page, the image was fractured, almost unreadable, disintegrating – an appropriate symptom of the day's event.[89]

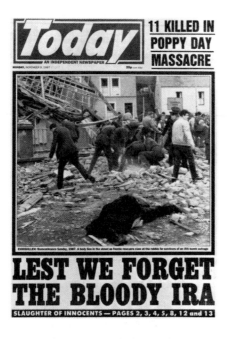

Today.
9 November, 1987.

The strangeness was overlayed by other, more positive and unifying, incidents and pictures. Representative of these was the composition used on the front page of *Today*, where we see the dead body of a victim and 'frantic' rescuers 'clawing at the rubble', or the organized rescue, pictured across the front and back pages of the *Daily Mirror*, in which we see firemen and heavy machinery at work.[90]

Even this visible alteration in the scene, from death and injury to the restoration of values through the work of rescue was taken further, into the realm of the symbolism of honoured dead. All the papers made reference to the meaning of the day; and although pictures of the Enniskillen war memorial were printed on the inside pages of the *Mirror* and *Today*, only the *Independent* used this picture on the front page, eschewing the corpses of the day to remark upon the 'Glorious dead dishonoured'.[91] Here, unusually, the emphasis lay upon the enormity of desecrating a symbol and a memory: in terms of newspaper practice, usually based in the value of shock news and human interest, the choice of this photograph as a lead was almost perverse. At this first stage of reporting the incident, the *Independent* marked the furthest reach into the symbolic and the furthest distance from the macabre but stereotypical

photographs of the newly dead.

Later, when the mood had returned to quiet resolution and mourning, led notably by press coverage of the fortitude of the parents of the youngest victim, the war memorial became a more 'natural' symbol, and figured prominently in the pictures of funerals and of the Remembrance Day Service when it was finally held.

The Enniskillen bomb was made to fit into a familiar narrative: death and destruction, rescue and comfort, calls for reprisals and political action, sad funerals and the quiet resolution never to be defeated by the terrorists. This sequence was accompanied, and its normality accentuated by, the evidence of photographic realism. A complete and sufficient story and explanation are offered; there seems to

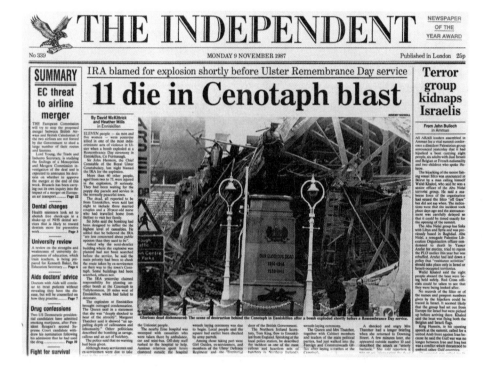

Independent,
9 November, 1987.

be no alternative, nothing else that is thinkable.

The bomb at Enniskillen revived the possibility of press attacks upon the Labour MP 'Red Ken' Livingstone, who said that the IRA would eventually 'win' and that 'as with all other colonial situations we have been involved in, Britain will go'.[92] These remarks provoked protest within the mainstream Parliamentary Labour Party, and a distancing by the leadership from such unpopular, unthinkable views.

The most pungent use of Livingstone's ideas to pillory the man himself appeared in the *Star*, which named him on the front-page as 'The Widow Maker'.[93] It asked the rhetorical question 'Victory to the IRA?', and answered it with 'tell that to all the widows and orphans, Mr Livingstone'. It combined the story with photographs of the IRA's 'first victim' – a soldier who died in 1971, 'but not in vain' said the *Star* – and, alongside, the portrait of the youngest of the Enniskillen dead, of whom it said, 'an angel died, but not in vain'.

That the newspaper should combine 'old' news with the latest incident, and suggest that these deaths had a *purpose*, indicates the narrow compass of the thinkable in the affairs of Northern Ireland. There is resolution in the face of terrorist acts and an almost fatalistic acceptance that people will continue to die. Some killings are seen as pointless and incomprehensible; others may be represented as 'tragic' and poignant. The press reports the 'revulsion' of people over the 'outrage', with the ritualistic hope and expression of grief that these deaths are 'not in vain'.

Occasionally, one newspaper may go further than its rivals in the display of horror, and further than its readers will readily accept. Following the killing of the Signals corporals in March 1988, the *Sunday Telegraph* was alone in publishing a front-page picture of a priest giving mouth-to-mouth resuscitation to one of the victims under the headline 'Murdered by the Mob – Two Soldiers Lynched by Funeral Thugs'.[94]

More capital was made out of this incident the next weekend, when, under the headline 'Should we have published lynching picture?', the editor printed fourteen letters as a sample of the 'shock and emotion' felt by many readers at the picture story.[95] Some made serious points. A serving officer said the pictures would distress the family of the dead. A woman said that journalism is cathartic. She described the 'weight of terrible emotion': she felt 'horror, revulsion, outrage and hatred', and then became 'increasingly calm and rational'. Finally, she decided that 'it was an excellent piece'.

Though most readers 'felt that the pictures should not have been used', the editor decided to publish 'because it told me more of the truth about the tragic events of the last weekend than any amount of words, however graphic'. He went on to describe his reaction to the picture as less disgusted than harrowed, 'rather as one might be looking at a picture of the Crucifixion'. So he felt it 'transcended the merely horrific'. The whole incident, including the parts played by writers and readers, was contained within the received opinion on documentary photography and its effectiveness. The letters are both a cross-section and a caricature of the paper's readers: one correspondent said, 'The photographs of the slain soldier greatly distressed me. I was put off my Sunday worship, my Sunday lunch and had a disturbed night's sleep.'

Sunday Telegraph,
20 March, 1988.

THE CYCLE OF REPRISALS

Since events do follow one another, day after day, it seems 'natural' that they should be read sequentially, as cause followed by effect. The random or staccato procession of facts can appear to have necessary connections, events following one another with logic. In the case of Northern Ireland, for the people who live there, the events arise from ideas about race and religion, about colonial oppression or the historical obligations of the Union. In the British newspapers, some of these reasons derive from crude but ancient prejudices about the Irish. Stories can be couched in terms of bewilderment at their perversity, using the rhetoric of the racist stereotype. Since the main framework for the stories is the common sense of British law and peace, it seems that havoc is wrought only by Irish hardhearts and madmen.

The appearance of cause and effect leaves much out of the account. The framework for action is much wider than the press reports; their framework for the interpretation and selection of 'facts' is already in existence, and has been for many years. In the most scandalous and public incidents it is possible to see the press apply a stereotypical frame of newsworthiness, setting apart the legal and illegal forces in ways as fixed as any that an 'expert' like Maurice Tugwell might employ.

An infamous case happened in 1988, when a cycle of reprisals was set in train by the SAS killings of the IRA active service unit in Gibraltar on 6 March. At the IRA funeral on 16 March a loyalist, Michael Stone, attacked the crowd at Milltown Cemetery in Belfast and killed three mourners. A few days later, on 19 March, the IRA held the funeral of Kevin Brady who had been killed by Michael Stone. Two corporals were not told of this funeral by their immediate superior and, apparently in ignorance, drove into it, were cornered and shot dead.[46] Obviously these incidents happened one after the other, but they did not only happen because of each other. The reasons for all three incidents run deep, and none of them can be explained with reference only to the immediate circumstances.

Firstly, the representation in press reports of the Gibraltar killings led in a direction which was predictable within news practice. The daily papers closed ranks with the government, with variations coming only from their different concepts of front-page news. On 8 March the headline in the *Daily Telegraph* was 'Dreadful Act of Terror Averted Howe Tells MPs'. This paper was alone in carrying a photograph of hijacked vehicles in west Belfast burning near a poster of 'the area's MP, Mr. Gerry Adams, leader of Sinn Fein'. The choice of words and picture not only widened the story to include the anger of nationalists in Northern Ireland, but also hinted at what might have been in Gibraltar. It was a front page that spoke of fear and firm government. Also on 8 March, and in a similar vein but a totally different

voice, the *Mirror* wanted more action. It carried a small photograph taken from Spanish television of Danny McCann lying dead in the street, but the headline said 'Find Evil Evelyn', the 'IRA girl hunted for Gibraltar bomb plot'. Readers still had cause to be afraid of, or at least excited by, the possibility of the-same-but-worse. The twin themes of resolution and fear were continued on 9 March by *Today* and the *Star*: the headline in the former said 'Rock Solid', and was accompanied by a photograph of colourful pageantry, the changing of the guard; the headline in the latter was 'Target London', and was illustrated by a collage in which Parliament was seen through a gunsight. The newspaper said, 'we reveal IRA plot to blitz London'. Some three days after the shootings, the papers had chosen which

The Star,
9 March, 1988.

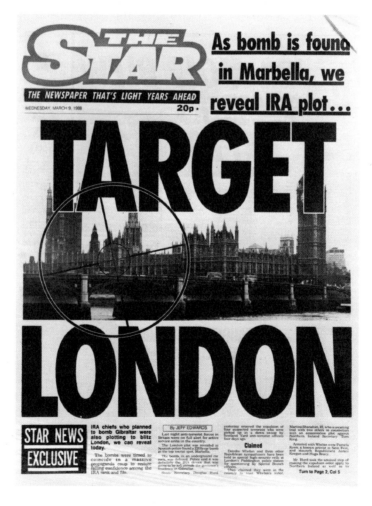

of the solutions they guessed their readers would prefer – reassurance and therefore confidence in government, or fear and therefore the expectation that government would strike even harder.

The latter is a constant promise. The SAS shootings were not the first nor most recent hard strikes against the IRA. In 1987 the SAS had ambushed and killed eight of their members (and a passer-by) at Loughgall. In the *Observer* this was reported as a clear warning to the terrorists: the headline was 'Ambush Signals New Assault on Provos – Terror Target that Became an IRA graveyard'.[97] These SAS attacks were unseen, but in contrast the next assault on the IRA was a spectacular media event (rivalling the SAS assault on the Iranian Embassy in London in 1980). Like these events, the loyalist Michael Stone killing republicans at Milltown Cemetery was clearly news. But, according to the press, he turned the SAS operations at Loughgall and Gibraltar inside out: he had gone both public and mad. The *Star* called him the 'kamikaze terrorist', and likened him to a fanatical and foreign enemy. No one mentioned that he may have proceeded even from a misguided belief in the legitimacy given by the state to street executions of the republican 'enemy'.

This would have been both embarrassing and unnecessary, since loyalists were already practised in summary political murders – and these have not stopped. On the contrary, there seems to be a swift reaction from loyalist gunmen when they persuade themselves that they have been given a 'lead' by the Crown. Blame for the murder of solicitor Patrick Finucane extended further than the internecine warfare of the Province. Before and after the killing, politicians had castigated a government spokesman for his irresponsible speech in Parliament concerning the legal representation of the IRA, saying he had pointed loyalist extremists towards this new type of victim.

Michael Stone and the killers of Patrick Finucane are always an em-barrassment to the government and to the press because they spoil the simple demarcation of 'them' from 'us'. The loyalists' excessive and religious zeal, leading to political assassinations and sectarian murders, is completely foreign to the core values of the English, commonly perceived (by the English, especially) to be the same as British values. Hence sectarian murders with a religious basis carried out between white people disturbs the concept of the race by being not-quite-British. This foreign behaviour among the Irish leads easily into the idea of madness. So the *Star*, one of the least reflective of the tabloids, typically represented Michael Stone as a loner. Its headline ran, 'Mad Dog – Crazed Killer Blasts Funeral'.[98] The need to place Stone beyond the pale was embraced even by proscribed loyalist groups and carried through to his trial, conviction and gaol sentence of a minimum of thirty years: a paramilitary leader said, 'Because of the Milltown business there's a bit of a myth about him. He's a hero figure to some. To me he's a lunatic.'[99]

However, all the national dailies, speaking with their own voices, joined in the same distancing used by the *Star*. *Today* also placed the incident in 'madness' in its headline 'Rampage of Tombstone Assassin'; the *Daily Mail* placed it in 'madness' within Ulster, a peculiar geographic and historical space full of 'bloodstained tribal enmity'; headlines in the *Guardian* and the *Independent* suggested no more than the killing of three people by a gunman at an IRA funeral, making no connections with 'mad' Ulster, but nor with the Gibraltar shootings. The only message possible in the British press after the Signals corporals were killed was the fanaticism and cruelty of the republicans, scarcely credible in civilized people.

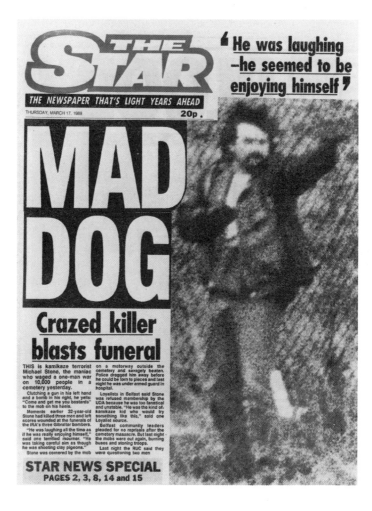

The Star,
9 March, 1988.

THE VIOLENT SOCIETY

The state can push the IRA criminals into oblivion because they are also terrorists. This is a contagion which could spread throughout society. At a seminar held at the Royal United Services Institute in 1973, the Conservative MP and member of the right-wing Monday Club, John Biggs-Davidson, spoke of the recent IRA bombing campaign. He said, 'What happened at Aldershot, what happened at the Old Bailey, reminds us that what happens in Londonderry is very relevant to what can happen in London, and if we lose in Belfast, we may have to fight in Brixton or Birmingham.'[100]

In the event, the army did not fight an 'urban guerrilla war' in these places, but in 1985 the police had to fight in these and other cities in Britain, as well as in pit-villages. So, although Biggs-Davidson may have been incorrect in forecasting the massive intrusion of terrorist warfare into Britain, his underlying belief in a 'we' who will have to 'fight' an 'enemy within' has found fulfilment in civil disorder.[101]

The idea of the enemy within was stretched to include all disaffected groups, widening the spheres of danger and vigilance, and turning the people on themselves. Once the term 'terrorist' is expanded (and diluted), it justifies increased surveillance at the micro-level of society, of small and particular groups or of individuals. Surveillance is now the norm. Aerial reconnaissance flights over Northern Ireland use infra-red cameras and image intensifiers 'to provide a microscopic layout of any area and recent changes or additions which might indicate arms caches'.v Video film is now commonly used to plot the movements of vehicles and to identify individuals in crowds, at riots, demonstrations, funerals and football matches. 'The price of liberty' said the *Sun* in 1974, 'is *eternal vigilance*: the consensus and its institutions are continually threatened by the subversive activities of a small but significant minority composed of agitators, militants, criminals, degenerates and extremists of all kinds.'[103]

As Steve Chibnall said in *Law-and-Order News*, written in 1977,

> The Gunman, Bomber and Thug are the shadowy and half-recognised spectres of anomie, the chaos of expectation, the disruption of the taken-for-granted – this is the key to understanding the peculiar generality of the law-and-order crisis, the reason why ... it becomes inseparable from the anxiety engendered when gasmen, miners and electrical workers withdraw their labour.... The murder of policemen, the bombing of cabinet ministers, the tarring and feathering of young girls in the Bogside are not so much separate causes as varied occasions for its expression.[104]

The most fundamental changes in the representation of events in Northern Ireland have to be seen in the context of broader changes. A revision of the ideas of the late 1960s began in the early 1970s: this included a retrenchment because of economic hardships and a general hardening of attitudes, subsequently legitimized by the Thatcher government in the name of individualism, freedom of choice and market forces.

Hard-hitting documentary photography was a genre that suited the era of protest, and whose gritty realism found favour in the new colour supplements. By the early 1980s, it had disappeared: the supplements were replete with advertising and editorial copy on the pleasures of conspicuous consumption.[105] The movement away from documentary-style photography was but one part of a shift that took effect across the range of social experience. The vigour of protest marchers faded before a combination of concession, piecemeal reform, apathy and harassment. The representation of protesters who remained, or re-grouped, changed in accord with the shift from novelty to boredom, from delight to mistrust. Civil rights campaigners became the activists of what the tabloid press represented as unpopular or 'loony left' causes such as gay rights, women's rights or Black rights. The 'flower power' of 1968, a protest at militarism and the role of the USA in Vietnam, withered before that war had ended; whilst support for the 'peace women' of the 1980s, camped outside the US military base at Greenham Common, withered before the arrival of Cruise missiles (and under the sustained attack of the popular press which portrayed the women as degenerates). The tolerated beatniks of the late 1960s became the parasitic communes and convoys of drug-crazed hippies, perceived to be so threatening to society in the mid-1980s that they were brutally dispersed by the police, with the aid of the Department of Health and Social Security.

Linked to the internal policing of dissent, but moving in a different direction, is the perception of terrorism as an international threat. In 1974 the *Sun* declared,

> There is a myth that the IRA are a band of patriots crusading for a united Catholic Ireland. They are not.... They are lepers, not leprechauns.... Behind the front lies something more sinister.... The destroyers. What we loosely call Marxists. The idea of international rebellion against all that most of us hold dear.[106]

The mode of address may be the *Sun*'s own, but not the sentiment. The appeal to the 'red menace' is common amongst the experts on terrorism, but it is a point of view that does not receive the unqualified assent of those, such as Paul Wilkinson, who claim to occupy the patriotic centre-ground, founded on common sense. Whilst he alludes to neo-Marxist and Trotskyist strains in

the Provisional IRA, and mentions their links with West European and Middle Eastern terrorist organizations, he says, 'it is very important that the significance of their international connections should not be exaggerated [since] PIRA has very deep roots in its own community'.[107] In other words, terrorism is not only an alien threat: it is nurtured within the democracy; the state harbours the enemy that would undo it. This representation of terrorism as something native, working from within, is more potent and therefore more usual than the xenophobic simplicity of the state under Russian siege. The models exist in tandem, but as the Russian army was never here, the threat of a communist takeover was harder to sustain, except as a diffuse fear, than the idea of the enemy within. Then events in late 1989 and 1990 completely defused the threat of communism in the West. Communism collapsed in Eastern Europe, the republics of the USSR sought democracy, Germany was reunified and the Cold War ended. Potent as these changes were, they did not dispel the fear of threat, which was simply transferred to other centres. From August 1990, the threat came from the state terrorism of Iraq, whose leader was popularly perceived in the West as a version of Hitler. Hence blame for events from 1939 to 1945 and from 1990 were placed upon the narrow base of individuals rather than wider aspects of history, economics and politics. The complexities of the issues were forgotten in the need for a simplified wicked ruler. The continuing presence of the threat shows that crisis is everywhere, in ever changing forms that includes the activities of the IRA and criminals on the streets.

Terrorism, then, is not widely understood to be the aberrant fantasy of right-wing politicians and sympathizers. It is a commonplace, a 'given' fact of the modern world. Its prevalence is more plausible if, as so often happens, the historical or local conditions of a terrorist attack are ignored. Hence Paul Wilkinson can draw together the assassination of Mrs Ghandi and the attempt on the life of Mrs Thatcher at Brighton in the same month of 1984, even though the similarities are superficial and less important than the historic differences that led to the attacks.[108]

This simplification is the standard practice of officials, and is a favoured piece of rhetoric in Prime Ministerial speeches. Another device is to allow definitions to slide, so that rationality and democratic institutions mutually imply each other. The terms 'freedom', 'democracy' and 'national interest' are interchangeable, and directly oppose a monolithic 'terrorism'. In a speech in 1984, Mrs Thatcher said,

> ironically it is the free societies which are most exposed to the evils of terrorism.... Democratic institutions [the terrorist] holds in contempt. His weapons are the gun and the bomb. Whether he pursues his callous trade in Brighton or in Beirut, in Belfast or in St. James Square, he must be brought to understand that his savagery will only strengthen our resolve.[109]

Here the Prime Minister has brought together the IRA, the Palestine Liberation Organisation (PLO) and the 'regime' of Colonel Gadaffi in Libya, whose officials killed a woman police officer during a demonstration outside their embassy in London.

When disparate groups are thrown together in this way, the prospect of any historical understanding of their political aims disappears. The whole politics and history of the world dwindles into a struggle between the forces of good and evil. So, from an orthodox point of view, 'the terror network'[110] is the weapon of illegal or criminal regimes, whereas the largely secret lawless actions of the strong state (such as the alleged policy of shoot-to-kill and assassinations), should they come to

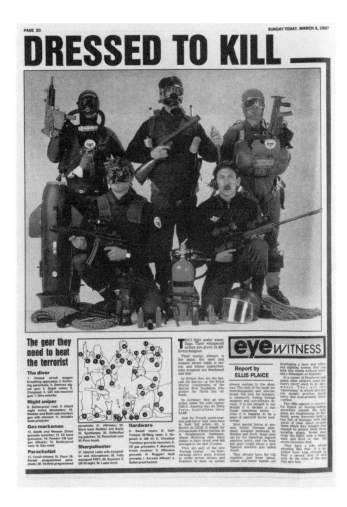

Sunday Today,
1 March, 1987.

light, are justified as counter-insurgency. In the press, or those television news bulletins and reviews that are constructed like the press, the depiction of acts of violence supports the official perspective.

One effect of the deep criminalization of the IRA, and their simultaneous elevation onto the 'world stage' as international terrorists, has been to justify the trickle of publicity for the special forces that must defeat them: so dangerous are they that the police have to learn anti-terrorist techniques. More importantly, crack military squads have to be trained to fight international terrorism. From the mid-1970s, the light of publicity was swung away from the ordinary soldiers in Northern Ireland and began to flicker across the SAS on undercover operations, when, for example, 'The Undercover Guardsman' Captain Nairac was (in the words of the *Daily Mirror*) 'Missing while on active service, believed *executed*'.[111] The SAS came emphatically into the open in the televised storming of the Iranian Embassy in 1980,[112] and received more publicity, along with the SBS and Marine Commandos, in the Falklands Campaign. In the late 1980s, they were presented as 'normal' front-line troops against terrorism. In the defunct *Sunday Today* they were pictured as the diver, the night sniper, the gas marksman, the parachutist and the sharpshooter, 'with the gear they need to beat the terrorist': 'they are part of the new "Foreign Legion" – an international secret army trained to strike across oceans and frontiers to meet an enemy always waiting in the shadows'.[113]

Terrorist crimes are presented as ceaseless waves of rackets, robberies, arson attacks, kidnaps, hijacks, bombings and mass or indiscriminate murders. Represented as a corruption of the social fabric, terrorism is proof of the crisis. Terrorism promotes interest in policing, in crimewatch and in neighbourhood watches; it suggests an increased interest in the private sphere, in the family and the home. All this becomes a model for the regeneration of the nation: as long as terrorism goes on being destructive, it provides imagery for making sense of the world.

SPREADING THE NET

Photographs of bomb damage, murders, arms caches, smugglers and kidnappers, or photofits of 'wanted' men and women, help to fix in place the idea of a rising tide of crime, which must be matched with a 'strong' response from the police.[114] This has received wide support when directed at terrorism, though when it spills into controlling crime and civil disorder, has led to the public increasingly losing confidence in the police. They have lost ground 'throughout the community, particularly among groups which used to be their strongest supporters – women, the elderly, whites, and residents of small towns and rural areas'.[115] In 1982, 43 per cent of people surveyed thought the police were doing a very good job compared

with only 25 per cent in 1990. Of course, the loss of confidence may signal a call for even stronger tactics. Certainly, the tide of crime, and the great amount of terrorist activity that can be included within this category, has a noticeable effect upon beliefs about 'out-laws': the attribution of 'terror' seeps into other 'criminal' sectors of society which had earlier escaped the net.

In this manoeuvre, of especial use is the concept of the assassin. The assassin is a special type of murderer, often fictionalized as cool and cunning. He can cut to the heart of society and tear it out. Since the Brighton bomb of 1984 had proved to be a weapon too imprecise for its target, the IRA were said by the *Daily Express*, in an 'exclusive' story during the 1987 General Election campaign, to have hired a gunman who 'has Mrs Thatcher in his sights'.[116] Under the headline 'IRA Killer Stalks Maggie', the paper reproduced 'the face of a hitman' and a smaller portrait of the Prime Minister herself, described as 'the target'. The text was authoritative, referring to warnings from the Ulster police intelligence unit, Special Branch officers, and SAS units hunting down the 'hitman on revenge trial'.

Daily Express,
18 May, 1987.

The IRA danger is seen by government and the press to be greatly increased through links with international terrorism. In this story the Provo killer was alleged to have used Libyan expertise, Czech weapons, Dutch and East German hideaways. The story ended in a greater chill (or thrill): if the hitman cannot shoot Mrs Thatcher, the next target could be a member of the Royal family.

Terrorism was seen to move in two directions: outwards, to join forces with other murderous groups in the international terror network; and inwards, thrusting towards Parliament and the monarchy, though usually satisfied with the peripheral victims of police and even 'innocent' shoppers or holiday-makers.[117] So 'we' are all threatened.

The outer terror network, which supports the incursion of the enemy into the interior, stretches wider than the IRA or the terrorist groups scattered along the shores of the Mediterranean. At the Commonwealth Conference in October 1987 Mrs Thatcher 'denounced the African National Congress as a "terrorist

organization" on a par with the PLO and the IRA'.[118]

Blacks remain potential enemies within the country, and are supposedly easy to identify. They can be political militants and ally themselves with 'our' enemies,[119] or they can be killers. On the same day in 1987 that the Prime Minister had declared the ANC to be part of the terrorist network, the *Sunday Express*, in an 'exclusive' story, embedded Black terrorism deep within Britain.[120] The headline 'Jackal Ordered to Kill Maggie' was accompanied by an artist's impression of a 'hunted' man, named and described as a 'black jackal', after the novel and film *The Day of the Jackal* which centred upon an attempt to kill President de Gaulle. The fictional element in the storyline was anchored to otherwise factual statements

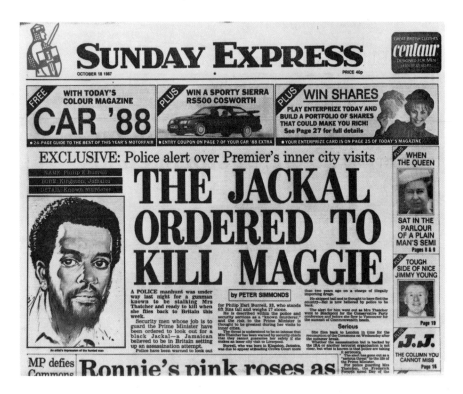

Sunday Express,
18 October, 1987.

about the IRA bomb in Brighton and Mrs Thatcher's visits to the inner cities. The text easily slipped between the factual and the fictive, moving from an account of the drug charge against the man into the untried but authoritative description of him by police and security services as a 'known murderer'.

The story is unambiguous: 'a police manhunt was underway last night for a gunman known to be stalking Mrs Thatcher and ready to kill'. The place that posed a threat so great that her safety could not be guaranteed was the inner city of

Liverpool. The good citizens of that place were given a picture to help them identify the would-be assassin. In its realism the drawing is close to photography: its lighting is similar to that in studio portraiture. The photographic likeness was useful, because it offered more information about the look of the man than the flat shapes of the photofit, which are always tentative. Here, the realism fleshed out the category of 'criminal' with a recognizable face to fit the name, a face with character, spirited, deceptively bland.

The realistic drawing is always moving between two points. One of them is the likeness of the 'known murderer', who could be identified on the basis of the picture; the other is the general type, a young black man with a characteristic (not just particular) physiognomy. The combination of the realisms of photography and drawing allow the representation to oscillate between the pictogram of 'blackness' and a photograph of an individual and dangerous Black, the one affecting the other.

The arrival of this man in Britain, unseen but suspected, was like the diagnosis of a virus, in this case a 'Black spot' which will make for the 'black spot' of Britain exemplified in the decay of Liverpool. From this degenerate haven the equally degenerate 'jackal' will seek to kill the Prime Minister.

At the end of the story, the *Sunday Express* said that senior Ministers were 'scandalised that the safety of the head of the democratically elected government cannot be guaranteed in one part of the United Kingdom'. Firstly, this criticized security chiefs, and secondly, it opened up the possibility of tough action.

In one day, the category of terrorism covered the IRA, the PLO, the ANC in South Africa (not apartheid), and actual as well as metaphoric blackness in Britain. The way to deal with this fearsome array of enemies is with more law and more force. Just as the *Daily Express* and *Sunday Express* are in the same company, this tale of the 'jackal' is the stable companion of the story about the IRA assassin. They relate to each other, and extend the concept of 'terror' across the whole social map of Britain.

In fact the ANC, then nominally headed by Nelson Mandela (since his release from detention in February 1990 he has become deputy president), is recognized by all other Commonwealth countries as the main Black political organization in South Africa, and the British Foreign Secretary had met Oliver Tambo, its leader in exile. These diplomatic niceties have to be swept aside if unambiguous lines are to be drawn between those who are for 'us' and those against 'us'.

Usually, there is a clear divide between the actions of states and the terrorisms of their opponents. The idea of terror as alien has clarity, and is more potent as an image and a concept than the confusing idea of terror as the imbroglio of friends with enemies. The clarity of definition extends to the different weights

given by governments, and most of the press, to the terrorist crimes of republicans and loyalists. In this case, the simplicity of a concept of terrorism which separates friends from enemies makes it resistant to new and contradictory information. Only in the face of overwhelming evidence will the government act against its public position. For instance, in April 1989, three loyalist members of Ulster Resistance were charged with arms offences in France after allegedly selling UK missile secrets to a South African diplomat in return for weapons. The government was embarrassed by the need for a clear response to South African support for terrorism because, until then, there had been no action against that state. In the words of the correspondent in the *Independent*,

> the lack of action by the British government against South Africa has upset only Africans and the Anti-Apartheid movement. Refusal to act against breaches of the arms embargo and attacks on the ANC in London may make a mockery of Mrs Thatcher's hard line on terrorism, but they do not hurt Britain. This time it is different. The weapons are being provided by South Africa to kill British citizens, perhaps even British soldiers on British soil....Who can doubt what Mrs Thatcher's reaction would have been if it had been Libya or Iran supplying the arms to terrorist organisations in the UK or attempting to steal UK military secrets?...Why should Britain be lenient towards South Africa?[121]

Early in May, three South African diplomats were expelled from London, which was an acknowledgement of the role of their government in the affair.[122]

Changes in world politics, especially in South Africa, forced the British Government to change too, so that the ANC was carefully separated from the IRA. After Mandela's release, he travelled the world and in July 1990 came to Britain to talk to Mrs Thatcher. The day before he arrived, he had been in Eire and appeared to suggest that the British should talk to the IRA without that movement first abandoning violence. According to the report in the *Independent*, he said, 'There's nothing better than opposites sitting down to resolve problems by peaceful means.... People are slaughtering one another when they could sit down and discuss the problems in a peaceful manner'.[123]

When he was later asked whether he might be a supporter of the IRA 'armed struggle', he tried to defuse the 'controversy' in which he had been caught without intending it. He said that in response to an uninvited question about the IRA, he had restated the 'well-known position of the African National Congress of an end to man-made death anywhere and everywhere'. These general remarks, denying a relationship between the ANC and the IRA, were in contrast to the admitted ANC

contacts with the PLO, Libya and Cuba. 'We are a liberation movement and they support our struggle to the hilt', he said. The difficulties that might be raised by Mandela's remarks were brushed aside by the Government. As the *Independent* said, Mrs Thatcher 'does not appear to believe' allegations that the ANC 'has had a regular and long-standing relationship with the IRA'. For the Government, the meeting with Mandela was already 'sensitive', including a discussion of sanctions against South Africa and the continuation of the ANC's 'armed struggle'. The Government would now have to explain its attitude to the IRA. In this context, and in the interests of exploring a solution to apartheid, it was politic that the ANC at least should be rehabilitated.

Independent,
3 July, 1990.
Photograph:
Pacemaker.

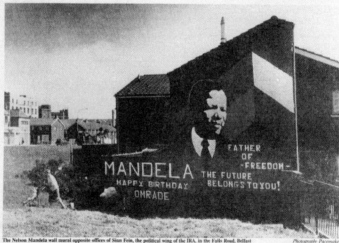

THE INDEPENDENT

No 1,161 TUESDAY 3 JULY 1990 ★★ Published in London 35p

Mandela seeks to defuse IRA row

SUMMARY

Rebels cut routes out of Monrovia

Rebels attacked Monrovia in a two-pronged offensive last night, cutting all major land routes out of the Liberian capital. The US has offered to help the embattled President, Samuel Doe, to leave Page 10

TODAY: 16-PAGE SPECIAL REPORT
Fleet and executive cars

Opting-out battle

Plans to thwart the government drive to encourage schools to opt out of local authority control are being drawn up in council offices Page 5

Health market

The first three hospitals applied for self-governing trust status Page 6

10,000 jobs to go

Philips, the ailing Dutch electronics firm, says results will show a net loss of 2bn guilders (£615m) this year and 10,000 jobs will go Page 18
View from City Road, page 21

Bested by Becker

Boris Becker produced his best tennis of the Wimbledon tournament to defeat Pat Cash in straight sets. Steffi Graf beat the 14-year-old American Jennifer Capriati 6-2, 6-4 .. Page 30

Backley record

Steve Backley, Britain's Commonwealth Games javelin champion, set a world record of 89.58 metres with his first throw at a Grand Prix meeting in Stockholm Page 30

Storm follows suggestion that talks should not depend on renunciation of violence

By Richard Dowden, Alan Murdoch and Colin Brown

ON THE EVE of his crucial meeting with the Prime Minister, Nelson Mandela is trying to defuse the storm which followed his suggestion yesterday that the Government should talk to the IRA without the movement first abandoning violence.

His remarks, made in Dublin before he flew to London last night, embarrassed his friends and created an awkwardness which Downing Street and the African National Congress were hoping to avoid before tomorrow's sensitive meeting with Margaret Thatcher.

MPs condemned Mr Mandela's suggestion of talks with the IRA, but there seems to be an acceptance that it was made because of bad advice rather than any desire to stir up controversy. The only person to interpret his words favourably was Gerry Adams, of Sinn Fein. He welcomed the ANC leader's remarks and said he was "prepared to co-operate and to engage in talks".

Speaking at a joint news conference in Dublin with the Irish Prime Minister Charles Haughey, Mr Mandela, the ANC deputy president, was careful not to endorse the IRA and denied that there had been any meetings between the ANC and the IRA. But asked persistently for his views on Northern Ireland, he said: "I would like to see the British government and the IRA adopt precisely the line we have taken. There's nothing better than oppo-

The Nelson Mandela wall mural opposite offices of Sinn Fein, the political wing of the IRA, in the Falls Road, Belfast

Photograph: Pacemaker

sites sitting down to resolve problems by peaceful means.

Pointing to the Rhodesian experience, he said: "The British government, without insisting that anyone should lay down their arms, got involved and was able to press people to conclude a peace

agreement. That is a precedent which should not just apply to African political organisations which are fighting a white government. It is a principle that should be applied in all similar situations."

Asked if he was aware that the IRA commanded only a small mi-

nority of support, Mr Mandela replied: "That's not the issue. The issue is that people are slaughtering one another when they could sit down and discuss the problems in a peaceful manner." Asked later whether he might be taken for a supporter of IRA "armed

struggle", he said: "I am stating what I believe in."

But last night, attempting to defuse the controversy, Mr Mandela said: "It saddens me that as we leave Ireland we find ourselves dragged into a controversy that is not of our making and which we

never intended. This morning a question which we did not invite was asked of us about the IRA. In response we reiterated the well-known positions of the African National Congress of an end to man-made death anywhere and everywhere. We reiterated the

view ... that the violence should stop, as should the mutual slaughter, and that all concerned could, as with other situations of conflict, find a way to establish peace. We do not prescribe to anyone as to how this should be achieved."

Neil Kinnock, a firm supporter of Mr Mandela and his politics, had said earlier that the ANC leader might have been extremely badly advised about the IRA. The Labour leader said that he would raise the matter with Mr Mandela when they met tomorrow. "I have a friendly relationship with Mr Mandela. I am sure that will endure," he said. "But as a friend, I owe it to him to say that the Provisional IRA are a bunch of murderous gangsters."

By contrast, Downing Street sought to play down the remarks, suggesting that Mr Mandela might have been speaking to his own constituency, and seeking to justify the refusal of the ANC to renounce violence. Mrs Thatcher does not appear to believe allegations by Andrew Hunter, the Tory MP for Basingstoke that the ANC has had a regular and long-standing relationship with the IRA.

Nevertheless it is understood Mrs Thatcher will feel constrained to explain the Government's attitude to the IRA — adding another sensitive subject to an agenda that includes sanctions against South Africa and the continuation of the ANC's "armed struggle".

Mr Mandela's denial of a relationship between the ANC and the IRA stands in contrast to his attitude to the PLO, Libya and Cuba, for which he was strongly criticised in the United States. There he admitted and defended ANC contact with Yasser Arafat, Colonel Gaddafi and Fidel Castro, saying it was wrong to suggest "our enemies are your enemies. We are a liberation movement and they support our struggle to the hilt," he said.

Black workers strike, page 8
Fit for high office, page 17
Leading article, page 18

Pilgrims die of suffocation in

Gorbachev attacks left and right

AS CONSERVATIVES and radical reformers joined battle for the future of the Soviet Communist

From Rupert Cornwell in Moscow

Mr Gorbachev rejected the "depoliticisation" of the army, the KGB and court system and re-

Although his survival as party leader is scarcely in question, the congress's final outcome is far

6

THE BODY IN THE PRESS

In wartime and after, people have recorded the pleasure, boredom and fears of soldiering; and on the home front there are similar records of bonding, fear and indifference. In the First and Second World Wars, these experiences and records were 'national': everyone in Britain was touched by them. The Falklands campaign also existed as a 'national' experience, despite the relatively few people in danger. It was national because the enterprise was a risk for government, and a venture that derived from ideas and feelings about patriotism. For many years patriotism had been ill-defined, unfashionable, or corralled by the National Front and other racists. The Falklands campaign was represented as reviving patriotism for everyone.

In these three wars, blood was sacrifice: it was spilt for sovereignty and freedom. The wars were moral and defensible, and were so described and seen in the media of their day. They had goals that could be clearly defined, and could end in clear-cut victory: the defeat of the 'Hun'; the defeat of the European fascist and the Japanese; the defeat of the South American fascist. To reach these goals was to end the story.

In the case of Northern Ireland, there is a place for the concepts of sovereignty and patriotism and even of sacrifice. Otherwise, the situation and its representation are entirely different from the straightforward wars. The active enemy is small in number, a guerrilla army: it cannot be identified easily and simply wiped out. The internal logic of the conflict precludes a clear-cut settlement, and so the story seems to be never-ending.

This ragged, endless shape owes something to the historical origins of the campaign and something to press practice. Firstly, for both republicans and loyalists the historical perspective is very long, and the desired outcome is known. But for

those on the mainland who have little knowledge of Irish affairs, there is no perspective at all other than the peculiar distortion that arises from seeing only periodic acts of terror. Everyday press practice avoids stories without ends. It deals in 'events', and so it responds directly to terrorist 'outrages'. Each of them is a nugget in news terms – small, discrete and laden with the saleable value of human interest.

In the absence of an open war with a clear narrative, the press aligns terrorism with the fear of horrible deaths. Both are everywhere, and can be mapped onto each other. Both have news value in their daily eruptions because they seem so arbitrary, sudden and complete. Exactly like cruel fate, which is a universal mark of unreason in nature, what terrorists do is inhuman: they both test human frailty, destroy aspiration, hope and progress. The terror is that of death – a dread for particular individuals, an experience for everyone *in the end*; but death becomes especially newsworthy if it is fateful and murderous. Political murder is poignant (within the form of the human interest story) if the *undeserving* are killed; and so random death amongst civilians can be 'national' news. This convergence is not surprising since many politically motivated acts have brought terrible deaths to 'innocent' civilians. When an aircraft crashes and people fall miles to their deaths, investigators seek pilot error, structural failure and a terrorist bomb in the hold.

At the level of 'nation', terror is imaginative and ironic. The author of *The Satanic Verses*, Salman Rushdie, thought he was writing no more than a novel. No text can be limited to ideal readers and, in this case, the book was broken into parts, translated in fragments and travelled as rumour in the Islamic world. There it was transformed into prize money for murder, a contrary moral crusade and a shower of death warrants – for some already signed, sealed and delivered. The terror awakened everyone to the possibility of more terrorist bombs on aircraft, embroiled governments in unexpected confrontations, stirred up race hatred, fuelled nationalism, and sold newspapers.

Photographic realism infiltrates stories of terror, and stamps them with the authority of verified fact, but is bound to fit the conventions of storytelling. When terrorists blew up the Pan American jet over Lockerbie on 21 December 1988, the town was too far away from the newspaper production centres, and the time too close to deadlines, for any details to make the national newspapers the following day. Instead, readers who may well have heard the news first on radio or television were attracted to the press by classically bold headlines, as in the *Daily Mirror*'s 'Air Crash Wipes out Town'.[1] There were no pictures, and only the briefest (mis)statement of facts. On its inside pages, the *Mirror* continued with its usual diet of diversionary tales.

By the evening of 22 December, the regional evening newspapers such as the Birmingham *Evening Mail* were publishing photographs taken the previous night,

and printing accounts over several pages of the wreckage and carnage.

On the following day, 23 December, the national tabloids and broadsheets responded with the most complete story packs: there were even more photographs, taken in daylight, and more reports of the scene, more thoughts on the culprits; and, crucially, lengthy descriptions of some of the dead and grieving.

The effects of terror could be read and seen in a sufficiency of detail, enough to produce in some a surfeit of horror, or to induce boredom. Nevertheless, there was a gap between the written and pictorial records. The photographs of corpses that were published either were taken from a distance, or showed them draped and flagged by the police. Either the photo-journalists did not take pictures of the most gruesome sights they saw, or none of these was published in the British press, which in these matters of 'taste' practises a degree of restraint. Both the *Mirror* and *Today* chose to print heavily symbolic pictures – the cockpit seen from a graveyard. There are exceptions to this self-restraint, generally in the case of terrorism, and notably in the case of the deaths in the crowd at the football match in Sheffield, when the suffocations unfolded over several minutes in front of television cameras and photo-journalists. This placed them in a new situation – watching people die slowly: subsequently, the issue became for the editors of the news a question of taste in relation to pictures of British dead. How much would they dare show? In all the papers the disaster was represented in unusually horrific photographs, and there were complaints to the Press Council about the coverage in the *Mirror* which published a unique close-up of victims.

Usually, it is not the process of dying which is visible in the press, only the aftermath; and then much of the thrill lies in imagining the process. How great was the terror? How completely was the body destroyed? At Lockerbie, no pictures matched the language of the writers, who did not baulk at describing people in states of reduction, from 'shattered bodies' to 'mangled remains' to 'scraps of flesh'. Yet even in this worst terrorist attack in Britain, the stories are not more extensive or in any way unusual among press reports of mass deaths. At the same time, despite the gruesome press language, it is still conventional and restrained in describing detail. The conventions of press language are parallel to those of photo-journalism, both operating within boundaries. Newspapers do not look or read like pathologists' reports or medical journals. The pictures and descriptions are horrible enough, but not the same as being there. The explanation for the parallel unreality of prose and pictures lies in forms of rhetoric.

Experience either cannot be described, or language exhausts itself in the attempt: it 'beggars description'. Hence the terror remains an experience and an imaginative construct, but the two are not necessarily or even likely to be the same. In addition, though facts and feelings remain elusive in language, they are more nearly described than some other properties given to objects, such as moral worth.

Photographs are just as limited as a map of experience and morality by the gap which exists between their realism of representation and the reality of experience. Even so, photographs are sufficiently useful as an acceptable index of 'the real'; and it is as a sufficient map of reality that both prose and pictures are printed in newspapers. In addition, both have a purpose there, which in sum is the purpose of news: a secular vision of heaven and hell, in which the present pleasures of consumption stave off intimations of mortality.

Photographic realism delivers interwoven pleasures: 'history itself' in the currency of the document, the fascination of human interest, and the dream of unity. No single photograph could carry this weight of potential meaning, nor needs to, because the pleasures are always related in a context that is practised every day and has been commonplace for as long as anyone can remember. It is the utterly limpid and normal look of realism and its enchantments that support the content of news-value, gathering around the spectacular and the stereotypical.

The stereotype may be used 'to preserve our illusion of control over the world'.[2] It is a deeply-seated measure of differentiation commonly used to make visible those groups whom 'we' wish to place as lesser than 'ourselves' and more dangerous than 'we' are. In recent times, in representing terrorism, civil conflict and the centrality of the law, the threat has been spread through the country, and attached to particular groups within it. The threat is not evenly distributed, nor has it been emptied of the taint of the foreign. These two factors help locate it in stereotypical places such as inner cities which 'decay', and amongst people made stereotypical, such as criminals, Blacks, youths, deviants and militants.

The importance in news-value of the spectacular event and its representation in pictures is connected to the hope of everlasting movement and to its impossibility. Press practice demands that photo-journalists see everything, whether the life-styles of 'good' consumers in the world of actual or comparative wealth and 'normality'; or their contradiction in poverty and then in death.

The stereotypical world is both dangerous and exciting, and so is the world in the newspapers. Side by side, and often overlapping, are the agencies of life and death. They appear in a variety of styles that are complementary rather than mutually exclusive: there are life-styles (the real as heaven) and death-styles (the real as hell). The seeming bipolarities of heaven/hell or life/death are linked so that the distinctions remain but the fascinating extremes draw near. Life-style is in 'goods' and present pleasures; death-style is in terror and pleasure that is eternally deferred. In the search for ironies in the cruel deaths of 'victims', it is always considered newsworthy if they died on a 'shopping spree': in that case, the tickets to oblivion were more than they 'bargained for'. Readers may comfort themselves with still being able to enjoy the stories, and may imagine enjoying the 'goods' that are often advertised on the same pages, close to the miseries of consumption ended.

News-value is found in both styles of the real, in horror and in entertainments, and in the rich vein of transfers between them.

Fascination can be fed, and even desire kindled, by rumour and testimony. An additional delight is to catch sight of an object, to *hold it in view*: this displaces less than veracious speech with the 'objective' truth of the *eye*. It is not enough to know that the wealthy exist: to be believable, they must be seen, to show and be put on show.

The same is true of disasters. Although photo-journalists are often unable to be present immediately at scenes of death, there are stock methods of treating the subject: photographs of wreckage; dignitaries who pay respects; survivors and rescuers: heroes and heroines; the law; and, preferably, a body. These are the elements of the narrative, any one of which may provide the story's ending. But, in terms of news-value, the body itself is central – whether bursting into flame in a football stadium in Bradford in 1985, or crushed in a Belgian football stadium in the same year, or in 1987 drowned and hanging from the porthole of a capsized ferry in the North Sea, or in 1989 crushed during a football match in Sheffield.

Marks and meanings are inscribed upon bodies. The place of realism in rendering these satisfactions can be seen, curiously, in a case in which for a time realism was thwarted – the 'Hungerford massacre' of August 1987, when Michael Ryan shot dead sixteen people before committing suicide.[3] This was a news story, locating horror in English small-town life, but press practice was disturbed by the absence of pictures and therefore the verification by sight. The normal pressure existed to find or take photographs within the lifetime of the story, and it proved difficult to find a picture of the murderer because he had burned all trace of his past. At first the newspapers used aerial photographs of the town and diagrams of where people had been killed, or portraits taken from family albums. To make the story whole, the press needed a photograph of Ryan himself.

The most recent, and in one sense the most appropriate for the news story, were those pictures taken after his suicide by police or Home Office photographers for the use of pathologists and coroners. None was used, possibly because the sight was too grotesque. Nor did the press use a photograph of Ryan's dead body covered in a sheet as part of the public spectacle, for vilification or as an object of wonder.

The decision not to publish such a photograph must evolve from police rules and press practice, but it is a sign of more than their power or squeamishness: it suggests that an explanation for Ryan lay not in the dead body, but in the mind of the man, and the closest that anyone could come to knowing that would be in his *face*. The only route for the press for practical reasons was in the portrait: one had to exist, and eventually it was found and published.

In the style of a passport photograph, it showed a young, impassive man who wore a military type of camouflage hat: this now stood in for his guns and killer

instinct. Trouble in locating a photograph of Ryan suited the few scraps of biography, all of which became the basis of a popular psychoanalysis of him as a 'nobody', a repressed, silent and invisible man, who 'cracked' and through this crack became visible. The portrait, as a rare object, was invested with significance. At last, the 'nobody' could be seen. The photograph was a disappointment, because the face bore no crude sign of evil; at the same time, the photograph did show that blank stare and combat hat which, with hindsight, could be read as intimations that something was awry. That Ryan looked 'faceless' under his hat proved his inscrutable madness: this was an undiagnosed condition that was 'triggered' by an unknown event (the press speculated on sexual rejection). The way was opened towards an explanation in the world of the insane, which completely closes the story.

Wanton murder on this scale, and of strangers, was otherwise inexplicable within the gentility of English market towns. Ryan was an outsider who used foreign weapons and modelled himself upon foreign violence, the filmic mass murderer and US national hero, Rambo. In Hungerford, and in the symbolic world of which the town is an archetype, the eruption of a foreign enemy made no sense except as personal insanity: Ryan may have wished to turn himself into Rambo, but Vietnam could never be laid over the timeless 'peace' of the English countryside, 'undisturbed' since the seventeenth century. The shock of the massacre was accompanied in the press by the need to restore old English values, those that are essentially at the heart of village life, the domestic and provincial virtues of community.

The press search for an explanation of Ryan had to save the paradigm not only of English values but also of English freedoms, and this meant saving the rights of 'the gun lobby' which is itself (in the squirearchy) central to customary rural life. Compromised in this direction, the critique tended to search for easier prey in the open sale of automatic weapons and in the form of one man's madness. In the press, it remained important that the explanation of mayhem should focus upon Ryan himself, and that he be represented as a 'nobody'.

Another important stage in the process of reducing Ryan to nothing was the fate of Ryan's corpse. After some discussion over funeral arrangements, his remains were scattered far and wide without ceremony: a counter-ritual to forestall demonstrations or ghouls, and to establish symbolically that the man might never have existed. The family, the press and the authorities connived in the paradoxical elimination of a man whom they had rendered meaningless: a man without family, without friends, with the love only of an oppressive mother, without the love of a wife or of children. Hence the agreement to leave no trace of his body was the final act of recognition – Ryan was meaningless. Through this act, it was possible to heal the rupture in the essential decency of British life.

The publication of Ryan's portrait was an important moment in his erasure: *the nobody* was paradoxically made to appear to be *a nobody* and a mad type in the mug-shot photograph, before proceeding on the way to becoming *nobody* in the actual form and dispersal of ash. Through this series of negations, and ignoring the gaps in the story in order to close the narrative, the senseless incident was resolved into a sense of order; unmeaning was transformed into a version of its opposite, in the stereotype of the lunatic. The story achieved this passage from bewilderment to explanation in the typical forms of the news story in the press, and in the typical use of realism.

In the process of news production, neither the scale nor the duration of the incident determines its representation. The news event might be world wars lasting for many years, or a distant skirmish, or continuing civil wars and civil disturbances; or it might be a spectacular murder, blaze, wreck or flood. The determinant for news is not the reality itself, but the reality that can be represented within the narrative styles conventional in the industry.

These draw upon both the pleasures of spectacle and the pleasures of endings. Though these pleasures may sometimes pull in different directions, this conflict is but a narrative delay, a rhetorical device that, in the case of individual stories, will not prevent a resolution. In general, however, the resolutions are provisional: this is so partly because of change in the experiential world, and partly because the industry depends upon selling the fiction of the never-ending story. The press encourages its consumers to sit on the edge of their chairs, to peer into the commodity made hours before, and to demand to know what happened, and what will happen next.

Fascination can be fed by realism, yet there is another paradox: the sighting actually satisfies the desire to see, even if the images (through censorship) are disappointingly indistinct or bland. This means the newspapers offer a continuous parade of the spectacular and its continuous cancellation. In this industry, any individual photograph has an unstable position: once it has fulfilled the need to see, it is discarded. At the same time, the position of photographs in general is assured, as they are, like any other part of the paper, continuously remade in its old image. Thus the forward movement offered to consumers is illusory. The press writes its copy in the style and format of old newspapers. The question 'whatever next?', which supposedly motivates consumers, is perpetually asked and answered by the newspapers themselves. And so the real is made serial.

The repeats and serials of old stories of war or disorder, or of strangely foreign murders, acquire their tidy solutions within the framework of press practice. Like all systems of representation, this depends upon convention and can be most potent at its least imaginative – as in the use of the stereotype. The national life, in its representations and phenomena, is clearly identified through stereotypes. Some

of them tie into individuals-as-heroes, and events-as-victories. Others restate the immemorial institutions, such as the monarchy, Parliament and the Church, whose influences extend to the preservation of democracy, stability and morality in the whole of society.[4] Still others relate to the symbolic importance of the countryside, the coasts, and even the soil itself.

These stereotypes enable a national history to be seen and learned.[5] This history is not solely conserved as 'heritage': it is actively produced, turned into fiction and presented as the thing itself.[6] It is simulated in replicas, or re-enactments. and massively represented in photographic realism. The idealization in these representations, whether they appear in the various narrative forms, in print or in image, or in schools, fairs, museums and festivals, is the perfect relation of present experience with history. Though unattainable, this idealization does not nullify the relation between history and experience. On the contrary, the only perfectible place for the relation is in the realm of myth: here contradictions are resolved by devices in the story, then made actual in tableaux and in the pervasive mode of realism. The elaboration of a national history is not the business of the press, but it draws upon myths that already exist, and are hugely represented in realism: the myth of the family, and the conflation of the family into the unity of the nation. Paradoxically, these myths hold the definitions of the real in place, and through them the world is saved; or at least the world of legend is saved. Photography is everywhere in the service of the fable, enabling its transposition to the real.

NOTES

1

THE BAZAAR OF DEATH

1 See Nicholas Pronay, 'Rearmament and the British public: policy and propaganda', in James Curran, Anthony Smith and Pauline Wingate (editors), *Impacts and Influences: Essays on Media Power in the Twentieth Century*, London, Methuen, 1987, pp.53–96; and D. G. Boyce, 'Crusaders without chains: power and the press barons 1896–1951', in Curran, Smith and Wingate, op. cit., pp.97–112. For surveys see James Curran and Jean Seaton, *Power without Responsibility – The Press and Broadcasting in Britain*, London, Methuen, 1985, and Jeremy Tunstall, *The Media in Britain*, London, Constable, 1983. For an appendix on the commercial interests of the companies which own Britain's national press see Mark Hollingworth, *The Press and Political Dissent – A Question of Censorship*, London, Pluto, 1986.

2 'Report on the press', May 1940, paragraph 1.1., File report 126, *The Tom Harrisson Mass-Observation Archive*, Part 1: File reports 1937–1941, Brighton, University of Sussex, Tom Harrisson Mass-Observation Archive, 1983.

3 See Graham Murdock, 'Class, power, and the press: problems of conceptualisation and evidence', in Harry Christian (editor), *The Sociology of Journalism and the Press*, Keele, Staffordshire, Sociological Review Monograph, vol. 29, University of Keele, 1980, pp.37–70.

4 See Paul Rock, 'News as eternal recurrence', in Stanley Cohen and Jock Young (editors), *The Manufacture of News*, London, Constable, 1981, (completely revised edition), pp.64–70.

5 See Harvey Molotch and Marilyn Lester, 'News as purposive behaviour: on the strategic use of routine events, accidents and scandals', in Cohen and Young, op. cit., pp.118–37.

6 James Curran, Angus Douglas and Garry Whannel, 'The political economy of the human-interest story', in Anthony Smith (editor), *Newspapers and Democracy, International Essays on a Changing Medium*, Cambridge, Massachusetts, The MIT Press, 1980, p.306.

7 ibid., p.312.

8 Stuart Cloete, *A Victorian Son*, London, Collins, 1972, p.227.

9 Paul Fussell, *The Great War and Modern Memory*, Oxford University Press, 1975.

10 Patrick Bishop, 'Reporting the Falklands', *Index on Censorship*, no.6, 1982, p.7.

11 David E. Morrison and Howard Tumber, *Journalists at War: The Dynamics of News Reporting during the Falklands Conflict*, London, Sage Publications, 1988, p.109.

12 Stuart Hall, 'The determinations of news photographs', in *Working Papers in Cultural Studies* no. 3, Centre for Contemporary Cultural Studies, University of Birmingham, 1972, pp.53–87.

13 *An Phoblact/Republican News*, vol. 2, no. 23, 6 February 1972.

14 *Daily Mirror*, 31 January 1972.

15 *The Times*, 15 August 1989.

16 *Independent*, 15 August 1989.

17 Herbie Knott, 'Coming on Strong for the Camera', *Independent*, 16 August 1989; Liam Clarke, 'The Media and the Message', *The Sunday Times*, 20 August 1989; See also David McKittrick, 'Photographer Expected to appear in Belfast Court', *Independent*, 17 August 1989. This reports the arrest of a freelance photo-journalist for provocation.

18 *Daily Mail*, 16 June 1982.

19 Allan Sekula, 'Reading an archive: photography between labour and capital', in Patricia Holland, Jo Spence and Simon Watney (editors), *Photography/Politics: Two*, London, Comedia/Photography Workshop, 1986, p.158. The full three-part essay 'Photography between labour and capital' is in Benjamin Buchloh and Robert Wilkie (editors), *Mining Photographs and Other Pictures: A Selection from the Negative Archives of Shedden Studio, Glace Bay, Cape Breton, 1948–1968. Photographs by Leslie Shedden*, Halifax, Nova Scotia, The Press of Nova Scotia College of Art and Design and The University College of Cape Breton Press, 1983. Other key articles by Sekula, including 'On the invention of photographic meaning', 'The instrumental image: Steichen at war', and 'The traffic in photographs' are in Allan Sekula, *Photography against the Grain, Essays and Photo-Works 1973–1983*, Halifax, Nova Scotia, The Press of Nova Scotia College of Art and Design, 1984. 'On the invention of photographic meaning' is also in Victor Burgin (editor), *Thinking Photography*, London, Macmillan, 1982, pp.84–109.

20 ibid., p.157.

21 ibid., p.159.

22 See John Tagg, 'The currency of the photograph' in Burgin (editor), op. cit., pp.110–41. Other key articles by John Tagg include 'Power and photography: Part one. A means of surveillance. The photograph as evidence in law', *Screen Education*, no. 36, Autumn 1980, pp.17–55: and 'Power and photography: Part two. A legal reality: the photograph as property in law', *Screen Education*, no. 37, Winter 1980/81, pp.17–27. These articles are in John Tagg, *The Burden of Representation, Essays on Photographies and Histories*, London, Macmillan, 1988.

2

THE FIRST WORLD WAR

1 Cited in Eric J. Leed, *No Man's Land, Combat and Identity in World War I*, Cambridge, Cambridge University Press, 1979, p.95.

2 *Daily Telegraph*, 15 December 1914.

3 'Kadaver', *Nation*, 31 October 1925, pp.171–2.

4 P. Knightley, *The First Casualty*, New York, Harcourt Brace Jovanovich, 1975, p.106.

5 See *The Times* and *Daily Mail*, 16–19 April 1917.

6 War Office to Colonel J. Buchan at the Ministry of Information, 17 September 1917, PRO FO 395/147. A British eyewitness at the front believed the press reports of the factories. He reported that on the Vimy Ridge, which had been the scene of 'tremendous battles', there were fewer than

200 graves; there was evidence that corpses had been taken away in boxes 'to hide their real purpose'. See Brigadier Morrison with the BEF to R. McCleod, the Press Gallery, Parliament, Ottawa, 10 June 1917, PRO FO 395/147.

7 V. Wellesley at the Foreign Office to the Under Secretary of State at the India Office, 26 April 1917, PRO FO 395/147.

8 See John Taylor, 'Atrocity propaganda in the First World War', in Kathleen Collins (editor), *Shadow and Substance: Essays on the History of Photography*, Bloomfield Hills, Michigan, The Amorphous Institute Press, 1990, pp.305–17.

9 A. Marwick, *The Deluge*, Harmondsworth, Penguin, 1967, p.229.

10 Ernest L. Bogart, *Direct and Indirect Costs of the Great War*, Carnegie Endowment for International Peace, Preliminary Economic Studies of the War, no. 24, New York, Oxford University Press, 1919, pp.270–2.

11 'The eyes of the war', *Optician*, 12 January 1916, pp.210–11.

12 'Photography as the eyes of the army', *British Journal Photographic Almanac Advertisments*, 1918, p.114.

13 John H. Gear, 'The influence of photography in the war', *Photographic Journal*, December 1916, p.269.

14 'Synopsis of British air effort during the war', *Flight*, 1 May 1919, p.580.

15 'The camera at war', *Photographic Dealer*, February 1919, p.58.

16 G. R. Sims, 'British photography in the Great War: its romance and its reality', *The Photographic Industry of Great Britain*, London, published by the British Photographic Manufacturers' Association Ltd., 1920, p.17.

17 ibid., p.17.

18 See *Photographs Taken by the Royal Flying Corps*, Printed in the Field by no. 4 Advanced Section, Army Printing and Stationery Services, 1917. This is a book of 39 original aerial reconnaissance photographs, with a photographed introductory page by Major J. T. C. Moore-Brabazon, O i/c Photography, Royal Flying Corps, and a photographed page of conventional signs.

19 'Aero-photography', *British Journal of Photography*, 22 November 1918, p.527.

20 Sir Philip Gibbs, *The War Despatches* (edited by Catherine Prigg), London, Anthony Gibbs & Phillips, 1964, p.44.

21 Robert Blake (editor), *The Private Papers of Douglas Haig, 1914–19*, London, Eyre and Spottiswoode, 1952, p.154.

22 'The Casualties', *Spectator*, 12 June 1915, p.804.

23 *Daily Mirror*, 12 April 1917.

24 'The photographic trade and Germany', *Amateur Photographer*, 7 September 1914, p.225.

25 Bruce Bliven, 'An inside view of Kodak advertising', *British Journal of Photography*, 29 March 1918, p.150.

26 'Prescribed areas', ibid., 4 February 1916, p.66.

27 Letter to the editor on the 'regulation of photography in restricted areas', ibid., 17 March 1916, p.163.

28 'Outdoor camera work in war time, peaceful photography, permits and prohibitions', *Amateur Photographer*, 24 July 1916, pp.66–7.

29 See for instance *The Times*, 21 September 1915, *British Journal of Photography*, 21 April 1916, *The Times*, 11 April 1917 and 13 May 1918.

30 'After two years of war, the present position of photography', *Amateur Photographer*, 24 July 1916, p.63.

31 '"Snapshots from home", how the work is being organised', ibid., 2 August 1915, p.88.

32 'Snapshots from home', *British Journal of Photography*, 31 December 1915, p.846.

33 'Snapshots from Home League', *Photography and Focus*, 1 February 1916, p.81.

34 Will and Carine Cadby, 'Some of our "snapshots from home"', *Amateur Photographer*, 6 December 1915, p.456; and Alvin Langdon Coburn, '"Snapshots from home" for the pictorial photographer', ibid., 8 November 1915, p.376.

35 'The Snapshots-from-Home League', *British Journal of Photography*, 1 October 1915, p.634.

36 '"Snapshots from home", a great project to hearten our soldiers and sailors, mobilising the cameras', *Amateur Photographer*, 26 July 1915, p.67.

37 'A national movement, YMCA Snapshots-from-Home League success depends upon dealers', *Photographic Dealer*, July 1915, p.236.

38 'The "Snapshots from Home" diploma', *Amateur Photographer*, 10 July 1916, p.33.

39 The Snapshots-from-Home League Accounts to 31 March 1916, War Emergency Committee Minute Book of the YMCA for 27 July 1916, p.190.

40 The total income from 31 July 1915 to 31 December 1917 was £9,882 15s 9d. Manufacturers donated £8,732 17s 0d; Dealers donated £1,029 0s 7d; the public donated £23 5s 5d. The remainder came from sales and interest on a deposit account. See 'Income & Expenditure Account, 31 July 1915 to 31 December 1917', 'Snapshots from Home' League, Committee's Report & Balance Sheet, YMCA, 1918.

41 'British Photographic Industries Ltd.', *British Journal Photographic Almanac*, 1921, pp.322–3.

42 'Snapshots for soldiers and sailors – a national movement', *British Journal of Photography*, 23 July 1915, pp.475–6.

43 Will Cadby, 'The hero of the hour', in 'Wartime record work', *Amateur Photographer*, 19 June 1916, pp.496–7.

44 Mrs R. M. Weller, 'Hero worship', ibid., 4 March 1918, p.138.

45 H. B. Redmond, 'Where will they send us?', ibid., 1 February 1915, p.91.

46 Arthur Dawson, 'Rejected', ibid., 20 September 1915, p.236.

47 Mrs G. A. Barton, 'In time of war', ibid., 26 October 1914, p.398.

48 F. J. Mortimer, 'The Presidential address to the Photographic Convention of the United Kingdom', *British Journal of Photography*, 11 July 1913, p.530.

49 See M. L. Sanders and Philip M. Taylor, *British Propaganda during the First World War 1914–18*, London, Macmillan, 1983; Deian Hopkin, 'Domestic censorship in the First World War', *Journal of Contemporary History*, no. 4, 1970, pp.151–69; D. G. Wright, 'The Great War, government propaganda and English "men of letters" 1914–16', *Literature and History*, no. 7, 1978, pp.70–100; A. G. Marquis, 'Words as weapons: propaganda in Britain and Germany during the First World War', *Journal of Contemporary History*, no. 3, 1978, pp.467–98.

50 *Daily Sketch*, 13 September 1915.

51 ibid., 13 December 1915.

52 See Arthur Marwick, *Women at War 1914–1918*, London, Fontana in association with the Imperial War Museum, 1977.

53 'Photographic demonstration', *British Journal of Photography*, 25 February 1916, p.110.

54 Rebecca West, *The Young Rebecca West: 1911–1917* (edited by Jane Marcus), New York, Viking, 1978, p.392. Cited by Jane Marcus, 'Corpus/corps/corpse: writing the

body in/at war', in Helen M. Cooper, Adrienne Auslander Munich and Susan Merrill Squier (editors), *Arms and the Woman, War, Gender, and Literary Representation*, Chapel Hill, The University of North Carolina Press, 1989, p.130.

55 *Daily Sketch*, 13 August 1915.

56 'The King "Clocks On" at the Works', ibid., 17 May 1917.

57 ibid., 19 July 1915.

58 *Daily Mail*, 19 July 1915.

59 *Daily Telegraph*, 2 July 1917; and see Anna Davin, 'Imperialism and motherhood', *History Workshop Journal*, no. 5, Spring 1978, pp.9–65.

60 *Daily Sketch*, 2 July 1917.

61 *Daily Mirror*, 18 December 1914.

62 ibid., 14 June 1917.

63 See Anna Davin, 'Imperialism and motherhood'.

64 'Fire Stops a Pacifist Meeting', *Daily Sketch*, 8 October 1917.

65 ibid., 15 March 1916.

66 'A Message from the Front to the Greedy Landlord', ibid., 11 October 1915.

67 'The War on the Food Pirates', ibid., 28 August 1916.

68 ibid., 24 June 1916.

69 ibid., 20 December 1915.

70 A. P. Haslam, *Cannon Fodder*, Hutchinson & Co., n.d., pp.49–50.

71 *Daily Mirror*, 15 June 1918.

72 'Mobs Loot Aliens' Shops in East End', ibid., 13 May 1915.

73 Cited in Stephen Koss, *The Rise and Fall of the Political Press in Britain, Volume Two: The Twentieth Century*, London, Hamish Hamilton, 1984, p.257.

74 See *Daily Mirror*, 2, 3 and 6 May 1916.

75 J. A. R. Pimlott, *Recreations*, London, Studio Vista, 1968, p.46.

76 Walter Lippmann, *Public Opinion*, London, Allen & Unwin, 1922, p.92.

77 Norman Angell, *The Press and the Organisation of Society*, London, The Labour Publishing Co. Ltd., 1922, p.27.

78 *Daily Mirror*, 19 September 1917.

79 See G. R. Searle, *Eugenics and Politics in Britain 1900–1914*, Leyden, Noordhoff International Publishing, 1976.

80 Norman Angell, op. cit., p.69.

81 *Daily Mirror*, 28 May 1916.

82 Cyril Falls, *War Books 1914–18, A Critical Guide to the Literature of the Great War*, Peter Davies Ltd., 1930, p.xii.

83 Evelyn Underhill, 'Problems of conflict', *Hibbert Journal*, April 1915, p.509.

84 Philip Gibbs, *Adventures in Journalism*, London, Heinemann 1923, p.217.

85 *Daily Telegraph*, 19 August 1914.

86 Lucy Salmon, *The Newspaper and the Historian*, New York, Oxford University Press, 1923, p.205.

87 Ministry of Information Papers in the Imperial War Museum, Box 1, File 2, letter and minute relating to the appointment of the first War Office Official Photographers, March 1916.

88 S. D. Badsey, 'British official photography in the First World War', unpublished monograph in the Imperial War Museum, 1981, p.55. See Jane Carmichael, *First World War Photographers*, London, Routledge, 1989.

89 Memorandum to be given to Official Photographers, August 1917, PRO HO 139/31/124 part 1A.

90 Ministry of Information Papers, Box 1, File 3, the attempted creation of the War Office Photographic Committee, letter dated 13 September 1917.

91 ibid., Box 3, File 22, correspondence relating to miscellaneous contacts with photographers, letter dated 18 March 1917.

92 ibid., File 5, letters relating to Ernest Brooks, 27 December 1917.

93 'Over the Top', *Daily Mirror*, 11 April 1917.

94 P. Robertson, 'Canadian photo-journalism during the First World War', *History of Photography Journal*, no.1, January 1978, pp.37–52.

95 *Daily Sketch*, 27 December 1917; Ministry of Information Papers, Box 1, File 3, letter from N. Lytton to Photographic Section, 8 January 1918.

96 PRO HO 139/42, letter from M17A to Press Bureau, 5 December 1917.

97 Stuart Cloete, *A Victorian Son*, London, Collins, 1972, p.229.

98 Henry Williamson, *The Wet Flanders Plain*, London, Faber & Faber, 1929, p.112.

99 Ministry of Information Papers, Box 1, File 2, letter from Foreign Office to War Office, 2 May 1916.

100 Lucy Salmon, op. cit., p.207.

101 *Daily Express*, 7 July 1916.

102 H. Blackburn, 'The illustration of books and newspapers', *Nineteenth Century*, February 1890, pp.213–24, cited in Lucy Salmon, op. cit., p.377.

103 L. P. Jacks, 'The changing mind of a nation at war', in Eleanor M. Sidgwick, Gilbert Murray, A. C. Bradley, L. P. Jacks, G. F. Stout, B. Bosanquet, *The International Crisis in its Ethical and Psychological Aspects*, vol. 1, London, Oxford University Press, 1915, pp.92–3.

104 'Full Story of the Great and Glorious Advance', *Daily Sketch*, 12 July 1916.

105 'The Big Advance: Latest Official Photographs', ibid., 3 July 1916.

106 'Wounded Highlander's Graphic Story of the British Advance', *Daily Mirror*, 4 July 1916.

107 'How Tommy Walked Through Fire to Thrash the Huns', *Daily Sketch*, 12 July 1916.

108 'The First Photograph to Show British and German Soldiers Coming to Grips', 'Now, Lads, Cold Steel!', ibid., 29 May 1915.

109 '£600 for the Finest Picture of the War, "Now Lads, Cold Steel!"', ibid., 31 July 1915.

110 Philip Gibbs, op. cit., p.245.

111 'Soldier's Life Saved by a Watch', *Southend and Westcliffe Graphic*, 14 January 1916.

112 'Photograph that a Dead Man Took', *Daily Mirror*, 6 November 1915.

113 *Daily Sketch*, 22 July 1916.

114 Edward Price Bell, *The British Censorship*, an address before the American Luncheon Club, Savoy Hotel, London, 19 November 1915, London, Fisher & Unwin, 1916 p.21.

115 Sir Edward Cook, *The Press in War Time*, London, Macmillan, 1920, p.164.

116 *Daily Sketch*, 4 October 1916.

117 Stuart Cloete, op. cit., p.228.

118 *Daily Sketch*, 20 April 1917.

119 'That Eternal Mud – Flanders One Vast Quagmire', *Daily Mirror*, 6 September 1917.

120 Nicholas Reeves, 'Film propaganda and its audience: the example of Britain's official films during the First World War', *Journal of*

Contemporary History, vol. 18, no. 3, July 1983, p.468.

121 Stuart Cloete, op. cit., p.237.

122 *Statistics of the Military Effort of the British Empire during the Great War 1914–1920*, London, HMSO, 1922, p.643.

123 D. Englander and J. Osborne, 'Jack, Tommy and Henry Dubb: the armed forces and the working class', *Historical Journal*, September 1978, p.595.

124 ibid., p.594.

125 ibid., p.597.

126 See A. E. Ashworth, 'The sociology of trench warfare', *The British Journal of Sociology*, no 4, December 1968, pp.407–23.

127 Cited in Eric J. Leed, op. cit., p.171. See also Elaine Showalter, 'Male hysteria; W. H. R. Rivers and the lessons of shell shock', chapter 7, *The Female Malady, Women, Madness and English Culture, 1830–1980*, London, Virago, 1987, pp.167–94.

128 See J. M. Winter, 'The lost generation', chapter 3, *The Great War and the British People*, London, Macmillan, 1986, pp.65–99.

129 Pamela Horn, *The Changing Countryside in Victorian and Edwardian England and Wales*, London, Athlone Press, 1984, p.240.

130 See Philip Longworth, *The Unending Vigil: a history of the Commonwealth War Graves Commission 1917–1967*, London, Constable, 1967.

131 E. C. Pulbrook, *The English Countryside*, Batsford, 1915.

132 Cited in M. J. Wiener, *English Culture and the Decline of the Industrial Spirit 1850–1980*, Cambridge, Cambridge University Press, 1981, p.76.

3
THE SECOND WORLD WAR

1 *Daily Mirror*, 1 June 1940.

2 ibid., 5 June 1940.

3 ibid., 23 July 1940.

4 ibid., 12 October 1940.

5 ibid., 10 September 1940.

6 ibid., 15 July 1942.

7 ibid., 20 November 1944.

8 ibid., 6 February 1945.

9 ibid., 8 May 1945.

10 See Frances Thorpe and Nicholas Pronay, with Clive Coultass, *British Official Films in the Second World War*, Oxford, Clio Press, 1980; Nicholas Pronay and D. W. Spring (editors), *Propaganda, Politics and Film 1918–45*, London, Macmillan, 1982; Geoff Hurd (editor), *National Fictions: World War Two in British Films and Television*, London, BFI Books, 1984.

11 See Marion Yass, *This is Your War: Home Front Propaganda in the Second World War*, London, HMSO, 1983.

12 See L. Moss and K. L. Box, *Ministry of Information Publications: a Study of Public Attitudes towards Six Ministry of Information Books*, London, Central Office of Information, 1948.

13 See Ian McLaine, *Ministry of Morale: Home Front Morale and the Ministry of Information in World War II*, London, Allen & Unwin, 1979.

14 British Institute of Public Opinion Poll of June 1941, cited in A. H. Cantril, *Public Opinion 1935–1946*, Princeton, Princeton University Press, 1951, p.1077.

15 *Daily Mirror*, 12 April 1940.

16 ibid., 22 December 1939.

17 ibid., 6 August 1940.

18 ibid., 1 February 1943.

19 See Tom Hopkinson (editor), *Picture Post 1938–50*, Harmondsworth, Penguin Books, 1979; Stuart Hall, 'The social eye of *Picture Post*', *Working Papers in Cultural Studies*, no. 2, Spring 1972, pp.71–120; Stephen Edwards, 'The need to know: the northern town in documentary discourses of the nineteen thirties', unpublished thesis for an MA in the Social History of Art, University of Leeds, 1983.

20 See PRO INF 1/234.

21 *Daily Mirror*, 20 August 1942.

22 *Picture Post*, 5 September 1942.

23 Charles Craig, 'The British documentary photograph as a medium of information and propaganda during the Second World War, 1939–45', unpublished M Phil. thesis, Imperial War Museum, 1982, pp.181–2.

24 See Brian Bond, 'Dunkirk; myths and lessons', *Royal United Services Institute for Defence Studies Journal*, 1982, pp.3–8; William Rankin, 'What Dunkirk spirit?', *New Society*, 15 November 1973, pp.396–8; P. Grafton, *You, You and You! The People out of Step with World War II*, London, Pluto, 1981.

25 See Harold L. Smith, 'The effect of the war on the status of women', in Harold L. Smith (editor), *War and Social Change: British Society in the Second World War*, Manchester, Manchester University Press, 1986, pp.208–29.

26 Barbara Tuchman, *Sand against the Wind: Stilwell and the American Experience in China, 1911–1945*, London, Macdonald/Futura, 1981, p.557.

27 Richard M. Titmuss, *Problems of Social Policy*, London, HMSO, 1950, p.12; see also Tom Harrisson, *Living Through the Blitz*, London, Collins 1976, pp.350–1, footnotes 7 and 8.

28 A. J. P. Taylor, *English History 1914–45*, Oxford, Clarendon Press, 1965, p.519.

29 Ursula Powyss-Lybbe, *The Eye of Intelligence*, London, William Kimber, 1983, pp.25–67.

30 Angus Calder, *The People's War, Britain, 1939–45*, St Albans, Granada Publishing Ltd., 1982, (first published by Jonathan Cape, 1969), p.265.

31 Titmuss, op. cit., p.335.

32 ibid., pp.558–60. The author makes it clear that due to incomplete records, these figures 'must simply be accepted as showing the order of magnitude of casualty rates.'

33 'Summary of casualties of air raids and bombardments', *Statistics of the Military Effort of the British Empire During the Great War 1914–1920*, London, HMSO, 1922, p.678.

34 *Daily Mirror*, 13 July 1945. This figure for UK forces was later raised to 264,443 killed. See H. M. D. Parker, *Manpower: A Study of War-Time Policy and Administration*, London, HMSO, 1957, p.487.

35 *Statistics of the Military Effort*, op. cit., p.238.

36 Solly Zuckerman, *From Apes to Warlords*, Hamish Hamilton, 1978, p.142.

37 C. Webster and N. Frankland, *The Strategic Air Offensive against Germany 1939–45*, vol. I, HMSO, 1961, p.332.

38 Ursula Powyss-Lybbe, op. cit., p.213.

39 ibid., pp.40–4.

40 Ernest Mandel, *The Meaning of the Second World War*, London, Verso, 1986, p.78; and Ernest Mandel, *Late Capitalism*, London, Verso, 1980 (second impression), p.251.

41 The fullest contemporary account of the wartime uses of photography was given by F. J. Mortimer in his capacity as President of the Royal Photographic Society from 1941–4. These addresses were published, along with many illustrations, in the

Photographic Journal. See F. J. Mortimer, 'Photography's part in the War', ibid., April 1941, pp.124–45; F. J. Mortimer, 'More about photography's part in the War', ibid., April 1942, pp.88–105; F. J. Mortimer, 'Photography's part in the War: third year', ibid., April 1943, pp.98–112; F. J. Mortimer, 'Photography's part in the War: fourth year', ibid., April 1944, pp.74–88.

42 *Picture Post*, 5 June 1943. See also ibid., 3 February 1940, 4 June 1940 and 4 November 1944.

43 F. J. Mortimer, op. cit., 1944, p.75.

44 E. L. Hargreaves and M. M. Gowing, *Civil Industry and Trade*, London, HMSO, 1952, p.226.

45 F. J. Mortimer, op. cit., 1941–4.

46 'Limitation of supplies', the *British Journal of Photography*, 15 August 1941, p.365.

47 J. Edward Gerald, *The British Press Under Government Economic Controls*, Minneapolis, University of Minnesota Press, 1956, pp.32–3.

48 *Daily Mirror*, 13 April 1940.

49 See Andrew Hodges, *Alan Turing, the Enigma of Intelligence*, London, Unwin Paperbacks, 1985.

50 *Daily Mirror*, 28 July 1941.

51 *Daily Sketch*, 11 February 1942.

52 'German Atrocities. A report by Mass-Observation on the reaction of Londoners to the German atrocities in the concentration camps from material collected in direct and indirect interviews, 5 May 1945', File report 2248, *The Tom Harrisson Mass-Observation Archive*, Part 2, File reports 1942–1949, op. cit. For an account see Tom Jeffery, *Mass-Observation – a Short History*, Stencilled Occasional Paper no. 55, Centre for Contemporary Cultural Studies, Birmingham, University of Birmingham, 1978.

53 ibid.

54 'War photographs exhibition, Dorland Hall, London, 15 August 1942', File report 1378–9, *The Tom Harrisson Mass-Observation Archive*, Part 2: File reports 1942–49, op. cit.

55 See 'Report on the press', May 1940, File report 126; 'Report on press prestige', 17 July 1940, File report 283; 'What people think about the press', 12 August 1940, File report 343; 'Press guidance', September 1940, File report 423; 'The public and the press', 10 June 1941, File report 743, *The Tom Harrisson Mass-Observation Archive*, Part 1, File reports 1937–41, op. cit.

56 'German Atrocities. A report by Mass-Observation on the reaction of Londoners to the German atrocities in the concentration camps from material collected in direct and indirect interviews, 5 May 1945', File report 2248, *The Tom Harrisson Mass-Observation Archive*, Part 2, File reports 1942–49, op. cit.

57 G. H. Douglas, 'Airmen: morals and attitudes', 25 June 1941, File report 569, *The Tom Harrisson Mass-Observation Archive*, Part 1, File reports 1937–41, op. cit.

58 ibid.

59 ibid.; see also, 'Do you think it would be a good or bad thing for Churchill to go on being Prime Minister after the war is over?', 8 February 1944, File report 2024. In November 1942, 38 per cent supported Churchill and 45 per cent opposed; in February 1944, 28 per cent supported and 62 per cent opposed.

60 *Daily Mirror*, 13 February 1945.

61 ibid., 18 April 1945.

62 ibid., 19 April 1945.

63 ibid., 20 April 1945.

64 ibid., 24–6 April 1945.

65 ibid., 18 May 1945.

66 'Panel on the Atom Bomb', August 1945, File report 2277, *The Tom Harrisson Mass-Observation Archive*, Part 2, File reports 1942–49, op. cit.

67 *Sunday Graphic*, 12 August 1945.

68 *Sunday Pictorial*, 12 August 1945.

69 *Picture Post*, 13 July 1940.

70 ibid.

71 George Orwell, *The Lion and the Unicorn, Socialism and the English Genius*, London, Secker & Warburg, 1941, p.15.

72 *Picture Post*, 3 January 1942.

73 Thomas Burke, *The English and their Country*, London, published for the British Council by Longman, Green & Co., 1945, p.28.

74 H. V. Morton, *I Saw Two Englands*, London, Methuen, 1942, pp.288–9.

75 See John Taylor, 'The alphabetic universe: photography and the picturesque landscape', in Simon Pugh (editor), *Reading Landscape: Country – City – Capital*, Manchester, Manchester University Press, 1990, pp.176–96.

76 R. Carton, *The English Scene: The Spirit of England in the Monuments of her Social Life and Industrial History*, London, A. & C. Black, 1930, p.4.

77 See Terry Morden, 'The pastoral and the pictorial', in 'Rural Myths', *Ten.8*, no. 12, 1983, pp.18–25.

78 C. E. M. Joad, *The Untutored Townsman's Invasion of the Country*, London, Faber & Faber, 1946, p.12.

79 *Picture Post*, 6 July 1940.

80 Elizabeth Brunner, *Holiday Making and Holiday Trades*, Nuffield College, Oxford, Oxford University Press, 1945, pp.4–5.

81 'Topics of the week', *Amateur Photographer*, 17 September 1941, p.734.

82 R. Carton, op. cit.

83 *Picture Post*, 3 January 1942.

84 George Orwell, op. cit., p.54.

85 *Picture Post*, 4 January 1941.

86 *Daily Sketch*, 1 September 1939.

87 For an account see Titmuss, op. cit., and John MacNicol, 'The effect of the evacuation of schoolchildren on official attitudes to State intervention', in Harold L. Smith (editor), op. cit., pp.3–31.

88 *Daily Mirror* and *Daily Sketch*, 2 September 1939.

89 *Daily Sketch*, 1 September 1939.

90 C. H. Warren, *England is a Village*, London, Eyre & Spottiswoode, 1940, p.ix.

91 *Daily Sketch*, 9 September 1940.

92 See Louis Moss and Kathleen Box, *Newspapers: an Inquiry into Newspaper Reading amongst the Civilian Population*, Wartime Social Survey, Publications Division of the Ministry of Information, June–July 1943; and P. Kimble, *Newspaper Reading in the Third Year of the War*, London, Allen & Unwin, 1942.

93 *Daily Sketch*, 23 April 1942.

94 *Daily Mirror*, 4 November 1940.

95 See A. C. H. Smith, Elizabeth Immirzi, Trevor Blackwell and Stuart Hall, *Paper Voices, The Popular Press and Social Change*, London, Chatto & Windus, 1975.

96 *Daily Mirror*, 17 October 1940.

97 ibid., 4 October 1940.

98 ibid., 7 May 1941.

99 ibid., 17 August 1945.

100 G. Browne, *Patterns of British Life*, London, Hulton Press, 1950, p.32.

101 Sheila Ferguson and Hilde Fitzgerald, *Studies in the Social Services*, London, HMSO, 1954, p.20.

102 *Registrar General's Statistical Review of England and Wales for the six years 1940–45, Text, vol. II, Civil*, pp.88–9, cited in Ferguson and Fitzgerald, p.22.

103 Paul Wendover, Letters to the Editor, *Amateur Photographer*, 20 May 1942, p.325.

104 James Mackay, *Airmails 1870–1970*, London, Batsford, 1971.

105 F. J. Mortimer, op. cit., *Photographic Journal*, 1943, p.101; see also F. J. Mortimer's articles in *Photographic Journal* 1942, p.92 and 1944, p.78.

106 F. J. Mortimer, op. cit., *Photographic Journal*, 1944, p.78.

107 F. J. Mortimer, op. cit., *Photographic Journal*, 1943, p.101.

108 YMCA War Emergency Committee Minute, 13 June 1940.

109 'Topics of the week', *Amateur Photographer*, 3 July 1940, p.563.

110 Advertisement and Enrolment Form for the 'Snapshots from Home' League, ibid., 7 August 1940, opposite p.103.

111 'Topics of the week', ibid., 20 September 1939, p.291.

112 H. Cutner, '"Snapshots from Home" – and a suggestion', ibid., 11 September 1940, p.204.

113 J. D. Brotherton, 'Snapshots from Home', Letters to the Editor, ibid., 2 October 1940, p.286.

114 'Snapshots from Home', ibid., 10 July 1940, p.16.

115 R. W. J. Norton, '"Snapshots from Home" – the pictures they will like to receive', ibid., 31 July 1940, pp.69–70.

116 Helen Hinkley, 'A soldier's folk', ibid., 9 April 1941, p.345.

117 Ethel A. Miller, 'Let your photography cheer the Forces', ibid., 25 March 1942, p.192.

118 See Patricia Allatt, 'Men and war: status, class and the social reproduction of masculinity', in Eva Gamarnikow (editor), *The Public and the Private*, London, Heinemann, 1983, pp.47–61; Neil Grant, 'Citizen soldiers: army education in World War II', in *Formations of Nation and People*, Routledge & Kegan Paul, 1984, pp.171–87; and in the same volume, Janice Winship, 'Nation before family: *Woman*, the national home weekly', pp.188–211; Denise Riley, 'The free mothers: pronatalism and working mothers in industry at the end of the last war in Britain', *History Workshop Journal*, no. 11, 1981, pp.59–118.

119 See Stuart Hood, 'War photographs and masculinity', in Patricia Holland, Jo Spence and Simon Watney (editors), *Photography/Politics: Two*, op. cit., pp.90–2.

120 YMCA War Emergency Committee Minute, 2 May 1946.

121 Leonard A. Hall, 'Grade IV', *Amateur Photographer*, 20 January 1943, p.41.

122 F. J. Mortimer, op. cit., *Photographic Journal*, 1943, pp.98–9.

123 Ethel A. Miller, op. cit., p.192.

124 'Do you live in one of these places?', *Amateur Photographer*, 25 March 1942, p.195.

125 F. J. Mortimer, op. cit., *Photographic Journal*, 1944, p.75.

126 For comment on the limitation of supplies in photography see *British Journal of Photography*, 14 March 1941, pp.121–2; 9 May 1941, pp.217–18; 15 August 1941, p.365; 31 October 1941, p.454; 17 April 1942, p.142; 9 October 1942, p.379.

127 'Topics of the week', *Amateur Photographer*, 24 March 1943, p.188.

128 YMCA War Emergency Committee Minute, 2 May 1946.

129 H. Cutner, '"Snapshots from Home" – and a suggestion', op. cit.

130 'Topics of the week', *Amateur Photographer*, 19 June 1940, p.523.

131 See 'Further report on the *Daily Mirror*', 2 April 1942, File Report 1197; 'Report on Newspaper Strips', 10 March 1942, File Report 1146, *The Tom Harrisson Mass-Observation Archive*, Part 2: File reports 1942–49, op. cit.

132 See for instance *Daily Mirror*, 2/13/21 September 1939, and 3 January 1941.

133 ibid., 9 September 1940.

134 McLaine, op. cit., p.114.

135 *Daily Mirror*, 18 November 1940.

136 ibid., 27 July 1944.

137 ibid., 28 February 1941.

138 ibid., 18 December 1939.

139 See for instance ibid., 20 January 1943, 1 and 8 February 1943.

140 ibid., 3 September 1943.

141 For personal reminiscences see John Costello, *Love, Sex and War, Changing Values 1939–45*, London, Collins, 1985.

4
THE FALKLANDS CAMPAIGN

1 Bernard Crick, 'The curse of sovereignty', *New Statesman*, 14 May 1982, p.6.

2 See Glasgow University Media Group, *War and Peace News*, Milton Keynes, Open University Press, 1985; M. Cockerell, P. Hennessy and D. Walker, *Sources Close to the Prime Minister*, London, Macmillan, 1984, pp.143–87; A. Barnett, 'Some notes on media coverage of the Falklands', in Francis Barker, Peter Hulme, Margaret Iversen, Diana Loxley (editors), *Confronting the Crisis: War, Politics and Culture in the Eighties*, Colchester, University of Essex, 1984, pp.74–89; Valerie Adams, *The Media and the Falklands Campaign*, London, Macmillan, 1986.

3 House of Commons Defence Committee, *The Handling of Press and Public Information during the Falklands Conflict*, December 1982, vols HC 17–I and HC 17–II. The first volume contains the Report and the second the evidence of witnesses (hereafter these books will be noted as HC 17–I, or HC 17–II). See also Ministry of Defence, *The Handling of Press and Public Information during the Falklands Conflict: Observation on the First Report from the Defence Committee*, March 1983, Cmnd 8820; Ministry of Defence, *The Protection of Military Information, Report of the Study Group on Censorship*, December 1983, Cmnd 9112; Ministry of Defence, *The Protection of Military Information, Government Response to the Report of the Study Group on Censorship*, April 1985, Cmnd 9499.

4 'Memorandum submitted by the Ministry of Defence', HC 17–II, p.1.

5 See James Aulich (editor), *Nationhood, Identity, and Culture: The Falklands War*, Milton Keynes, Open University Press, 1991. See also the brief review in Derrik Mercer, Geoff Mungham and Kevin Williams, *The Fog of War*, London, Heinemann, 1987, pp.148–50. For more information, and comments by photographers, see David E. Morrison and Howard Tumber, *Journalists at War: The Dynamics of News Reporting during the Falklands Conflict*, London, Sage Publications, 1988, especially pp.178–83.

6 Robert Harris, *Gotcha: The Media, the Government and the Falklands Crisis*, London, Faber & Faber, 1983, p.57.

7 For the (slightly conflicting) list of newsmen see Robert Harris, op. cit., pp.11–12, David E. Morrison and Howard Tumber, op. cit.,

p.357, and 'Memorandum submitted by the Ministry of Defence, List of news media personnel accompanying Task Force to the South Atlantic', Appendix 1, HC 17–II, p.11.

8 'Memorandum submitted by Independent Television News', HC 17–II, p.67; 'Memorandum by Mr Patrick Bishop, the *Observer's* correspondent in the Falklands', ibid., pp.103–4; 'Memorandum submitted by the Press Association', Appendix D (i), Example of censorship, ibid., p.315; 'Memorandum submitted by the Ministry of Defence, "Censorship"/vetting', Annex A, ibid., p.411.

9 'Memorandum submitted by the Ministry of Defence', ibid., p.2.

10 'Memorandum submitted by Independent Television News', ibid., p.76.

11 'Memorandum by Mr Robert McGowan, *Daily Express* correspondent in the Falklands', ibid., p.186.

12 Robert Harris, op. cit., pp.124–9; and David E. Morrison and Howard Tumber, op. cit., pp.44–54 and 132–6.

13 'Memorandum by Mr Tony Snow, the *Sun's* correspondent in the Falklands', ibid., HC 17–II, p.105.

14 Mr Max Hastings, ibid., Q. 667.

15 Mr Max Hastings, ibid., Q. 690; Robert Harris, op. cit., p.143; and David E. Morrison and Howard Tumber, op. cit., pp.152–8.

16 HC 17–I, p.viii.

17 David E. Morrison and Howard Tumber, 'The government and information in time of war: the Falklands and the media', in Francis Barker *et al.*, op. cit., p.105.

18 Mr Alan Protheroe, HC 17–II, Q. 144.

19 David E. Morrison and Howard Tumber, 'The government and information in time of war: the Falklands and the media', op. cit., pp.102–5; and David E. Morrison and

Howard Tumber, *Journalists at War*, op. cit., pp.163–70.

20 Sir Frank Cooper, HC 17–II, Q. 71.

21 Dr John Gilbert, Michael Mates and Chris Patten with Rt Hon Mr John Nott and Sir Frank Cooper, ibid., QQ. 1900–4.

22 'Memorandum submitted by Independent Television News', ibid., p.63.

23 Mr Brian Hanrahan, ibid., Q. 327.

24 Mr Michael Nicholson, ibid., Q. 412.

25 David Nicholson-Lord, 'Ministry Wakes up to Propaganda War', *The Times*, 14 May 1982.

26 'Memorandum submitted by the Press Association', HC 17–II, p.308.

27 'Memorandum by the *Daily Mail*', ibid., p.122.

28 HC 17–I, p.xxxviii, and 'Memorandum submitted by the Ministry of Defence, PR arrangements for the Falklands operation', Annex C, HC 17–II, p.7.

29 HC 17–I, p.xliii, and 'Memorandum by *The Scotsman*', HC 17–II, p.117.

30 *Daily Express*, 25 May 1982.

31 *Daily Mirror*, 26 May 1982.

32 HC 17–I, p.xxxviii, and Mr Bob Hutchinson, HC 17–II, Q. 1230.

33 'Memorandum by *The Scotsman*', HC 17–II, p.118.

34 Mr Bob Hutchinson, ibid., Q. 1230.

35 HC 17–I, p.xliii.

36 Sir Frank Cooper, HC 17–II, Q. 40.

37 HC 17–I, p.xliii.

38 *Daily Mail*, 26 April 1982.

39 *Daily Mirror*, 4 June 1982.

40 Mr Jim Meacham, HC 17–II, Q. 732. See David E. Morrison and Howard Tumber, *Journalists at War*, op. cit., pp.202–6.

41 *News of the World*, 6 June 1982.

42 'Falklands Death Verdict Quashed', *Guardian*, 18 February 1988. See also 'Briton Died in Missile Attack by Royal Navy', 'Mother Wins Six-year Battle to Reverse Verdict on Death of Son in Falklands Conflict', *Independent*, 20 October 1988.

43 *Daily Mirror*, 6 May 1982.

44 *Sun*, 6 May 1982.

45 'The Widow, Wendy, 17, Mourns Husband of Three Weeks', *Daily Mirror*, 2 June 1982; 'Bride of 17 Mourns her Husband', *Daily Telegraph*, 2 June 1982.

46 'Grief of War Widow', '8 Hour Bride', *Sun*, 10 June 1982; 'Helicopter Crash Leaves One-day Bride a Widow', *The Times*, 10 June 1982.

47 'Just Married: Debbie Flanked by Two Teenage Guardsman Soon to Die', *Daily Mail*, 15 June 1982; 'Pride and Pain of Brides Made Widows at Bluff Cove', *Guardian*, 15 June 1982.

48 'Double-Death Heartbreak of Tragic Sisters', *Sun*, 16 June 1982; 'Double Blow', *Guardian*, 16 June 1982.

49 *Daily Mirror*, 7 May 1982.

50 *Daily Express*, 1 June 1982.

51 *Sun*, 26 May 1982.

52 Mr Alan Protheroe, HC 17–II, Q. 168.

53 *Star*, 31 May 1982.

54 ibid.

55 *Guardian*, 31 May 1982.

56 *Sunday People*, 30 May 1982.

57 *Daily Mirror*, 31 May 1982.

58 ibid., 31 May 1982.

59 *Sun*, 31 May 1982.

60 Cited in Ian Kettlewell, 'Designing a crisis, the Falklands and the design of the popular press', *ffotoview*, no. 10/11, Winter 1984, p.12.

61 *Daily Express*, 27 May 1982.

62 *Daily Mail*, 6 April 1982.

63 *Star*, 8–22 April 1982.

64 *Daily Mirror*, 6 April 1982.

65 *Daily Express*, 13 April 1982.

66 Deborah Cherry and Alex Potts, 'The changing images of war', *New Society*, 29 April 1982, p.173.

67 *Daily Mail*, 7 June 1982.

68 *Sun*, 16 June 1982.

69 *Sunday People*, 8 August 1982.

70 *Sun*, 1 May 1982.

71 ibid., 29 April 1982.

72 ibid., 16 April 1982.

73 ibid., 12 June 1982.

74 *Daily Mirror*, 13 May 1982.

75 *Star*, 14 May 1982.

76 ibid., 28 May 1982.

77 *Daily Mirror*, 4 June 1982.

78 *Star*, 19 June 1982.

79 *Daily Mail*, 12 June 1982.

80 *Daily Mirror*, 22 June 1982.

81 ibid., 26 June 1982.

82 ibid., 27 June 1982.

83 The Prime Minister's speech to a Conservative Party rally at Cheltenham racecourse, 3 July, London, Conservative Central Office, 1982.

84 Julian Critchley, 'The Patriotism Waiting to be Voiced', *Daily Telegraph*, 6 July 1982.

85 Mr Martin Helm, HC 17–II, Q. 996.

86 ibid., QQ. 1006–1011.

87 Major General Sir Jeremy Moore, ibid., Q. 1096; see *Daily Mail*, 16 June 1982.

88 Rear Admiral Sir John Woodward, ibid., Q. 1146.

89 David E. Morrison and Howard Tumber, *Journalists at War*, op. cit., p.182.

90 Dr John Gilbert, HC 17–II, Q. 1334.

91 Mr D. Fairhall, ibid., Q. 1344.

92 Mr P. Preston, ibid., Q. 1334.

93 Mr P. Preston, ibid., Q. 1336.

94 Mr Michael Nicholson, ibid., Q. 446.

95 Mr David Chipp, ibid., Q. 1303.

96 Mr David Chipp, ibid., Q. 1306.

97 Mr P. Preston, ibid., Q. 1346.

98 Mr D. Fairhall, ibid., Q. 1341.

99 Brigadier M. J. A. Wilson, ibid., Q. 1212.

100 Major General Sir Jeremy Moore, ibid., Q. 1211.

101 HC 17–I, p.xvi.

102 Julian Critchley, op. cit.

5

TERRORISM AND NORTHERN IRELAND

1 *Daily Mirror*, 11 August 1977.

2 ibid., 7 January 1976.

3 The main issue has been invasion of privacy, which can include private grief. The press was given a last chance to prove that voluntary self-regulation through self-censorship would work, but it was suggested by the Calcutt Committee that the Press Council should be disbanded and replaced by a tougher independent Press Complaints Commission from January 1991. For early warnings, see Stephen Goodwin, 'Press is Put "On Probation"', *Independent*, 22 April 1989; Judy Jones, 'Falling Standards "Threaten Press Freedom"', *Independent*, 27 April 1989; Louis Blom-Cooper, 'A Remedy for Lost Dignity', *Guardian*, 26 April 1989. For the use of shocking photographs, see broadsheet and tabloid press reports of 17 April 1989 on the Hillsborough football ground disaster. The role of sports' photo-journalists in this incident is reviewed by Eamonn McCabe, 'When Sport Turns to Hillsborough', *Guardian*, 24 April 1989. For further use of shocking photographs (of air crash victims) see *People*, 23 July 1989; for the invasion of the privacy of the Royal Family and Sammy Davis Junior, see *People*, 19 November 1989. Following publication of the latter, the editor was sacked. For an account see Stanley Reynolds, 'Curtains for a Freak Show', *Guardian*, 21 November 1989. For a report on newspaper editors attempts to forestall legislation with their own code of practice, see Georgina Henry, 'Press Gang in Danger of Riding in Different Directions', *Guardian*, 20 November 1989. The code of practice was published in the national press on 28 November 1989. For information on the Calcutt Committee report on press and privacy, see Maggie Brown, 'Last Chance for Voluntary Press Code', and Christian Wolmar, 'Editors Fear Move to Statutory Constraints', *Independent*, 22 June 1990. For press reaction, see Georgina Henry, 'Editors Query Calcutt', and Hugo Young, 'The Great, the Good and the Disastrous',

Guardian, 26 June 1990; Georgina Henry, 'Press Council Refuses to Give up Role', *Guardian*, 27 June 1990; Adrian Holloway, 'Holding the Line against Calcutt', *Guardian*, 13 August 1990. For a review of tabloid press defiance of Calcutt, see Georgina Henry, 'The Long Lens and the Law', *Guardian*, 5 July 1990.

4 Philip Schlesinger, *Putting 'Reality' Together: BBC News*, London, Constable, 1978, p.230.

5 Philip Schlesinger, '"Terrorism", the media and the liberal-democratic state: a critique of the orthodoxy', *Social Research*, no. I, Spring 1981, p.75.

6 Paul Wilkinson, *Terrorism and the Liberal State*, London, Macmillan, 1986 (2nd edition), p.51.

7 There are always legal ambiguities. For example, see *The Gibraltar Report*, published by The National Council for Civil Liberties, April 1989, and press summary in *Guardian*, 7 April 1989.

8 Alan Protheroe, 'The broadcasters greatest hazard is fear', *Index on Censorship*, no.1, 1986, p.17.

9 See, for example, 'The knock on the door in the night – secret society', *New Statesman*, 6 February 1987, front page and p.3.

10 Insight, 'Inadmissible Evidence?' *Sunday Times*, 8 May 1988; and Insight, 'TV Lie Part Two', *Sunday Times*, 25 September 1988.

11 For newspaper comment on the inquest see, for instance, Heather Mills, 'Many Secrets Stay Hidden on the Rock', *Independent*, 1 October 1988; and Ian Jack, 'Questions on the Rock', *Observer*, 2 October 1988.

12 *Independent*, 27 Jan 1989. For an analysis, see Peter Kellner, 'Power Wields Bigger Guns than Truth – The Crime – Questioning an Official Version of Events', *Independent*, 30 January 1989.

13 Andrew Roth, 'Television's New McCarthy', *New Statesman & Society*, 13 January 1989, pp.10–11.

14 This phrase was used by Mrs Thatcher in a speech to the American Bar Association, and concerned a voluntary limitation on publicity during terrorist hijackings. See Peter Evans, 'Thatcher Unfolds Strategy to beat Hijack Terror', *The Times*, 16 July 1985.

15 'Critics Attack Ulster TV gag', *Independent*, 20 October 1988.

16 John Birt, Deputy Director-General of the BBC, 'Gagging the Messenger', ibid., 21 November 1988.

17 David McKittrick, 'Verbal Fig-Leaves of the Speakers who can be Seen but not Heard', *Independent*, 30 January 1989. See also David Hearst, 'Hurd's Gag Begins to Tighten', *Guardian*, 8 May 1989.

18 *Independent*, 27 March 1989.

19 *Sun* and *Today*, 5 April 1989. For accounts of the convictions and sentencing, see *Guardian* and *Independent*, 2 June 1989.

20 For a list of major events, see '20 Years of Undeclared War', *Independent*, 1 October 1988. See also review of events in Northern Ireland on the twentieth anniversary of British soldiers in Ulster in David McKittrick, 'Decades of Violence in a World of Stalemate', *Independent*, 14 August 1989; and a four-page survey introduced by David Pallister in 'Two Decades of Bloodshed', *Guardian*, 14 August 1989. For a graphic representation of 'The Number of Terrorist Deaths in Northern Ireland, 1969–1988', see *Independent*, 5 August 1988. For an account of the IRA campaign outside of Northern Ireland since 1985, see David Pallister and Richard Norton-Taylor, 'Trail of Terror Stretches Back Five Years', *Guardian*, 1 August 1990. For a list of IRA attacks in the year leading up to the killing of the Conservative MP, Ian Gow, in East Sussex, see 'Toll of Year's Terrorism', *Independent*, 31 July 1990.

21 *The Times*, 24 February 1976.

22 ibid., 27 February 1976.

23 Eamonn McCann, *The British Press in*

Northern Ireland, Northern Ireland Socialist Research Centre, 1971, p.27.

24 See *Independent*, 13 February 1989.

25 David McKittrick, 'Death Toll Mounts in War of INLA Splinter Groups', ibid., 2 March 1987.

26 'No Chance', *Sunday Mirror*, 21 August 1988.

27 *Today*, 31 August 1988.

28 See *Independent*, 15 November 1988.

29 ibid., 14 November 1988.

30 'RUC Reprimands Cause Disquiet', *Guardian*, 16 March 1989.

31 The Irish Freedom Movement handbook, *The Irish War*, London, Junius publications, 1985, p.203.

32 *Daily Telegraph* and *Daily Mirror*, 20 April 1972. For an account of media coverage of 'Bloody Sunday' see Liz Curtis, *Ireland, The Propaganda War: the British Media and the Battle for Hearts and Minds*, London, Pluto, 1984, pp.40–51.

33 Maurice Tugwell, 'Politics and propaganda of the provisional I.R.A.', *Terrorism, an International Quarterly*, vol. 5 nos. 1 and 2, 1981, p.29.

34 See David McKittrick, 'Anglo-Irish Deal Fails to Live up to Expectations', *Independent*, 15 November 1988.

35 Roger Faligot, *Britain's Military Strategy in Ireland: The Kitson Experiment*, London, Zed Press 1983, p.4.

36 *Daily Mirror*, 13 August 1971.

37 *Sun*, 8 December 1983.

38 Leader in *Guardian*, 7 December 1988.

39 Richard Norton-Taylor, 'Stumbles in the Shadows of Terror,' ibid., 4 July 1990.

40 There are plans to shift the police into a

military role. See Malcolm Pithers, 'Paramilitary Role for Police in Event of War, Study Says', *Independent*, 16 November 1988.

41 *Daily Mirror*, 17 June 1974.

42 Paul Johnson, 'The Resources of Civilisation', *New Statesman*, 31 October 1975, quoted in Philip Elliott, 'All the world's a stage, or what's wrong with the national press', in James Curran (editor), *The British Press: a Manifesto*, London, Macmillan 1978, p.157.

43 Philip Elliott, 'Reporting Northern Ireland: a study of news in Britain, Ulster and the Irish Republic', *Ethnicity and the Media*, Paris, UNESCO 1978, pp.295–6. First published by Centre for Mass Communication Research, University of Leicester, 1976.

44 See Colin Brown, Sarah Helm, Terry Kirby, Jack O'Sullivan and Phil Reeves, 'Judicial Inquiry Ordered over Guildford Four', *Independent*, 20 October 1989; Simon Freeman and Christopher Elliott, 'Early Doubts Ignored over Guildford Four', *Sunday Correspondent*, 22 October 1989.

45 David Sharrock and Martin Linton, 'DPP Admits Maguire 7 Convictions Were Unsafe', *Guardian*, 15 June 1990; Heather Mills and Colin Brown, 'Maguire Convictions to be Quashed', *Independent*, 12 July 1990.

46 For reports on efforts to release the Birmingham Six, see David Pallister, 'Birmingham Six Scientists "Discredited"', *Guardian*, 16 June 1990; Heather Mills, 'Dismissal of Case Led Campaigners to Redouble Efforts', *Independent*, 30 August 1990. For developments occurring at the time of writing, see accounts in the broadsheets from 5 March 1991.

47 Paul Hoyland, Owen Bowcott and Ian Traynor, 'Two Terrorist Units "Active in Britain"', *Guardian*, 20 September 1990.

48 *Independent*, 20 September 1990.

49 For provisions of the Bill see ibid.,

26 November 1988. See Clive Walker, *The Prevention of Terrorism in British Law*, Manchester, Manchester University Press, 1986.

50 For press accounts of British violations of the European Convention of Human Rights see 'The Anglo-Irish Crisis', *Independent*, 30 November 1988.

51 For an example of E-fit picture issued by Staffordshire police following the killing in June 1990 of a soldier at Lichfield station, see ibid., 26 June 1990; for E-fits, photofits and artist's impressions see David Connett and Robin Wilson, 'Inside Story: the IRA – One Small Cell Attacking the Body Politic', *Independent on Sunday*, 1 July 1990.

52 *Daily Mirror*, 16 November 1974.

53 *Sun*, 15 October 1981.

54 See Bob Lumley, 'Notes on some images of terrorism in Italy', *Screen Education*, no. 40 Autumn/Winter 1981, pp.63–4.

55 Stuart Hall, 'The determinations of news photographs', in *Working Papers in Cultural Studies* no. 3, Centre for Contemporary Cultural Studies, University of Birmingham, 1972, p.85.

56 Paul Johnson. op. cit.

57 *Daily Mirror*, 21 July 1976. For the continuing mixture of policing and political killings in 1990, see press reports on the death of Ian Gow, 'Police Warned Gow he was IRA Assassination Target', *Independent*, 31 July 1990.

58 Roger Faligot, op. cit., p.108.

59 Liz Curtis, op. cit., p.69.

60 *Daily Mirror*, 12 August 1971.

61 ibid., 28 August 1979.

62 Philip Elliott, 'Press performance as political ritual', in Harry Christian (editor), *The Sociology of Journalism and the Press*, Sociological Review Monograph 29, University of Keele, 1980, p.142.

63 *Daily Mirror*, 28 August 1979.

64 ibid., 29 August 1979.

65 *Sun*, 29 August 1979.

66 *Daily Mail*, 29 August 1979.

67 *Star*, 1 September 1988.

68 Paul Wilkinson, 'Terrorism and the media', *Journalism Studies Review*, vol. 3, 1978, p.4.

69 *Daily Mirror*, 21 March 1972.

70 ibid., 20 July 1970.

71 ibid., 15 August 1984.

72 ibid., 11 August 1971.

73 Alan Hooper, *The Military and the Media*, Aldershot, Gower 1982, p.131.

74 *Daily Mail*, 11 August 1976.

75 *Belfast Telegraph*, 11 August 1976.

76 *Daily Mirror*, 11 August 1976.

77 Martin Bell at a seminar on 'Terrorism and the media', in Jennifer Shaw, Rear Admiral E. F. Gueritz, Major General A. E. Younger, Frank Gregory, Commander Joseph Palmer (editors), *Ten Years of Terrorism: Collected Views*, London, Royal United Services Institute for Defence Studies, 1979, p.93.

78 Roger Faligot, 'Autopsy for the Women's Peace Movement', in Faligot, op. cit., pp.184–209.

79 Frank Kitson, *Low Intensity Operations: subversion, insurgency, peace-keeping*, Faber, 1971, p.87, quoted in Roger Faligot, op. cit., p.184.

80 *Irish Times*, 30 August 1976.

81 *Daily Mirror*, 14 October 1976.

82 See Liz Curtis, op. cit., p.39.

83 *The Sunday Times*, 28 November 1976.

84 Quoted by Roger Faligot, op. cit., p.198.

85 Belinda Loftus, 'Images for sale: government and security advertisements in Northern Ireland 1968–78', *Oxford Art Journal*, October 1980, pp.76–7.

86 *Daily Mail*, 22 November 1974.

87 *Sun*, 10 November 1987.

88 *Daily Mirror* and *Star*, 9 November 1987.

89 *Guardian*, 9 November 1987.

90 *Today* and *Daily Mirror*, 9 November 1987.

91 *Independent*, 9 November 1987.

92 *Guardian*, 17 November 1987.

93 *Star*, 17 November 1987.

94 *Sunday Telegraph*, 20 March 1988.

95 'Letters to the Editor', *Sunday Telegraph*, 27 March 1988.

96 *Guardian*, 7 April 1989.

97 *Observer*, 10 May 1987.

98 *Star*, 17 March 1988.

99 'Violent Career of a "Quiet" Labourer who Became an Assassin', *Independent*, 4 March 1989.

100 Quoted in Carol Ackroyd, Karen Margolis, Jonathan Rosenhead, Tim Shallice, *The Technology of Political Control*, Harmondsworth, Penguin, 1977, p.115.

101 See Gerry Northam, *Shooting in the Dark, Riot Police in Britain*, London, Faber, 1988.

102 Ron McKay, Steve Peak, Karen Margolis, 'Terminal surveillance' in 'Reporting on Northern Ireland', *Camerawork*, no. 14,

August 1979, p.17, reprinted from *Time Out*, no. 469, 13 April 1979.

103 *Sun*, 6 June 1974.

104 Steve Chibnall, *Law-and-Order News: an analysis of crime reporting in the British Press*, London, Tavistock 1977, p.120.

105 See Martin Slavin, 'Colour supplement living', *Ten.8*, no. 23, 1986, pp.2–25.

106 *Sun*, 15 June 1974.

107 Paul Wilkinson, 'The Provisional I.R.A.: an assessment in the wake of the 1981 hunger strike', *Government and Opposition*, vol. 17, 1982, p.152.

108 Paul Wilkinson, *Terrorism and the Liberal State*, op. cit., p.viii.

109 Speech by the Prime Minister at the Lord Mayor's Banquet, Guildhall, London, 12 November 1984, London, Press Office, 10 Downing Street, p.13.

110 See Claire Sterling, *The Terror Network: the Secret War of International Terrorism*, London, Weidenfeld & Nicholson, 1981. For a critique, see Edward S. Herman, *The Real Terror Network: Terrorism in Fact and Propaganda*, Boston, South End Press, 1983.

111 *Daily Mirror*, 17 May 1977. For an analysis see Frank Webster, *The New Photography: Responsibility in Visual Communication*, London, Platform Books/ John Calder 1980, pp.238–243.

112 See Philip Schlesinger, 'Princes' Gate, 1980: the media politics of siege management', *Screen Education*, no. 37, Winter 1980/81, pp.29–54; and Cary Bazalgette and Richard Paterson, 'Real entertainment: the Iranian Embassy siege', in ibid., pp.55–67.

113 *Sunday Today*, 1 March 1987.

114 See advertisement for Metropolitan Police, 'Could You Disarm Him?' in the *Sunday Times Magazine*, 13 December 1987.

115 *Guardian*, 19 September 1990. See *The Police*

and the Public in England and Wales, Home
Office research report 117, London, HMSO,
1990.

116 *Daily Express*, 18 May 1987.

117 See, for instance, press reports of killing by
IRA of two solicitors in Holland, mistaken
for servicemen, 29 May 1990.

118 *Guardian*, 19 October 1987.

119 Arlen Harris, 'Black Link to IRA', *Observer*,
24 January 1988.

120 *Sunday Express*, 18 October 1987.

121 Richard Dowden, 'An Explosive Test for
Britain's Hard Line on Terrorism',
Independent, 28 April 1989.

122 David McKittrick, 'Expulsion of Diplomats
Reflects Change of Course', ibid., 6 May
1989.

123 Richard Dowden, Alan Murdoch and Colin
Brown, 'Mandela Seeks to Defuse IRA Row',
ibid., 3 July 1990; *Guardian*, 3–5 July 1990.

London, Secker & Warburg, 1986, later
published as *Travels in Hyper-Reality*,
London, Picador, 1987.

6

THE BODY IN THE PRESS

1 *Daily Mirror*, 22 December 1988.

2 Sander L. Gilman, *Difference and Pathology:
Stereotypes of Sexuality, Race and Madness*,
Ithaca, Cornell University Press, 1985, p.18.

3 See press from 19 August 1987.

4 See Eric Hobsbawm and Terence Ranger
(editors), *The Invention of Tradition*,
Cambridge, Cambridge University Press,
1983.

5 See Patrick Wright, *On Living in an Old
Country: The National Past in Contemporary
Britain*, London, Verso, 1985.

6. See Robert Hewison, *The Heritage Industry:
Britain in a Climate of Decline*, Methuen,
1987; and Umberto Eco, *Faith in Fakes*,

BIBLIOGRAPHY

Ackroyd, Carol, Margolis, Karen, Rosenhead, Jonathan, Shallice, Tim, *The Technology of Political Control*, Harmondsworth, Penguin, 1977.

Adams, Valerie, *The Media & the Falklands Campaign*, London, Macmillan, 1986.

Allatt, Patricia, 'Men and war: status, class and the social reproduction of masculinity', in Gamarnikow, Eva (editor), *The Public and the Private*, London, Heinemann, 1983, pp.47–61.

Angell, Norman, *The Press and the Organisation of Society*, London, The Labour Publishing Co., 1922.

Ashworth, A. E., 'The sociology of trench warfare', *The British Journal of Sociology*, no. 4, December 1968, pp.407–23.

Aulich, James (editor), *Nationhood, Identity, and Culture: The Falklands War*, Milton Keynes, Open University Press, 1991.

Badsey, S. D., 'British official photography in the First World War', unpublished monograph in the Imperial War Museum, 1981.

Barnett, A., 'Some notes on media coverage of the Falklands', in Barker, Francis, Hulme, Peter, Iversen, Margaret, Loxley, Diana (editors), *Confronting the Crisis: War, Politics and Culture in the Eighties*, Colchester, University of Essex, 1984, pp.74–89.

Bazalgette, Cary, and Paterson, Richard, 'Real entertainment: the Iranian Embassy siege', *Screen Education*, no. 37, Winter 1980/81, pp.55–67.

Bell, Edward Price, *The British Censorship*, an address before the American Luncheon Club, Savoy Hotel, London, 19 November 1915, London, Fisher & Unwin, 1916.

Blake, Robert (editor), *The Private Papers of Douglas Haig, 1914–19*, London, Eyre and Spottiswoode, 1952.

Bogart, Ernest L., *Direct and Indirect Costs of the Great War*, Carnegie Endowment for International Peace, Preliminary Economic Studies of the War, no. 24, New York, Oxford University Press, 1919.

Bond, Brian, 'Dunkirk; myths and lessons', *Royal United Services Institute for Defence Studies Journal*, 1982, pp.3–8.

Boyce, D. G., 'Crusaders without chains: power and the press barons 1896–1951', in Curran, James, Smith, Anthony, and Wingate, Pauline (editors), *Impacts and Influences: Essays on Media Power in the Twentieth Century*, London, Methuen, 1987, pp.97–112.

Browne, G., *Patterns of British Life*, London, Hulton Press, 1950.

Brunner, Elizabeth, *Holiday Making and Holiday Trades*, Nuffield College, Oxford, Oxford University Press, 1945.

Burgin, Victor (editor), *Thinking Photography*, London, Macmillan, 1982.

Burke, Thomas, *The English and their Country*, London, published for the British Council by Longman, Green & Co., 1945.

Calder, Angus, *The People's War, Britain, 1939–45*, St Albans, Granada Publishing Ltd., 1982, (first published by Jonathan Cape, 1969).

Cantril, A. H., *Public Opinion 1935–1946*, Princeton, Princeton University Press, 1951.

Carmichael, Jane, *First World War Photographers*, London, Routledge, 1989.

Carton, R., *The English Scene: The Spirit of England in the Monuments of her Social Life and Industrial History*, London, A. & C. Black, 1930.

Cherry, Deborah, and Potts, Alex, 'The changing images of war', *New Society*, 29 April 1982, pp.172–4.

Chibnall, Steve, *Law-and-Order News: An Analysis of Crime Reporting in the British Press*, London, Tavistock 1977.

Cloete, Stuart, *A Victorian Son*, London, Collins, 1972.

Cockerell, M., Hennessy, P., and Walker, D., *Sources Close to the Prime Minister*, London, Macmillan, 1984.

Cohen, Stanley, and Young, Jock (editors), *The Manufacture of News*, London, Constable, 1981 (completely revised edition).

Cook, Sir Edward, *The Press in War Time*, London, Macmillan, 1920.

Costello, John, *Love, Sex and War, Changing Values 1939–45*, London, Collins, 1985.

Craig, Charles, 'The British documentary photograph as a medium of information and propaganda during the Second World War, 1939–45', unpublished M. Phil. thesis, Imperial War Museum, 1982.

Curran, James (editor), *The British Press: A Manifesto*, London, Macmillan, 1978.

Curran, James, and Seaton, Jean, *Power without Responsibility – The Press and Broadcasting in Britain*, London, Methuen, 1985.

Curran, James, Douglas, Angus, and Whannel, Garry, 'The political economy of the human-interest story', in Smith, Anthony (editor), *Newspapers and Democracy, International Essays on a Changing Medium*, Cambridge, Massachusetts, The MIT Press, 1980, pp.288–347.

Curran, James, Smith, Anthony and Wingate, Pauline (editors), *Impacts and Influences: Essays on Media Power in the Twentieth Century*, London, Methuen, 1987.

Curtis, Liz, *Ireland, The Propaganda War: The British Media and the Battle for Hearts and Minds*, London, Pluto, 1984.

Davin, Anna, 'Imperialism and motherhood', *History Workshop Journal*, no. 5, Spring 1978, pp.9–65.

Eco, Umberto, *Faith in Fakes*, London, Secker & Warburg, 1986, later published as *Travels in Hyper-Reality*, London, Picador, 1987.

Edwards, Stephen, 'The need to know: the northern town in documentary discourses of the nineteen thirties', unpublished thesis for an MA in the Social History of Art, University of Leeds, 1983.

Elliott, Philip, 'All the world's a stage, or what's wrong with the national press', in Curran, James (editor), *The British Press: A Manifesto*, London, Macmillan, 1978, pp.141–70.

Elliott, Philip, 'Press performance as political ritual', in Christian, Harry (editor), *The Sociology of Journalism and the Press*, Sociological Review Monograph 29, University of Keele, 1980, pp.141–77.

Elliott, Philip, 'Reporting Northern Ireland: a study of news in Britain, Ulster and the Irish Republic', *Ethnicity and the Media*, Paris, UNESCO 1978, pp.295–6. First published by

Centre for Mass Communication Research, University of Leicester, 1976.

Englander, D., and Osborne, J., 'Jack, Tommy and Henry Dubb: the armed forces and the working class', *Historical Journal*, September 1978, pp.593–621.

Faligot, Roger, *Britain's Military Strategy in Ireland: The Kitson Experiment*, London, Zed Press, 1983.

Falls, Cyril, *War Books 1914–18, A Critical Guide to the Literature of the Great War*, Peter Davies Ltd, 1930.

Ferguson, Sheila, and Fitzgerald, Hilde, *Studies in the Social Services*, London, HMSO, 1954.

Fussell, Paul, *The Great War and Modern Memory*, Oxford, Oxford University Press, 1975.

Gear, John H., 'The influence of photography in the war', *Photographic Journal*, December 1916, p.269.

Gerald, J. Edward, *The British Press Under Government Economic Controls*, Minneapolis, University of Minnesota Press, 1956.

Gibbs, Sir Philip, *Adventures in Journalism*, London, Heinemann, 1923.

Gibbs, Sir Philip, *The War Despatches* (edited by Prigg, Catherine), London, Anthony Gibbs & Phillips, 1964.

Gilman, Sander L., *Difference and Pathology: Stereotypes of Sexuality, Race and Madness*, Ithaca, Cornell University Press, 1985.

Glasgow University Media Group,*War and Peace News*, Milton Keynes, Open University Press, 1985.

Grafton, P., *You, You and You! The People out of Step with World War II*, London, Pluto, 1981.

Grant, Neil, 'Citizen soldiers: army education in World War II', in *Formations of Nation and People*, Routledge & Kegan Paul, 1984, pp.171–87.

Hall, Stuart, 'The determinations of news photographs', in *Working Papers in Cultural Studies*

no. 3, Centre for Contemporary Cultural Studies, University of Birmingham, 1972, pp.53–87.

Hall, Stuart, 'The social eye of *Picture Post*', *Working Papers in Cultural Studies*, no. 2, Spring 1972, pp.71–120.

Hargreaves, E. L., and Gowing, M. M., *Civil Industry and Trade*, London, HMSO, 1952.

Harris, Robert, *Gotcha: The Media, the Government and the Falklands Crisis*, London, Faber & Faber, 1983.

Harrisson, Tom, *Living Through the Blitz*, London, Collins, 1976.

Haslam, A. P., *Cannon Fodder*, Hutchinson & Co., n.d.

Herman, Edward S., *The Real Terror Network: Terrorism in Fact and Propaganda*, Boston, South End Press, 1983.

Hewison, Robert, *The Heritage Industry: Britain in a Climate of Decline*, Methuen, 1987.

Hobsbawm, Eric, and Ranger, Terence (editors), *The Invention of Tradition*, Cambridge, Cambridge University Press, 1983.

Hodges, Andrew, *Alan Turing, the Enigma of Intelligence*, London, Unwin Paperbacks, 1985.

Holland, Patricia, Spence, Jo, and Watney, Simon (editors), *Photography/Politics: Two*, London, Comedia/Photography Workshop, 1986.

Hollingworth, Mark, *The Press and Political Dissent – A Question of Censorship*, London, Pluto, 1986.

Hooper, Alan, *The Military and the Media*, Aldershot, Gower, 1982.

Hopkin, Deian, 'Domestic censorship in the First World War', *Journal of Contemporary History*, no. 4, 1970, pp.151–69.

Hopkinson, Tom (editor), *Picture Post 1938–50*, Harmondsworth, Penguin Books, 1979.

Horn, Pamela, *The Changing Countryside in Victorian and Edwardian England and Wales*, London, Athlone Press, 1984.

House of Commons Defence Committee, *The*

Handling of Press and Public Information during the Falklands Conflict, December 1982, vols HC 17–I and HC 17–II.

Hurd, Geoff (editor), *National Fictions: World War Two in British Films and Television*, London, BFI Books, 1984.

The Irish Freedom Movement handbook, *The Irish War*, London, Junius publications, 1985.

Jeffery, Tom, *Mass-Observation – a Short History*, Stencilled Occasional Paper no. 55, Centre for Contemporary Cultural Studies, Birmingham, University of Birmingham, 1978.

Joad, C. E. M., *The Untutored Townsman's Invasion of the Country*, London, Faber & Faber, 1946.

Kettlewell, Ian, 'Designing a crisis, the Falklands and the design of the popular press', *ffotoview*, no. 10/11, Winter 1984, pp.10–13.

Kimble, P., *Newspaper Reading in the Third Year of the War*, London, Allen & Unwin, 1942.

Kitson, Frank, *Low Intensity Operations: Subversion, Insurgency, Peace-keeping*, London, Faber & Faber, 1971.

Knightley, P., *The First Casualty*, New York, Harcourt Brace Jovanovich, 1975.

Koss, Stephen, *The Rise and Fall of the Political Press in Britain, Volume Two: The Twentieth Century*, London, Hamish Hamilton, 1984.

Leed, Eric J., *No Man's Land, Combat and Identity in World War I*, Cambridge, Cambridge University Press, 1979.

Lippmann, Walter, *Public Opinion*, London, Allen & Unwin, 1922.

Loftus, Belinda, 'Images for sale: government and security advertisements in Northern Ireland 1968–78', *Oxford Art Journal*, October 1980, pp.76–80.

Longworth, Philip, *The Unending Vigil: A History of the Commonwealth War Graves Commission 1917–1967*, London, Constable, 1967.

Lumley, Bob, 'Notes on some images of terrorism in Italy', *Screen Education*, no. 40, Autumn/Winter 1981, pp.59–66.

McCann, Eamonn, *The British Press in Northern Ireland*, Northern Ireland Socialist Research Centre, 1971.

Mackay, James, *Airmails 1870–1970*, London, Batsford, 1971.

McKay, Ron, Peak, Steve, Margolis, Karen, 'Terminal surveillance' in 'Reporting on Northern Ireland', *Camerawork*, no. 14, August 1979, p.17, reprinted from *Time Out*, no. 469, 13 April 1979.

McLaine, Ian, *Ministry of Morale: Home Front Morale and the Ministry of Information in World War II*, London, Allen & Unwin, 1979.

Mandel, Ernest, *Late Capitalism*, London, Verso, 1980 (second impression).

Mandel, Ernest, *The Meaning of the Second World War*, London, Verso, 1986.

Marcus, Jane, 'Corpus/corps/corpse: writing the body in/at war', in Cooper, Helen M., Munich, Adrienne Auslander, and Squier, Susan Merrill (editors), *Arms and the Woman, War, Gender, and Literary Representation*, Chapel Hill, The University of North Carolina Press, 1989.

Marquis, A. G., 'Words as weapons: propaganda in Britain and Germany during the First World War', *Journal of Contemporary History*, no. 3, 1978, pp.467–98.

Marwick, Arthur, *The Deluge*, Harmondsworth, Penguin, 1967.

Marwick, Arthur, *Women at War 1914–1918*, London, Fontana in association with the Imperial War Museum, 1977.

Mercer, Derrik, Mungham, Geoff, and Williams, Kevin, *The Fog of War*, London, Heinemann, 1987.

Ministry of Defence, *The Handling of Press and Public Information during the Falklands Conflict: Observation on the First Report from the Defence Committee*, March 1983, Cmnd 8820.

Ministry of Defence, *The Protection of Military Information, Government Response to the Report of the Study Group on Censorship*, April 1985, Cmnd 9499.

Ministry of Defence, *The Protection of Military Information, Report of the Study Group on Censorship*, December 1983, Cmnd 9112.

Molotch, Harvey, and Lester, Marilyn, 'News as purposive behaviour: on the strategic use of routine events, accidents and scandals', in Cohen, Stanley, and Young, Jock (editors), *The Manufacture of News*, London, Constable, 1981 (completely revised edition), pp.118–37.

Morden, Terry , 'The pastoral and the pictorial', in 'Rural Myths', *Ten.8*, no. 12, 1983, pp.18–25.

Morrison, David E., and Tumber, Howard, 'The government and information in time of war: the Falklands and the media', in Barker, Francis, Hulme, Peter, Iversen, Margaret, Loxley, Diana (editors), *Confronting the Crisis: War, Politics and Culture in the Eighties*, Colchester, University of Essex, 1984, pp.100–10.

Morrison, David E., and Tumber, Howard, *Journalists at War: The Dynamics of News Reporting during the Falklands Conflict*, London, Sage Publications, 1988.

Mortimer, F. J., 'More about photography's part in the War', *Photographic Journal*, April 1942, pp.88–105.

Mortimer, F. J., 'Photography's part in the War', *Photographic Journal*, April 1941, pp.124–45.

Mortimer, F. J., 'Photography's part in the War: fourth year', *Photographic Journal*, April 1944, pp.74–88.

Mortimer, F. J., 'Photography's part in the War: third year', *Photographic Journal*, April 1943, pp.98–112.

Morton, H. V., *I Saw Two Englands*, London, Methuen, 1942.

Moss, L., and Box, K. L., *Ministry of Information Publications: A Study of Public Attitudes towards Six Ministry of Information Books*, London, Central Office of Information, 1948.

Moss, L., and Box, K. L., *Newspapers: An Inquiry into Newspaper Reading amongst the Civilian Population*, Wartime Social Survey, Publications Division of the Ministry of Information, June–July 1943.

Murdock, Graham, 'Class, power, and the press: problems of conceptualisation and evidence', in Christian, Harry (editor), *The Sociology of Journalism and the Press*, Keele, Staffordshire, Sociological Review Monograph, vol. 29, University of Keele, 1980, pp.37–70.

Northam, Gerry, *Shooting in the Dark, Riot Police in Britain*, London, Faber & Faber, 1988.

Orwell, George, *The Lion and the Unicorn, Socialism and the English Genius*, London, Secker & Warburg, 1941.

Parker, H. M. D., *Manpower: A Study of War-Time Policy and Administration*, London, HMSO, 1957.

Photographs Taken by the Royal Flying Corps, Printed in the Field by no. 4 Advanced Section, Army Printing and Stationery Services, 1917. A book of 39 original aerial reconnaissance photographs, introduced by Major J. T. C. Moore-Brabazon, O i/c Photography, Royal Flying Corps, and a photographed page of conventional signs.

Pimlott, J. A. R., *Recreations*, London, Studio Vista, 1968.

Powyss-Lybbe, Ursula, *The Eye of Intelligence*, London, William Kimber, 1983.

Prime Minister's speech to a Conservative Party rally at Cheltenham racecourse, 3 July, London, Conservative Central Office, 1982.

Pronay, Nicholas, 'Rearmament and the British public: policy and propaganda', in Curran, James, Smith, Anthony, and Wingate, Pauline (editors), *Impacts and Influences: Essays on Media Power in the Twentieth Century*, London, Methuen, 1987, pp.53–96.

Pronay, Nicholas, and Spring, D. W. (editors), *Propaganda, Politics and Film 1918–45*, London, Macmillan, 1982.

Pulbrook, E. C., *The English Countryside*, Batsford, 1915.

Rankin, William, 'What Dunkirk spirit?', *New Society*, 15 November 1973, pp.396–8.

Reeves, Nicholas, 'Film propaganda and its audience: the example of Britain's official films during the First World War', *Journal of Contemporary History*, vol. 18, no. 3, July 1983, pp.463–94.

Riley, Denise, 'The free mothers: pronatalism and working mothers in industry at the end of the last war in Britain', *History Workshop Journal*, no. 11, 1981, pp.59–118.

Robertson, P., 'Canadian photo-journalism during the First World War', *History of Photography Journal*, no.1, January 1978, pp.37–52.

Rock, Paul, 'News as eternal recurrence', in Cohen, Stanley, and Young, Jock (editors), *The Manufacture of News*, London, Constable, 1981, (completely revised edition), pp.64–70.

Salmon, Lucy, *The Newspaper and the Historian*, New York, Oxford University Press, 1923.

Sanders, M. L., and Taylor, Philip M., *British Propaganda during the First World War 1914–18*, London, Macmillan, 1983.

Schlesinger, Philip, 'Princes' Gate, 1980: the media politics of siege management', *Screen Education*, no. 37, Winter 1980/81, pp.29–54.

Schlesinger, Philip, *Putting 'Reality' Together: BBC News*, London, Constable, 1978.

Schlesinger, Philip, '"Terrorism", the media and the liberal-democratic state: a critique of the orthodoxy', *Social Research*, no. I, Spring 1981, pp.74–99.

Searle, G. R., *Eugenics and Politics in Britain 1900–1914*, Leyden, Noordhoff International Publishing, 1976.

Sekula, Allan, *Photography against the Grain, Essays and Photo-Works 1973–1983*, Halifax, Nova Scotia, The Press of Nova Scotia College of Art and Design, 1984.

Sekula, Allan, 'Photography between labour and capital', in Buchloh, Benjamin, and Wilkie, Robert (editors), *Mining Photographs and Other Pictures: A Selection from the Negative Archives of Shedden Studio, Glace Bay, Cape Breton, 1948–1968. Photographs by Leslie Shedden*, Halifax, Nova Scotia, The Press of Nova Scotia College of Art and Design and The University College of Cape Breton Press, 1983.

Shaw, Jennifer, Gueritz, Rear Admiral E. F., Younger, Major General A. E., Gregory, Frank, Palmer, Commander Joseph (editors), *Ten Years of Terrorism: Collected Views*, London, Royal United Services Institute for Defence Studies, 1979.

Showalter, Elaine, 'Male hysteria; W. H. R. Rivers and the lessons of shell shock', chapter 7, *The Female Malady, Women, Madness and English Culture, 1830–1980*, London, Virago, 1987.

Sims, G. R., 'British photography in the Great War: its romance and its reality', *The Photographic Industry of Great Britain*, London, published by the British Photographic Manufacturers' Association Ltd, 1920.

Smith, A. C. H., Immirzi, Elizabeth, Blackwell, Trevor, and Hall, Stuart, *Paper Voices, The Popular Press and Social Change*, London, Chatto & Windus, 1975.

Smith, Anthony (editor), *Newspapers and Democracy, International Essays on a Changing Medium*, Cambridge, Massachusetts, The MIT Press, 1980.

Smith, Harold L. (editor), *War and Social Change: British Society in the Second World War*, Manchester, Manchester University Press, 1986.

Statistics of the Military Effort of the British Empire during the Great War 1914–1920, London, HMSO, 1922.

Sterling, Claire, *The Terror Network: The Secret War of International Terrorism*, London, Weidenfeld & Nicolson, 1981.

Tagg, John, 'Power and photography: Part one. A means of surveillance. The photograph as evidence in law', *Screen Education*, no. 36, Autumn

1980, pp.17–55.

Tagg, John, *The Burden of Representation, Essays on Photographies and Histories*, London, Macmillan, 1988.

Tagg, John, 'Power and photography: Part two. A legal reality: the photograph as property in law', *Screen Education*, no. 37, Winter 1980/81, pp.17–27.

Taylor, A. J. P., *English History 1914–45*, Oxford, Clarendon Press, 1965.

Taylor, John, 'The alphabetic universe: photography and the picturesque landscape', in Pugh, Simon (editor), *Reading Landscape: Country – City – Capital*, Manchester, Manchester University Press, 1990, pp.176–96.

Taylor, John, 'Atrocity propaganda in the First World War', in Collins, Kathleen (editor), *Shadow and Substance: Essays on the History of Photography*, Bloomfield Hills, Michigan, The Amorphous Institute Press, 1990, pp.305–17.

Thorpe, Frances, and Pronay, Nicholas, with Coultass, Clive, *British Official Films in the Second World War*, Oxford, Clio Press, 1980.

Titmuss, Richard M., *Problems of Social Policy*, London, HMSO, 1950.

The Tom Harrisson Mass-Observation Archive, Brighton, University of Sussex, Tom Harrisson Mass-Observation Archive, 1983.

Tuchman, Barbara, *Sand against the Wind: Stilwell and the American Experience in China, 1911–1945*, London, Macdonald/Futura, 1981.

Tugwell, Maurice, 'Politics and propaganda of the provisional I.R.A.', *Terrorism, an International Quarterly*, vol. 5 nos. 1 and 2, 1981, pp.13–40.

Tunstall, Jeremy, *The Media in Britain*, London, Constable, 1983.

Walker, Clive, *The Prevention of Terrorism in British Law*, Manchester, Manchester University Press, 1986.

Warren, C. H., *England is a Village*, London, Eyre & Spottiswoode, 1940.

Webster, C., and Frankland, N., *The Strategic Air Offensive against Germany 1939–45*, vol. I, London, HMSO, 1961.

Webster, Frank, *The New Photography: Responsibility in Visual Communication*, London, Platform Books/ John Calder 1980.

West, Rebecca, *The Young Rebecca West: 1911–1917* (edited by Marcus, Jane), New York, Viking, 1978.

Wiener, M. J., *English Culture and the Decline of the Industrial Spirit 1850–1980*, Cambridge, Cambridge University Press, 1981.

Wilkinson, Paul, 'The Provisional I.R.A.: an assessment in the wake of the 1981 hunger strike', *Government and Opposition*, vol. 17, 1982, pp.140–56.

Wilkinson, Paul, *Terrorism and the Liberal State*, London, Macmillan, 1986 (2nd edition).

Wilkinson, Paul, 'Terrorism and the media', *Journalism Studies Review*, vol. 3, 1978, pp.2–6.

Williamson, Henry, *The Wet Flanders Plain*, London, Faber & Faber, 1929.

Winship, Janice, 'Nation before family: *Woman*, the national home weekly', in *Formations of Nation and People*, Routledge & Kegan Paul, 1984, pp.188–211.

Winter, J. M., *The Great War and the British People*, London, Macmillan, 1986.

Wright, D. G., 'The Great War, government propaganda and English "men of letters" 1914–16', *Literature and History*, no. 7, 1978, pp.70–100.

Wright, Patrick, *On Living in an Old Country: The National Past in Contemporary Britain*, London, Verso, 1985.

Yass, Marion, *This is Your War: Home Front Propaganda in the Second World War*, London, HMSO, 1983.

Zuckerman, Solly, *From Apes to Warlords*, Hamish Hamilton, 1978, p.142.

INDEX